HIMALAYA

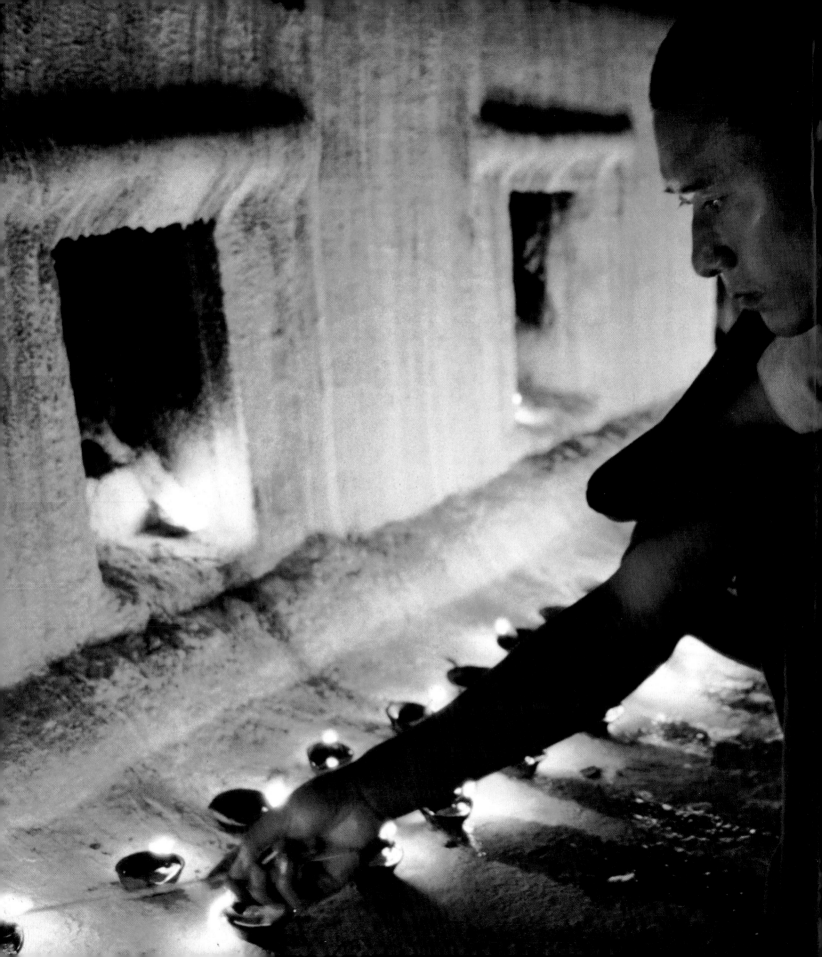

HIMALAYA

PERSONAL STORIES OF GRANDEUR, CHALLENGE, AND HOPE

Edited by Richard C. Blum, Erica Stone, and Broughton Coburn
of the American Himalayan Foundation

NATIONAL GEOGRAPHIC
WASHINGTON, D.C.

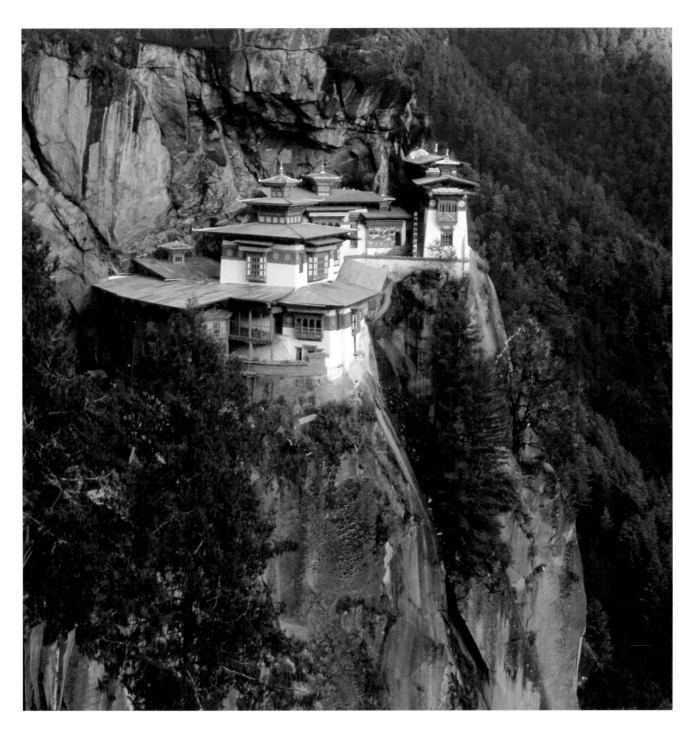

PRECEDING PAGE: *A monk lights butter lamps at the Great Stupa of Boudhanath, Kathmandu, Nepal.*
ABOVE: *Thaktshang, the Tiger's Nest Monastery in Bhutan, clings to a cliff above the Paro Valley. It is said that in the eighth century Guru Rinpoche flew here on a tiger and introduced Buddhism to Bhutan.*

TABLE OF CONTENTS

This book is dedicated to Sir Edmund Hillary, Urgyen Jigme Rabsel, and Meriama.

To SEE THE GREATNESS of a mountain, one must keep one's distance; to understand its form one must move around it; to experience its moods, one must see it at sunrise and sunset, at noon and at midnight, in sun and in rain, in snow and in storm, in summer and in winter and in all the other seasons. He who can see the mountain like this comes near to the life of the mountain, a life that is as intense and varied as that of a human being.

—Lama Anagarika Govinda

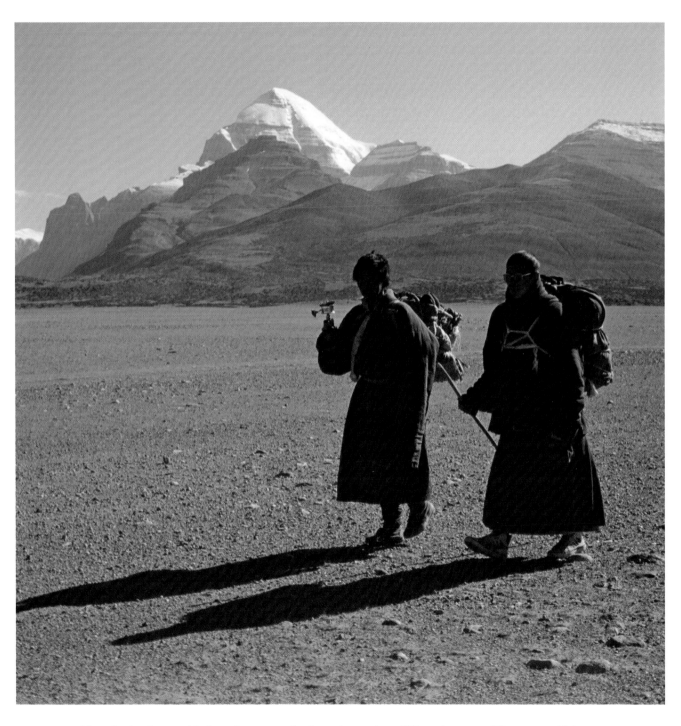

Two pilgrims have trekked nearly 1,500 miles from the province of Kham in eastern Tibet to sacred Mount Kailash, the source of four major Himalayan rivers. After circumambulating the holy mountain and crossing an 18,000-foot pass, they will traverse the Barkha Plain to Tirthapuri, another pilgrimage site.

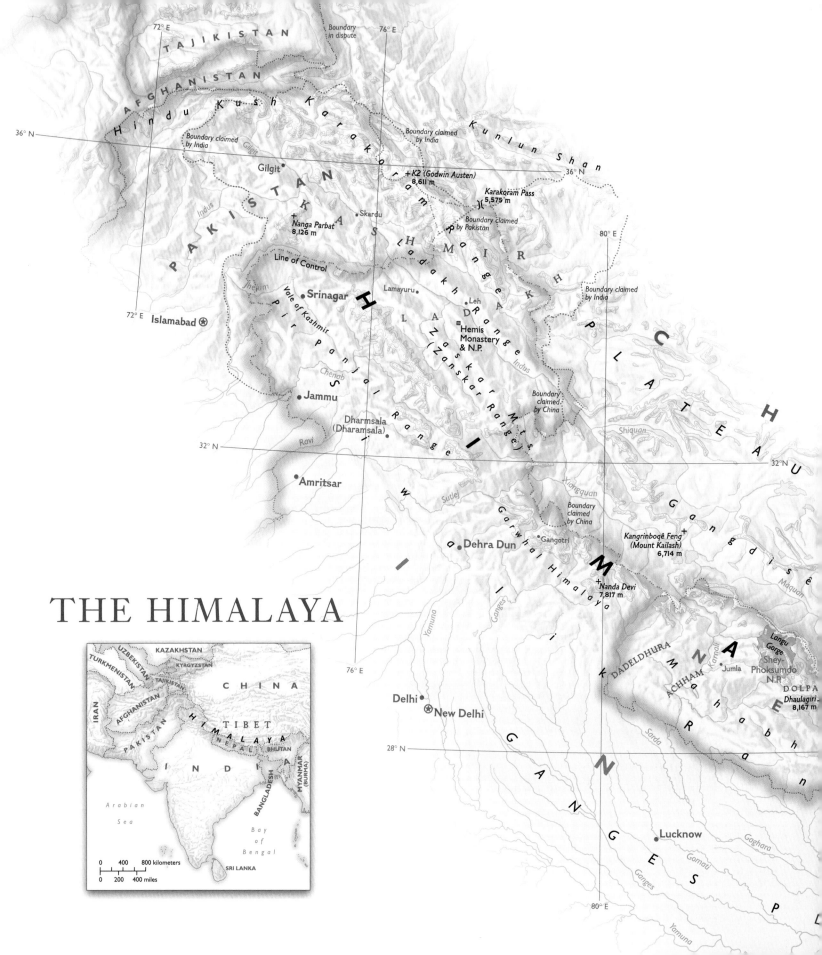

THE HIMALAYA

Map labels:

TAJIKISTAN

Boundary in dispute

AFGHANISTAN

Hindu Kush

Karakoram

Kunlun Shan

Boundary claimed by India

Boundary claimed by India

36° N — 36° N

Gilgit

K2 (Godwin Austen)
8,611 m

Karakoram Pass
5,575 m

PAKISTAN

Skardu

Boundary claimed by Pakistan

Nanga Parbat
8,126 m

KARAKORAM

KASHMIR

Ladakh Range

Line of Control

Jhelum

Srinagar

Lamayuru

Leh

Boundary claimed by India

PLATEAU

Vale of Kashmir

LADAKH

Drang

Hemis Monastery & N.P.

CHINA

Pir Panjal Range

Chenab

Zanskar Mts (Zanskar Range)

Shiquan

Jammu

Boundary claimed by China

Dharmsala (Dharamsala)

32° N — 32° N

Ravi

HIMA

Xiangquan

Gangdisê

Amritsar

Sutlej

Boundary claimed by China

Garwhal Himalaya

Kangrinboqê Feng (Mount Kailash)
6,714 m

Gangdisê

Dehra Dun

Gangotri

LAYA

Maqu

Nanda Devi
7,817 m

Ganges

Yamuna

DADELDHURA

ACHHAM

Mahabharat

Jumla

Langu Gorge

Shey-Phoksumdo N.P.

DOLPA

Dhaulagiri
8,167 m

Delhi

New Delhi

GANGES

Sarda

28° N — 28° N

Karnali

Lucknow

Gaghara

Gomati

Ganges

Yamuna

P

72° E 76° E 80° E

Inset map labels:

KAZAKHSTAN

UZBEKISTAN

TURKMENISTAN

KYRGYZSTAN

TAJIKISTAN

CHINA

IRAN

AFGHANISTAN

PAKISTAN

TIBET

HIMALAYA

NEPAL

BHUTAN

INDIA

MYANMAR (BURMA)

BANGLADESH

Arabian Sea

Bay of Bengal

SRI LANKA

0 400 800 kilometers

0 200 400 miles

THE GREAT HIMALAYAN RANGE *stretches 1,500 miles across southern Asia. Its name deriving from a Sanskrit word meaning "abode of the snow," the Himalaya is the source of three of the world's major rivers: the Indus, the Ganges, and the Brahmaputra. Half a billion people live within this watershed. The mountainous profile of the Himalaya continues to form as the Indian subcontinent squeezes beneath the Tibetan Plateau. Here, the Earth's crust is effectively two continents thick, which accounts for the range's dramatic topography, a landscape that rises five vertical miles in a distance of fifty and includes the world's fourteen highest peaks.*

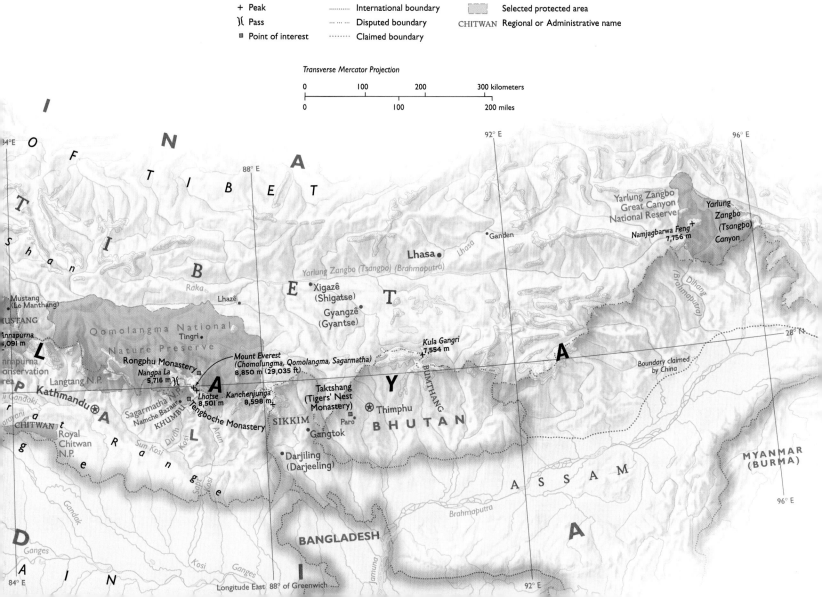

+ Peak	·········· International boundary	▨ Selected protected area
)(Pass	·—·—· Disputed boundary	CHITWAN Regional or Administrative name
▪ Point of interest	········· Claimed boundary	

Transverse Mercator Projection

0 — 100 — 200 — 300 kilometers
0 — 100 — 200 miles

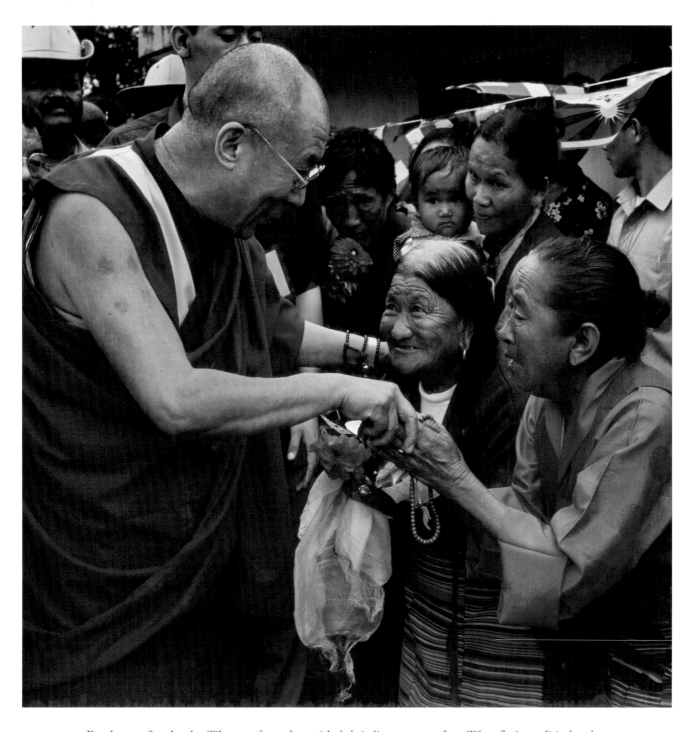

For the past five decades, Tibetan refugees have risked their lives to escape from Tibet, fleeing political and religious oppression. They continue to arrive in India in hopes of an audience with His Holiness the Dalai Lama, which he is granting here at the Tashilhunpo Monastery in southern India.

FOREWORD

His Holiness the Dalai Lama

The Himalayan region lies at the heart of Asia. Several of the continent's great rivers rise there, so it is a source of life, sustaining hundreds of millions of people in many lands, extending down to the distant surrounding oceans.

The rugged landscape of the region and the challenges of the climate have made conditions for transport difficult. Consequently, the region has been slower to change than elsewhere. The people who live there place much less importance on time than the inhabitants of the teeming cities in other parts of the world. Taking a patient, unhurried approach to life is a natural part of the local character. Of course, I am most familiar with the Tibetan people, but I have observed that throughout the Himalaya, people are similarly mild-mannered, easily contented, satisfied with whatever conditions are available, and resilient in the face of hardship. The rigors of the climate and environment contribute to this, but another significant factor has been the Buddhist culture that has flourished in the region for more than a thousand years.

For 1,300 years or more, we Tibetans have held custody of the full range of the Buddha's teachings. We received them largely from India and have analyzed them, refined them, and most important, have put them into practice, so that they have come to form the fabric of Tibetan culture. In the course of time, just as Tibetan military power once made itself felt far and wide, the influence of Tibetan culture spread throughout Central Asia and the Himalayan region. Temples and monasteries were established in these places and a steady stream of monks

and students were made welcome in Tibet's religious and medical institutions. Many of them, having completed their studies, would return to their homelands to teach and share what they had learned.

In the decades following the setbacks that befell Tibet, people in the surrounding lands were also deeply affected. They had been cut off from their traditional source not just of trade, but also of education and inspiration. Since then, Tibetan monastic universities and other cultural and educational institutions have been reestablished in several parts of India, and now it is not unusual to find students from right along the southern side of the Himalaya, and even from as far afield as Mongolia and the "Buddhist Republics" of the Russian Federation, studying alongside their Tibetan brothers and sisters once more.

Many people have observed that the Himalayan people seem to have an unusually well developed sense of inner peace and hope. I am convinced that our Buddhist heritage, with its teachings of love, kindness, and tolerance, has contributed to this, especially the notion that all things are relative and impermanent, which is very helpful when we are faced with difficulties. The people of this region may not be wealthy in material terms, but we have traditionally had all we needed, and we rarely went hungry. More important, the sense of freedom and contentment that we have long enjoyed, combined with the strength we draw from the Buddha's teachings, means that we have truly lived in peace.

I am very wary of idealizing old ways of living, because there is much that is commendable in the modern world. However, the clear challenge that faces us, whether we live in the developed or developing world, is to discover how we can enjoy the same degree of harmony and tranquility that we find in traditional communities, while benefiting fully from modern material developments. It is important that we improve standards of living, broaden educational opportunities, raise levels of health, and ease modes of transport. But as we progress from one way of life to another, there is a risk of abandoning what is tried and tested, what appears to be old, merely to have something modern instead. It would be a great shame if, in the process, we were to lose our sense of positive values.

For centuries, life went on in the Himalayan region, quiet and relatively undisturbed. Now, it seems, Himalayan life is beset by threats from many quarters. I am pleased and encouraged that this collection of essays, written from

many differing points of view and gathered together under the auspices of the distinguished American Himalayan Foundation and National Geographic Society, will introduce readers to much that is valuable and worthy of preservation. I hope that with increased awareness both of the treasures that exist in this part of the world and of how easily they may soon be lost, we may see more concerted efforts to restore the Himalaya as a zone of peace and to regain the natural conservation that once prevailed there for so long. ✤

O Buddhas, Bodhisattvas, and disciples
of the past, present, and future:
Having remarkable qualities
immeasurably vast as the ocean,
Who regard all helpless sentient
beings as your only child;
Please consider the truth of my anguished pleas.

Buddha's full teachings dispel the pain of worldly
existence and self-oriented peace;
May they flourish, spreading prosperity and happiness
throughout this spacious world.
O holders of the Dharma: scholars
and realized practitioners;
May your tenfold virtuous practice prevail.

—His Holiness the Dalai Lama

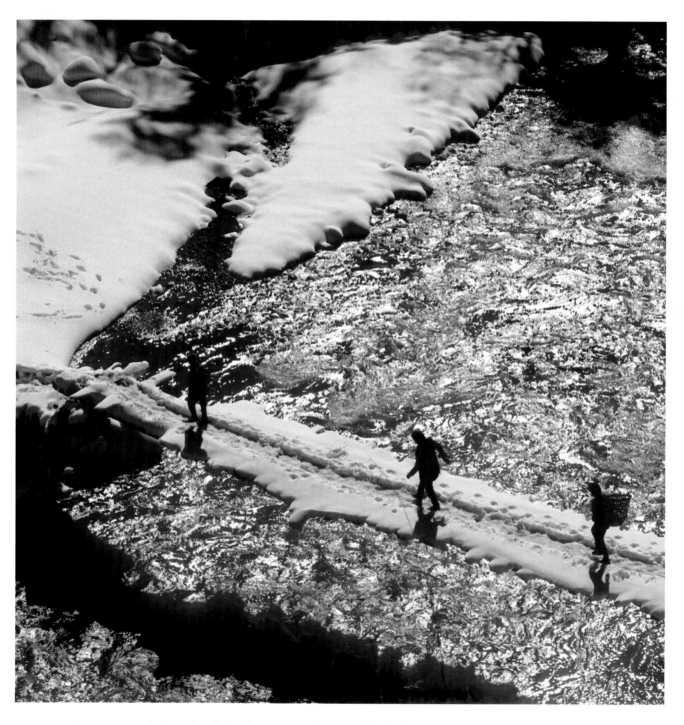

Porters and trekkers follow the single transportation artery that leads to Khumbu, the homeland of the Sherpas, across the Dudh Kosi near Namche Bazaar. Built after a glacial lake flooded, this bridge was later replaced with one of steel cable, suspended more than a hundred feet above the river.

PREFACE

President Jimmy Carter

TWENTY YEARS AGO, ROSALYNN AND I TREKKED to the Everest region of Nepal. I think often of that visit, and continue to marvel at the grandeur of the landscape and the remarkable resourcefulness and good cheer of the people who live there. Much of what follows is taken from words that I wrote upon our return.

The tremulous sounds of Buddhist ceremonial instruments woke me at first daylight. I opened the window a crack for a look outside. The view was breathtaking, with the 22,000-foot Thamserku peak towering over us in the east, shimmering white with its cloak of new-fallen snow. As we approached the *gompa*, or temple, of Tengboche Monastery after a long and steep ascent, we saw some large and exquisite birds feeding under the nearby rhododendron and juniper trees. They were blood pheasants, found only within a narrow range of altitude from 11,000 to 13,500 feet.

A few moments later we were startled to see three birds—even larger and with much more beautiful, iridescent colors—scratching in a small potato field. They flushed and swooped down over us, one of them, a cock, narrowly missing Rosalynn's head. The Sherpas exclaimed, "Those are danphes, which we rarely see." Known otherwise as impeyan pheasants, they are the Nepalese national bird, with feathers of nine different colors, varying from a tan tail to a shiny-blue topknot.

As we crossed the river the next morning, we witnessed an unforgettable scene. As in many developing countries, the people can no longer afford costly petroleum fuels for heating and cooking, and much of the original forest land is now denuded. The native families, having no alternative, must spend an increasing portion of their daylight hours in gathering wood.

Now, on the side of the steep avalanche area, we saw women and children digging the limbs and newly exposed roots out of the earth and rocks, chopping them into short pieces that could be carried on their backs, and attempting to haul the precious cargo up the sliding face of the cliff to the remaining trails far above them. The workers were constantly avoiding the stones and debris that slid or flew down to the river past their heads. It was the most difficult and dangerous work I had ever seen, and it made me glad that trekking parties are forbidden to use wood and must bring in their own kerosene for fuel.

We visited the school at Khumjung, a project spearheaded by Edmund Hillary. The headmaster and about 40 of the students were lined up with the traditional white scarves, or *katas*, to give us a royal welcome. By the time the tiniest students had completed their happy duty, I was completely covered with the katas, from my shoulders over the top of my head. There were 341 students enrolled in ten grades at Khumjung. About one third of them hiked both ways every day from Namche Bazaar, excellent training for their future careers as professional trekkers, for which the schooling—except for learning English—could take place only on the mountainsides. Even playing along the way, the children were able to make the trip in about half the time it had taken us.

When we reached Gorak Shep (which means "dead crow"), Ang Tsering and I were ahead of our companions—Pasang Kami, a Sherpa; Dick Blum; and Stan Armington. We decided to go almost straight up the cliff toward Kala Pattar, or "black rock."

We climbed over some very difficult terrain and finally arrived at the top, well ahead of most members of our group. We were exhausted, but proud and greatly relieved that our climbing was over. As we sat down to catch our breath and look over at Everest and the other mountains, we could also see far below us the red and yellow tents of the Indian and Japanese expeditions arrayed at the base camp. After a few moments, Ang Tsering said, "This is really not the top. Most people stop here, but the top peak of Kala Pattar is several hundred feet above us." He pointed farther to the west; we could barely see a tiny point of rock far above. Shocked to know that there was more climbing to do to reach our goal, I didn't know whether to faint or throw up. However, we resolved to go for it, and so began a slow and extremely dangerous climb upward. It was one of the most foolish decisions I've ever made.

Knowing nothing about the technical aspects of mountain climbing, I was extremely uncomfortable as we clung to the large and often loose rocks with our fingers, thighs, and toes. On our left was a precipitous drop of several hundred feet. We were not equipped with crampons or even a rope, and the snow and coating of newly frozen ice made each foothold uncertain. At that altitude the temperature was almost always below freezing, but in the midday sun some of the snow would melt in small patches on

the south side of rocks, then freeze hard as soon as the sun set below the western mountaintops. These sheets of ice made firm footing and handholds impossible. I could not imagine how I had ever gotten myself into such a predicament.

The snow's up to [his] hips. The ice overhead crackles and shifts.... At the peak of Kala Pattar, 18,000 feet up, he and his Sherpa cling to the ice-coated rocks. It is 11:15 AM, October 1985, in Nepal. This is what Jimmy Carter is doing today.

—*Life* magazine, November 1985

We had no time to lose; our daylight hours, during which we could traverse the steep mountainside with safety, were waning. We decided to descend by a circuitous but much safer route through the snow. After I picked up a few small stones as souvenirs for my grandchildren, we began our journey back down to Gorak Shep. The trail was not very steep but quite treacherous, and all of us fell more than once into the deep snow that surrounded us. At the base of the cliff I lay down to rest and thought I would never be able to get up again, but after some hot lemon tea, a piece of bread, and a bowl of soup, we were on our way back down the way we had come.

Today, more than 20 years later, I still hold vivid memories of our visit to the Himalaya. In Khumbu, I was impressed by the schools. Hundreds of children in that isolated region were getting educated superbly, and were being treated and immunized at a local hospital. This sort of effort contributes in a real, tangible sense to the legitimate and most urgent needs of the people.

I don't believe any nongovernmental organization could possibly do as much, with as little contribution from others, as the American Himalayan Foundation has. Dick Blum and Edmund Hillary have been working in the Himalaya for decades, and they know intimately what is needed most. And I have never met people more admirable in their willingness to do what is right than the Sherpas. The personal relationship of love and care that AHF has with the families in the Himalaya is an invaluable asset.

This extraordinary part of the world faces many challenges. But it also has magic. As you trek through the Himalaya by reading this book, I hope that you are as indelibly impressed as I have been that the people, the environment, and the culture are deserving of our attention and care. ⬡

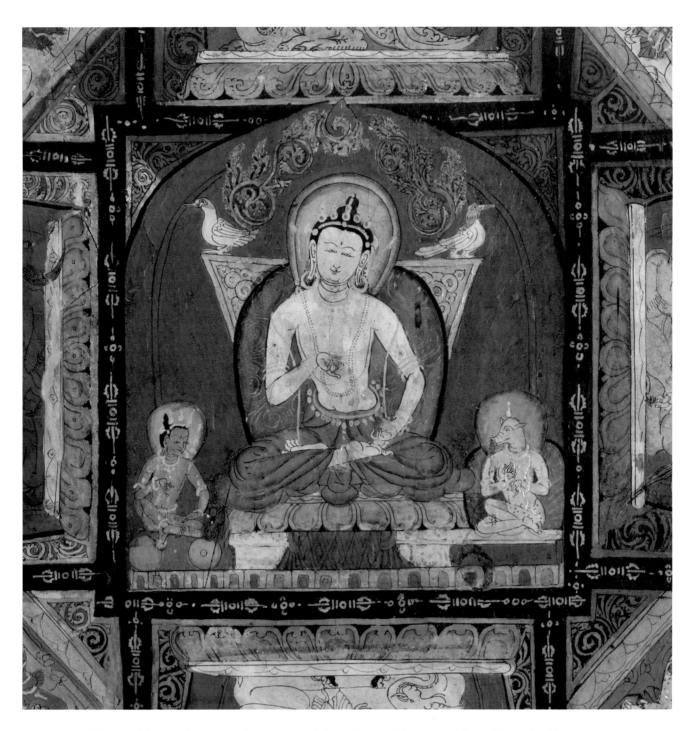

*This graceful figure forms a small part of one of the original 108 large mandalas in Jampa Lhakhang,
the early 15th-century monastic assembly hall dedicated to Maitreya, the Buddha of the Future, in upper
Mustang, Nepal. Mandalas in this temple were recently restored to breathtaking brilliance.*

INTRODUCTION

Richard C. Blum

MANY BOOKS ABOUT THE HIMALAYA RECOUNT an adventure or describe a people, their religion, and their culture.

This book tells another story—a story of how the people of the Himalaya gave of themselves and shared their traditions, and of how they introduced to the West a new understanding of compassion and kindness. It's also a story of reciprocating, of how we have tried to give back.

Ultimately, it's a story of how we learn from each other, how we give to each other, and how that creates profound and positive change in the world. In the West, where there is much talk about a clash of civilizations, this is a story of how two civilizations have helped each other and become good friends.

The Great Himalayan Range is one of the Earth's most intense places to experience life's drama. Lama Govinda, whom I was privileged to know in his later years, may have said it best when invoking *The Way of the White Clouds* in his book, *Insights of a Himalayan Pilgrim:* "To see the greatness of a mountain, one must keep one's distance; to understand its form, one must move around it; to experience its moods, one must see it at sunrise and sunset, at noon and at midnight, in sun and in rain, in snow and in storm, in summer and in winter and in all the other seasons. He who can see the mountain like this comes near to the life of the mountain, a life that is as intense and varied as that of a human being."

This passage, for me, is quintessential to the spirit and meaning of this book.

For over 2,000 years, pilgrims of many faiths have journeyed to the Himalaya to meet the challenges that it presents to the human spirit. Time spent in the mountains brings about a higher level of self-reliance, and even a certain degree of wisdom, gained through learning to cope with and understand nature.

"The more a man has to struggle with the adverse forces of nature," Lama Govinda goes on to say, "the greater is the intensity of his inner life and of his creative imagination. To balance the powerful influence of the external world, one has to build up his own inner world."

Lama Govinda also taught me that the deeper a person looks within himself, the better he understands that which brings about harmony with nature, as well as understanding, compassion, and kindness toward each other.

Ever since I was a boy, I had dreamed of traveling to the Himalaya. When a business trip took me to Thailand in 1968, I just kept going. In Nepal, a Sherpa named Pasang Kami (P. K.) and a couple of porters and I took off for the high country. We never saw another Westerner. It was a strange and compelling land, but what surprised me most was how P. K. sensed my apprehension as I struggled with the narrow trails, the high passes and deep valleys, the blazing sun and freezing nights. His concern for my unease did not come from subservience. It was the expression of a devout Buddhist showing compassion for another human being.

You must be the change you wish to see in the world.

—Mahatma Gandhi

That trip was the beginning of a great friendship. On his first visit to the United States, P. K. explained his predicament. "I have five daughters," he said, "and unless they receive an education, they will spend their lives as porters, carrying loads." At the time, very few Sherpa girls had even been to high school.

"From today onward," I told him, "your daughters are my daughters, and they will go to school." We educated all five of P. K.'s daughters. Two went on to college, and Nawang became the first Sherpa dentist. She now runs what may be the world's highest dental clinic, at 11,600 feet, in Namche Bazaar, on the approach route to Everest Base Camp. P. K. told me that my commitment to his daughters was one of the happiest days of his life.

It was one of the most rewarding days of my life as well. From that interaction came the genesis of the American Himalayan Foundation. Our first partner was Sir Edmund Hillary. He was, and still is, my model for how to work effectively in the mountains. I find it heartening that a member of Everest's first successful summit team would be the one to return to devote his life and legacy to helping the Sherpas.

When the American Himalayan Foundation was still a new organization, His Holiness the Dalai Lama asked if we would help the growing numbers of Tibetan refugees fleeing to Nepal and India, as well as the Tibetans inside Tibet. AHF has responded, for more than 20 years now, with education, health care, and enterprise opportunities.

Today, AHF is the broadest-reaching private foundation dedicated to the people and environment of the Himalaya. We support over 130 projects in Nepal, India, Tibet, Bhutan, and Mongolia. Our work is basic: We build schools, daycare centers, and hospitals; we shelter the elderly. We reforest hillsides, protect wildlife, restore ancient monuments, and work to save young girls from being trafficked into prostitution. It really does help, and of that I am proud. Our partners are winners all, and we are the catalyst, the facilitators of their destiny with success. We are partners in the true sense of the word, all of us equally willing to roll up our sleeves and dive in.

In his book *Ethics for a New Millennium*, His Holiness the Dalai Lama said that you can be a good person without being religious, and religious without being good. One should strive, therefore, toward being a good person. He has also told me, more than once, that his religion is kindness. I try to remember His Holiness' advice every day, and I feel our best decisions are inspired and informed by him.

I regard Jimmy Carter as America's counterpart to His Holiness. They are both spiritual people, working to apply compassion to the world we live in. In many ways, President Carter's unwavering sense of charity and service has provided a practical inspiration to our foundation, and his insight and experience have been a beacon.

"The Himalaya will change you more than you will change it,'" a friend once told me. I would say that not merely have I been changed, but I have been transformed by the great inner strength of the people of this mountain range, and by their lessons of caring and kindness.

Until his untimely death a few years ago, Pasang Kami and I wrote often. Today, his grandchildren send e-mails from a Namche Bazaar cybercafé to my grandchildren in a San Francisco classroom, in an exchange that wonderfully extends the legacy of friendship and the quest for understanding that began so long ago.

To understand the wisdom, culture, environment, and people of the Himalaya is part of our mission. To do what we can to help is the other part. The many humanitarian projects that the American Himalayan Foundation supports are our way of saying thank you—for the kindness shown to us, and for the chance to learn about the greatness of the cultures and the magnificence of these mountains, the range called Himalaya.

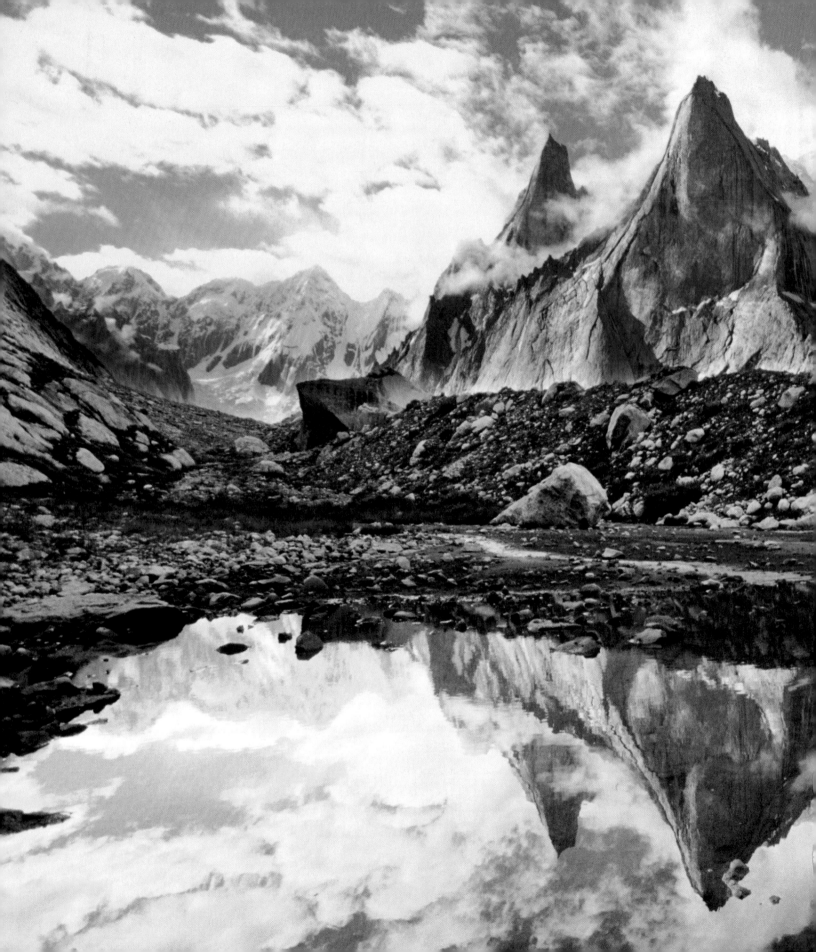

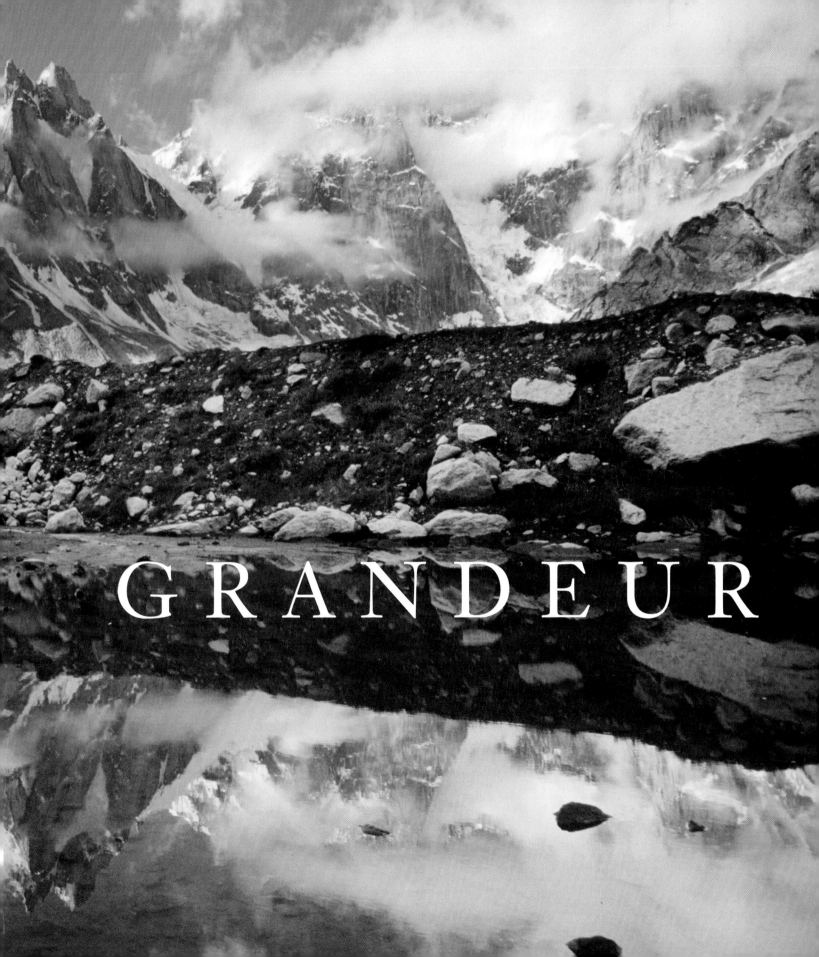

GRANDEUR

SCENES OF GRANDEUR

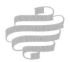

In a thousand ages of the gods I could not tell thee of
the glories of the Himalaya; just as the dew is dried
by the morning sun, so are the sins of humankind
by the sight of the Himalaya.

—Skanda Purana

THE GREAT HIMALAYAN RANGE is a geological anomaly, an oddity. It is also a by-product, a side show to the massive earthly forces that are driving the Indian subcontinent beneath the Siberian plate and continuing to lift the Tibetan plateau. In effect, the three-mile-high plateau is two continents thick, the rocky Himalayan arc at its southern margin mere accreted detritus plowed up from the floor of the ancient Tethys Sea.

Some detritus. The Himalaya are so immense that they generate their own gravitational pull, deflecting upward (more than four feet) the theoretical extension of sea level beneath their peaks. This calculation didn't escape the 19th-century Survey of India team, which measured the height of Mount Everest with remarkable accuracy from India's Gangetic Plain.

Where else within a breadth of 90 miles can you find subtropical jungle hosting tigers and rhinos, temperate forests of pine and musk deer, dry-steppe landscapes harboring snow leopard and yak, and arctic tundra visited mainly by climbers and Sherpas? Dramatic landscapes beget dramatic diversity: Nearly 500 species of birds,

PRECEDING PAGES: *Parhat Brakk and Fathi Brakk reach skyward, creating as well as defying the weather. These granite peaks tower over the Charakusa Valley in the eastern Karakorum Range, Pakistan, southeast of K2.*

40 species of rhododendron, not to mention hundreds of human ethnic groups and languages coexist here.

The weather has something to do with it. Intense and persistent monsoon rainfall turns rivers into angry and unruly torrents, such that watching erosion in real time can be exciting and scary. Indeed, the earth and rock of the Himalaya are being scoured away so quickly that the chief engine for the range's notorious uplift is believed to be the lightening of the mountains' load on the Earth's mantle. No wonder the world's deepest river gorges are found here, too.

The Himalaya's gravitational pull extends to pilgrims, pundits, travelers, and immigrants, and has captured the world's imagination. This may have been the Asian birthplace of imagination, for the range is the fountainhead of two of the oldest established religions and the natal home to gods, demigods, spirits, and emanations in abundance. It's not surprising that Lord Buddha was born in the foothills of the Himals.

No area of the globe is so populated with sacred power-spots, what Tibetans call *né*, holy places imbued with spiritual energy and the power to grant boons and blessings—depending, of course, on the visitor's intentions and purity of mind. These sacred sites are typified in their archaic, landscape form by river confluences where deities and the flow of sacred energy merge; by ridges and passes, where the collective karma of two valleys intersect and travelers are touched by purifying winds; by caves and springs, the homes of serpent deities known as *naga* or *lu*, which control the fertility of fields and forest; and by images of deities that have spontaneously, and intentionally, emerged from the Earth.

Just as the peaks of the highest Himalaya are sometimes just out of climbers' reach, the evolving character of the Himalaya, like wisdom and understanding, can also be elusive. Maybe that's what keeps seekers returning—venturing into the high valleys, searching, striving, all the while rejoicing in the splendor of the mountains.

Mountains are said to be the abodes of distant gods,
the unreachable metaphors for life.
But at moments such as this they become intimate,
offering communion and unity with the natural world.

—George B. Schaller

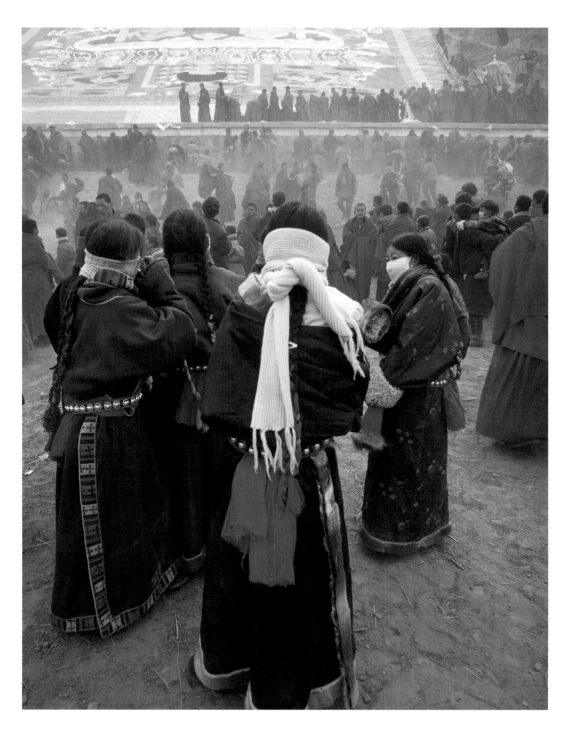

Monks and pilgrims mingle at Labrang Tashi Kyil Monastery in Amdo, northeastern Tibet. During Losar, the traditional Tibetan New Year's festival, monks unfurl a giant appliqué thangka *of Buddha Amitabha. Tibetans travel great distances to view the image during the several hours it is on display each year.*

BUDDHIST FROM BIRTH

Chokyi Nyima Rinpoche

Chokyi Nyima Rinpoche, a renowned Buddhist teacher, meditation master, and poet, is abbot of Ka-Nying Shedrub Ling Monastery in Boudha, Nepal, where he oversees one thousand monks, nuns, and retreatants. He heads an institute for Buddhist studies, has authored numerous books, and lectures around the world. He is known especially for his profound sense of humor.

I WAS BORN IN NAKCHUKHA, WHICH LIES NEAR LHASA, TIBET. My father came from Kham; my mother was a citizen of Lhasa. What occurred simply happened, although it might sound like I'm praising myself. People remarked that my birth was accompanied by various signs: The sun, the moon, and a star appeared in the sky all at the same moment—a circumstance regarded as very auspicious.

I'm told that when I was a baby, I pointed my finger in the direction of the regional monastery, Bong Gompa, and was heard to say, "Bong, bong…"

A few months later, a small group of senior monks arrived on horseback. They went from house to house, inquiring about newborn children and making a list of their parents' names. They came to our door. They showed my family a prediction letter from the Karmapa, a letter that identifies the reincarnation of a lama, which stated that the father of the child they were seeking was a *vidyadhara*, a master of Vajrayana Buddhism; the mother's name was such and such, the birth year sign was such and such. The child was said to possess moles marking the three places of mind, speech, and body: the forehead, throat, and heart. After investigating the details of my birth and infancy, the monks became convinced that I was the reincarnation of the head lama of Bong Gompa.

When the time came for me to learn to read, my father, Tulku Urgyen Rinpoche, taught me the alphabet. In fact, he gave teachings every day, and I would listen as he explained to people how samsaric pursuits, our earthly efforts, are as futile as building castles in the sand, how nothing lasts, and so forth.

My mother was fond of reading to me when I was small. Especially inspiring was the account of the life of the Buddha Shakyamuni and stories from his former lives, along with stories like the Jatakas and *The Sutra of the Wise and the Foolish*. My mom would read

Forests of prayer flags are seen throughout Bhutan—on ridges, in clearings, at river confluences, and near temples.

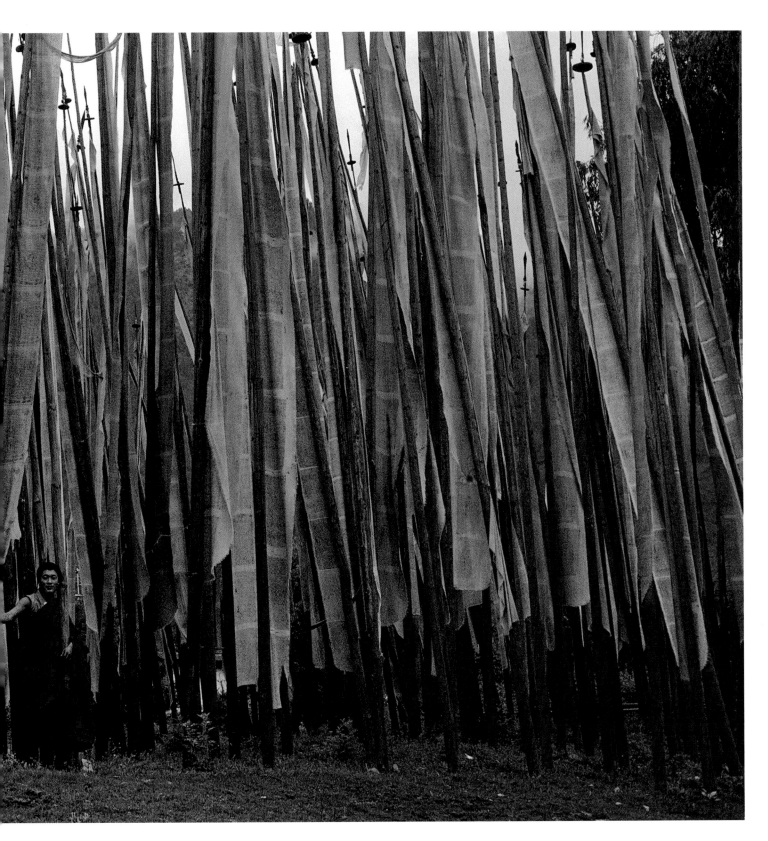

The flags are hand-printed on cloth, taken to a lama for blessing, and then attached to bamboo poles.

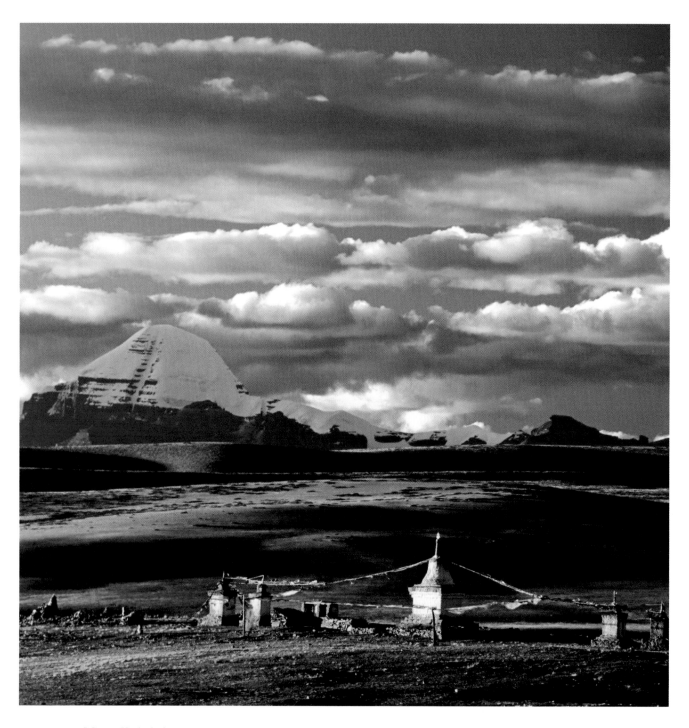

Mount Kailash, known in Tibet as Khang Rinpoche, is the abode of a pantheon of Buddhist, Hindu, Jain, and Bön deities. Hindus revere Kailash as the throne of Shiva, while Buddhists invoke Milarepa, the saint who vanquished his pre-Buddhist Bön-po opponent, Naro Bön-chung, in a contest of magical powers.

in a very clear voice, not like reading dry facts from a history book but in a way that was very moving. Often, she read passages from the biographies of Tilopa, Naropa, and Marpa. I especially recall her reading aloud from Milarepa's life story and songs. Hearing these stories repeatedly, I developed a strong faith in this great master. His songs instilled in me a deeply felt renunciation of samsara. A thought was acutely present in my young mind: "I should practice the dharma since nothing else has any real substance." Often when she read these stories to me, we would both be in tears.

I've had the good fortune to meet many masters from all the traditions and to receive from them many empowerments, transmissions, and instructions. Tibetans call such great masters *Lachen*. I've always been intensely interested in pursuing instructions from both monks and *ngakpas* (nonmonastic Buddhists), from all Buddhist schools, regardless of their status. These instructions have greatly benefited my mind, and I consider myself very fortunate in this regard. Putting these teachings into practice is, of course, my own responsibility, and if I neglect them, it's my own fault.

When my mother was on the verge of death, she said to me: "It's pointless to be swollen with pride just because you're a reincarnate lama. You've studied the scriptures and received a lot of initiations. Now you must practice a lot. The main point of Buddhist practice is to always scrutinize and improve yourself. The teachings should be taken to heart and applied personally to make one gentler, more peaceful, loving, and compassionate and to gain insight into the empty nature of things. Just be yourself, in a straightforward manner, and don't pretend to be special. Otherwise, your life will become a grand delusion. You won't find very many people who will dare tell you this; most will simply praise you and tell you how nice you are, but I can tell you quite honestly."

This counseling that my mother gave me was a great kindness, although it felt like a scolding. Her advice went straight to my heart. When she was about to die, she knew that she was dying, and so did our family members. But she had no anxiety about dying. "The best practitioner is someone who gladly dies," she said. "I'm not exactly glad about it, but I'm definitely not depressed. I have no regrets and no fear. There's only one reason for feeling this way: In my lifetime, I received many profound instructions and I've practiced them a little. As far as I'm concerned, the sole aim of all the training that I've undergone has been to help me at the time of leaving this life."

Before she fell ill and passed away, I didn't consider my mother as my teacher. But what she told me that day was a teaching in itself; therefore, I now regard my mother as one of my teachers.

Many predictions have declared that the teachings of Buddha Shakyamuni will flourish throughout the world. I feel this should happen, simply because the Buddha's

teachings reveal the true nature of things. It boosts your heart and attitude. Whoever sincerely practices the dharma is in harmony with others, has fewer conflicts, and finds himself or herself in better circumstances. Why? Because the two foremost principles in Buddhism are knowledge and compassion. The deepening of compassion brings benefit and happiness to all, while deeper knowledge eradicates ignorance, misunderstandings, doubt, and imperfect understanding. From this, sublime wisdom overflows from within. Isn't this the right time for the Buddha's teachings to spread everywhere?

Foreigners tell me that they find what I say helpful and somehow suitable. It is my impression that Westerners are inclined to immediately understand the teachings on emptiness and compassion, but there is a certain lack of readiness to accept the laws of karma and rebirth. Yet I feel that trust, karma, and rebirth are not the main issues in Buddhism. The main point is to gain certainty in the genuine view of emptiness and dependent origination; the other, secondary points will then come easily. Without a proper foundation in study and reflection of the Buddhist teachings, it is difficult to have instant success in meditation practice.

For as long as space endures

And for as long as living beings remain

Until then may I too abide

To dispel the misery of the world.

—Shantideva, eighth century

I've always found foreigners to be fresh, intelligent, and open-minded, so it has been a delight to teach them the dharma. Under my guidance, my translator, Erik, has translated more than 50 Buddhist books. I trust that these publications will spread far and wide and be of help to people in many different countries. In the future, it is my hope that this effort will multiply through the training of foreigners right here in Nepal to translate a great number of Buddhist texts for the welfare of people everywhere.

Knowledge and compassion are the very basis to which the word "Buddhism" refers. Whoever trains himself or herself in knowledge and compassion will be in harmony with others, both immediately and ultimately. This is an indisputable truth. All of us should try our best to study the qualities of knowledge and compassion, to reflect upon them, and especially to gain direct insight within ourselves. This will bring immense benefit.

FIRST INTO PARADISE

Charles Houston

Charles Houston, a physician, led the first American expeditions to Nanda Devi in 1936 and to K2 in 1953. He is regarded as the father of the study of high-altitude physiology. He was with the first group of foreigners to visit Khumbu, the Sherpas' homeland on the south side of Mount Everest. He lives in Vermont and divides his time between family, medicine, writing, and the mountains.

Travelers and pilgrims in the Himalaya light votive lamps, make offerings, and pray for blessings at shrines, monasteries, and other sacred sites.

FIFTY-SIX YEARS AGO, I HAD THE RARE PRIVILEGE of walking through a landscape and culture virtually untouched by the modern world. It was 1950, and the Maharaja of Nepal gave permission to my father, a New York lawyer and mountaineer, to undertake a reconnaissance expedition to the southern flanks of Mount Everest.

On a clear mid-October day, my father and I—along with Andy Bakewell, a Jesuit priest; Betsy Coles, a distinguished mountaineer; and Bill Tilman, a good friend (and already a famous climber)—stepped off an Indian steam train at Nepal's southern border.

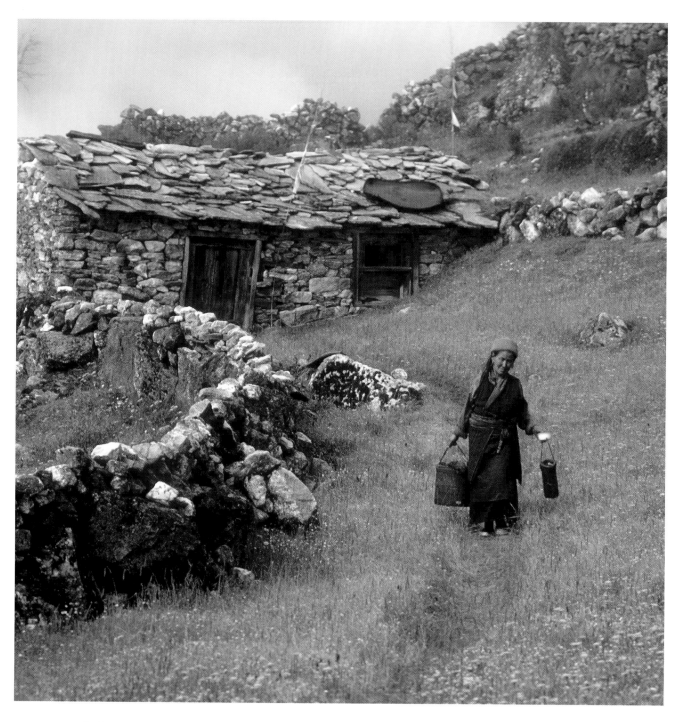

At the pasture of Labpharma, en route to Gokyo Lake in Nepal's Khumbu region, Gaga Yangzin spends two months each monsoon season, a quiet time of year, living in her tiny hut at 15,000 feet while her yaks graze the lush summer grasses.

From there, a truck jostled us 30 miles north to a cobbled path at the base of the Himalayan foothills. This would be the start of our 175-mile hike to the Everest region.

We quickly settled into a routine, greeting each sunrise with a cup of hot tea delivered to our tent by a cheerful Sherpa. We would then walk 10 to 12 miles a day, meandering through valleys and crossing ridges that seemed to go on forever. As we traversed the grain of Nepal, each day brought new beauty, new unspoiled wildness, and always happy faces. We bought food wherever we found it, especially eggs and an occasional scrawny chicken or goat. The nights were cool, the days spotlessly bright, clear, and warm.

Each new delight was eclipsed by the next. On a ridge near Dhankuta we watched children propel a handmade wooden Ferris wheel, 20 feet high. The main path through the neatly whitewashed village was teeming with men, women, and children carrying bamboo baskets loaded with every description of goods. One villager led us to a small schoolhouse filled with children studying English and arithmetic. An aphorism, written in English, was posted on the lintel of the schoolhouse door: "Gather courage. Do not be a chickenhearted fellow." This dazzled us. Perhaps it had come from the school's one-room library, which consisted of a dozen ancient books about British royalty. We would later send them a collection of more worldly flavor.

After Dhankuta, our small expedition climbed over a ridge and descended steeply to the stunningly beautiful Arun River Valley. Amid towering, snowcapped peaks, we bathed in the icy and swift waters—to the hilarious consternation of gathered villagers.

Continuing north, we gained elevation. Our entrance into Sherpa country was heralded by an exquisite *chorten*, a Buddhist shrine constructed of stone. We were now hiking through forests rich in fir, pine, and rhododendron, and passed prayer walls with inscribed *mani* stones and waterpowered prayer wheels. We crossed the dynamic Dudh Kosi, the river that drains the Everest region. Then we climbed steeply to the village of Namche Bazaar. Around us and above us, wooded hills buttressed snow-capped pinnacles untouched by human feet.

Our time in Namche was filled with joy. I remember being crowded into a smoke-filled living room, drinking (with some difficulty) tea enlivened with salt and yak butter, and even tasting the potent rice beer, *chang*. For hours we shared laughs, told stories, compared disparate lifestyles, and found unexpected similarities, too. The women shared a raucous and hysterical brand of laughter, infecting us all with mirth and good humor.

We also met the wife of Ang Tharkey, a renowned Everest veteran from the British expeditions of the 1920s and '30s. She appeared one day in an open field to say regretfully that her husband would not be able to join our expedition, but that he had sent us

a letter: "I am so happy that you are going into the beautiful country where I had the happiest days of my life… you will see beautiful sceneries."

From Namche, we crossed the Imja Khola and ascended through a dense rhododendron forest to the lateral moraine where the Tengboche Monastery sits. Here, the clouds finally lifted, and we had our first glimpse of the south side of Everest. Even from 40 miles away it was an impressive mountain, and we studied its South Face, assessing its potential as a route to the summit.

It was decided that Tilman and I, along with a Sherpa, would proceed up the valley and skirt the western rampart of the Nuptse-Lhotse wall, to get a closer view of the Khumbu Icefall and Everest's Southwest Face. En route, we stayed in Pheriche, a small encampment of stone corrals surrounded by bushy willows and juniper. The next day, we climbed to 19,000 feet, to a point across from the Khumbu Glacier, and had our first limited view of the Western Cwm, the rocky black summit of Everest towering far above us. "Formidable," "dangerous," and "difficult" were the first words that came to mind. But we also judged the route to be possible.

Tilman and I suffered severe headaches, probably high-altitude cerebral edema, though we didn't have a name for it at the time. Unable to climb higher, we returned to Tengboche, where we were entertained with lama dances and enjoyed *raksi*, the distilled version of chang.

With regret, we turned to head home, privileged to be the first Westerners to see this unspoiled place and its lovely people. On the trail out to the Indian border, we began to speculate about the future of our new friends, never imagining the flood of tourists, trekkers, and climbers that would one day inundate this spectacular valley.

In 1981, I followed my footsteps of 31 years earlier and returned to Khumbu. I was startled to find that radios blared in every village. Plastic had replaced the beautiful brass and aluminum kitchenware, and wide trails had scarred eroding hillsides. Teahouses were everywhere, filled with cheap artifacts and sundry items made in China and India. Khumbu had become a tourist mecca. Only the mountains hadn't changed.

Tourism was inevitable, I suppose, and it can be beneficial—or terribly destructive. Only a few countries have been able to keep expanding modernization from overtaking the local culture. We do need to help the Sherpa and Nepali people learn skills that will improve their self-sufficiency, but that should also include means for protecting their natural and cultural heritage.

Oscar Wilde wrote, "Each man kills the thing he loves." Aware of such a pitfall, may we who love the mountains strive to protect and sustain their beauty, and the culture and traditions of the people who live there.

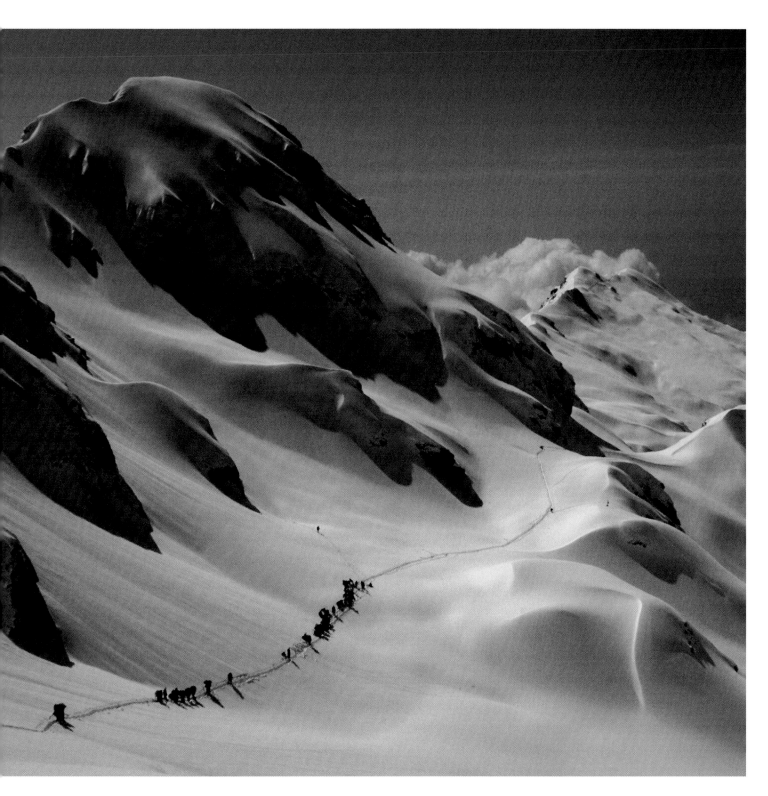

A line of porters with an American expedition to Mount Makalu approaches the Kongmo La,
or Shipton's Col, which separates the Arun and Barun River Valleys to the southeast of Khumbu.

Members of the 1963 American Everest Expedition—including Jim Whittaker, Barry Bishop, Gil Roberts, and Thomas Hornbein—pause for a last portrait near Namche Bazaar. On this expedition, five Americans reached the top, and they became an overnight sensation across the United States.

FOOTSTEPS OF GIANTS

Brent Bishop

In 1994, Brent Bishop became the first second-generation American climber to top Everest. He climbed the world's highest peak again with the National Geographic Channel's *Surviving Everest*. Bishop also led the Sagarmatha Environmental Expedition, which removed more than 25,000 pounds of trash from Everest's slopes. He owns a mountaineering shop in Bozeman, Montana.

MAY 2007 MARKS THE 44TH ANNIVERSARY of the first American ascent of Mount Everest. My father, Barry Bishop, was a member of that expedition, and I am lucky to have followed in his footsteps, reaching the summit of Everest in both 1994 and 2002. My relationship with the mountain, as well as with my father, has provided me a unique vantage point for reflection on the pioneering accomplishments of the 1963 American team.

As a boy, I remember watching "Americans on Everest," the first National Geographic television special to feature climbing. Orson Welles narrated, and his booming voice accompanied the American climbers as they ascended into the unknown. For me, this expedition captured the meaning of exploration. These men were giants, larger than life, and I had the privilege of knowing some of them.

The American Mount Everest Expedition (AMEE) was organized in the midst of America's age of Camelot, the time when a youthful President Kennedy championed the merits of living a "vigorous life." But it also occurred at the height of the Cold War with the Soviet Union. America lost the first match of the space race when the Soviets launched a man into orbit, and a mild nationalism swept the United States. We did not want to lose another symbolic contest to our rivals.

AMEE received a level of support unparalleled in the history of mountaineering. Hundreds of individuals made donations; outdoor companies contributed tons of equipment and supplies; and NASA and other agencies invested substantial sums in return for scientific research. The National Geographic Society participated, sending photographers and moving picture cameramen.

The expedition had three objectives. The first was to place a man on the summit via the Southeast Ridge, the route of Tenzing's and Hillary's first climb, ten years earlier. On

May 1, Jim Whittaker and Ngawang Gombu accomplished that goal, becoming the tenth and eleventh men to stand on the roof of the world. The expedition had succeeded.

AMEE's second objective was even more ambitious. The team wanted to complete a first ascent of Everest's West Ridge, then descend by way of the Southeast Ridge—a high-altitude, technical climb well ahead of its time. Retreat would have been impossible from this difficult traverse, for it required nothing less than total commitment. But on May 22, Willie Unsoeld and Tom Hornbein, after climbing horrendously steep, icy, and never explored terrain, reached the summit.

Usually we think that brave people have no fear.

The truth is that they are intimate with fear.

—Pema Chödrön

On their descent, a few hundred feet below the top, they met my father and Lute Jerstad, who had reached the summit earlier in the afternoon. The four attempted to descend along the Southeast Ridge but were caught by darkness. In an epic story of survival, they were forced to spend the night at over 28,000 feet, with no shelter, stove, or bottled oxygen. But the weather remained uncharacteristically calm, and the next day the four climbers descended to reach the safety and support waiting at the South Col. This climb of the West Ridge, followed by a traverse of the mountain, has yet to be repeated and is still regarded as the most significant American ascent in the Himalaya.

But it was not until I began climbing in the Himalaya myself that I began to marvel at the achievements of that first American expedition. On my first climb of Everest, the terrain awakened pictures embedded in my memory, flooding me with admiration and emotion. So few climbers had gone before them that the AMEE team wasn't working on accumulated knowledge of the mountain.

And they were tough. Laboring up the Geneva Spur to Camp IV, at 26,000 feet, I struggled under the load of my oxygen bottles. On the South Col, I picked up a discarded bottle from AMEE's era of rudimentary equipment. It weighed three times as much as my modern apparatus.

The first time I approached Everest's summit, tears ran down my face as a deep sense of connection to my father and those early Americans welled up inside of me—a connection I had finally earned a right to call my own. I now understood the strength and boldness of these climbers, for in 1963 there was no simple formula for success.

Scientific research was AMEE's third objective. The climbers—most of them medical doctors or Ph.D.'s—undertook experiments in glaciology, geology, solar radiation, psychology, and sociology. Everest was the perfect field lab, and the high-altitude physiology information they collected established the foundation for all subsequent research in that field. The research data may have been skewed, however, considering the exceptional physical and mental strength of these climbers.

The American public was captivated by the expedition. On their return to the U.S., President Kennedy received the team at the White House, and *Life* ran a cover story on

Gyurme Dorje Sherpa's mother has put down her load for a rest during the '63 American Everest Expedition.

the climb. This was America's first introduction to mountaineering via the media, and the team members were heralded as heroes akin to astronauts and polar explorers.

Less tangible but as enduring, however, was the inspiration they provided to subsequent generations of climbers. Since 1963, virtually every mountaineer has read Thomas Hornbein's *Everest: The West Ridge* or James Ramsay Ullman's official account, *Americans on Everest*—true adventure tales that convey the feeling that anything can be accomplished. The members of the American Mount Everest Expedition had raised the bar of what was possible for Americans climbing in the Himalaya. I, and others, have tried to uphold their legacy. Now all of us are climbing in the footsteps of giants.

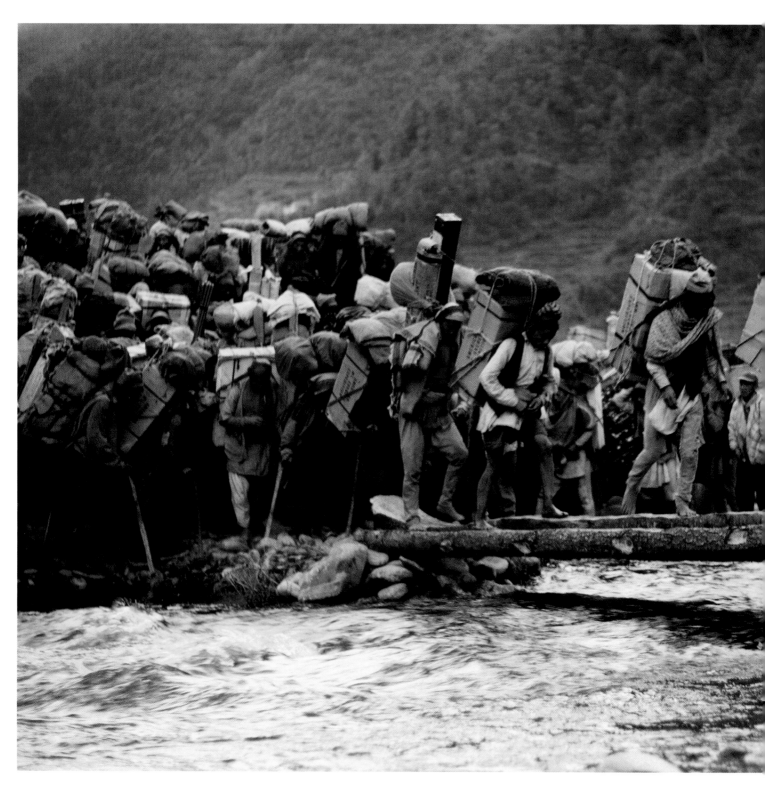

Porters en route to Namche Bazaar make a river crossing. During the '63 expedition, more than 500 loads were ferried to Everest Base Camp from the rim of the Kathmandu Valley, 260 miles away.

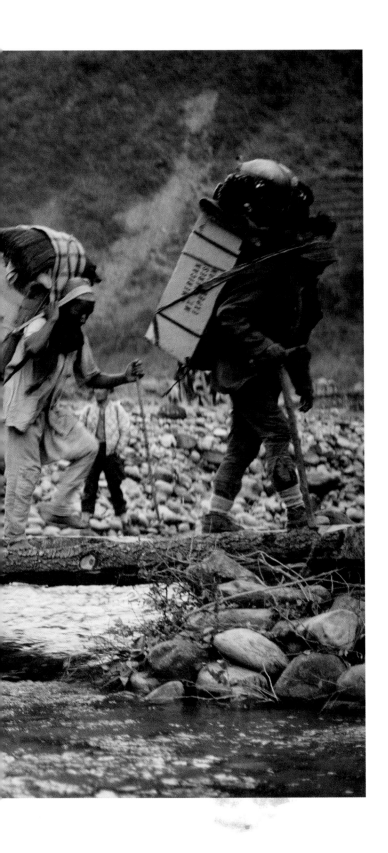

Although we touched each place for only
a day and then moved on, I wondered how
many such passings could be made before
the imprint would become indelible.
But awareness of our effect on the land was
lost beneath the effect of the land
and its people on us.

—Thomas F. Hornbein

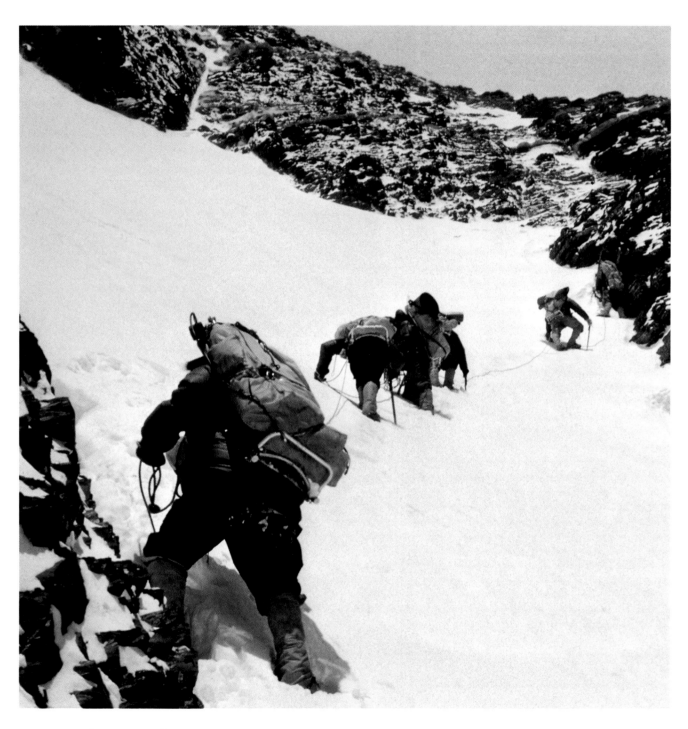

Above Everest's South Col, Sherpas ascend a snow gully toward the windswept Southeast Ridge. In 1963,
Americans Jim Whittaker, Lute Jerstad, and Barry Bishop reached the summit via this route. Tom
Hornbein and Willi Unsoeld forged a new route up the West Ridge, then descended to the South Col.

AN AMERICAN ON EVEREST

Jim Whittaker

Jim Whittaker is best known as the first American to climb Mount Everest and as former president and CEO of the outdoor retailer REI. Author of *A Life on the Edge: Memoirs of Everest and Beyond,* from which this piece is adapted, Whittaker is now an inspirational speaker. He lives in Port Townsend, Washington, with his wife, photographer Dianne Roberts, and their two sons, Joss and Leif.

EVEN ON A TWO-LITER-PER-MINUTE FLOW OF OXYGEN, climbing just 200 vertical feet an hour, Gombu Sherpa and I had to take five or six breaths with every step. In addition, we were continually being knocked over by the wind. The less steep the slope, the more we staggered; we came to prefer climbing to walking—at least while climbing, we had something to hold on to. We kept plodding ahead, half crawling, half climbing, becoming more exhausted with each labored step. I felt like a tarantula in a 90 mph gale.

We crested the South Summit of Mount Everest at about 11:30 a.m. and, for the first time, could see the true summit above us. There was a sharp drop ahead of us, then a saddle between us and the next obstacle, a steep rock face that we would have to climb. During the 1953 British expedition, Charles Evans and Tom Bourdillon had stood where we were now, looked at that pitch, then turned around and descended. The following day, New Zealander Edmund Hillary and Sherpa Tenzing Norgay scaled it. Ever since, that section has been known as "the Hillary Step."

We squatted on the South Summit and climbed the step with our eyes. Then we descended to the saddle and crossed over to it. At the base of the step, buffeted by the wind, we rested again. From here, it was practically straight up—rock on the left, snow cornice on the right. The cornice clung to the rock, but there were wind-cut cracks and hollows. Beneath the cornice, the Kangshung Face of Everest dropped thousands of feet into Tibet.

"If we fall," I thought to myself, "it'll be one hell of a border crossing. And I don't have my passport."

As Gombu belayed and anchored me, I wiggled and pried myself up through a slot between the lee side of the rock and the cornice, gasping for breath and cursing my pack for its weight and awkwardness. At last I crawled out to a good belay spot and took in the

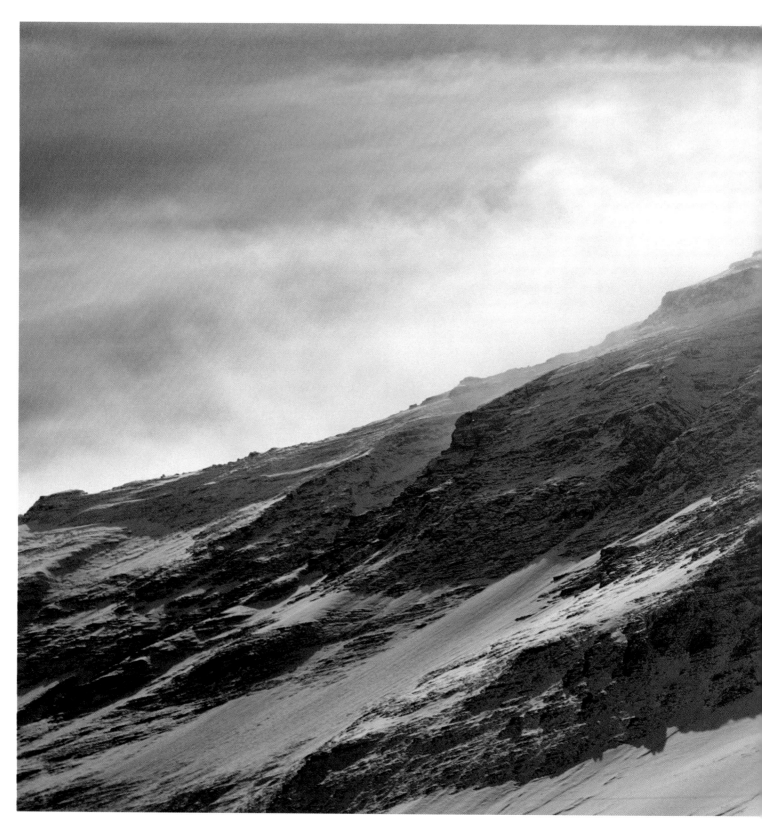

Wind scours the high slopes of Mount Everest. Climbers must wait for a narrow window of relatively calm weather,

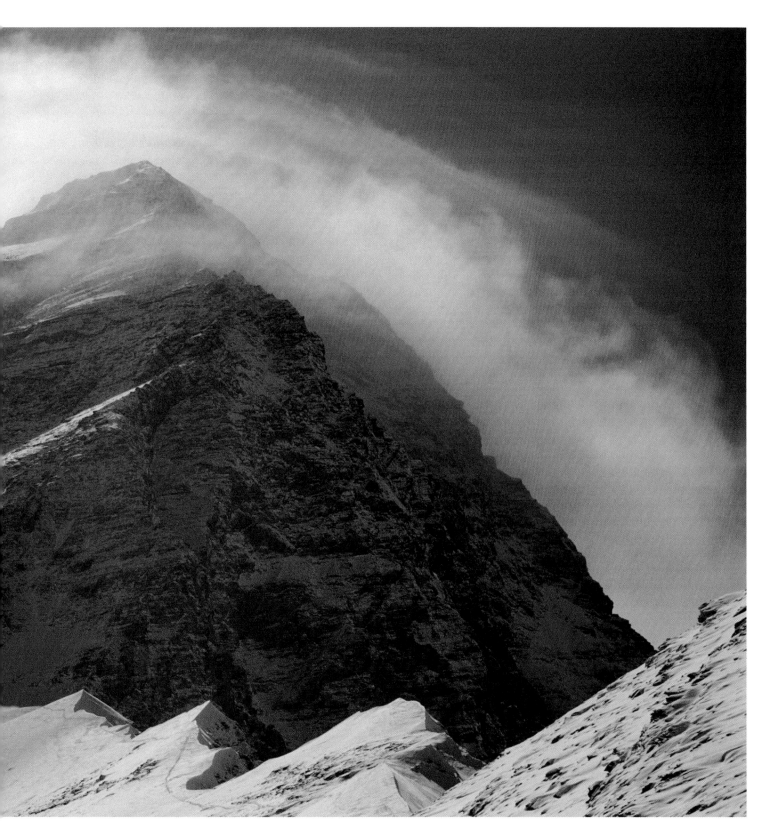

often lasting only a day or two in the spring and the fall, when the jet stream lifts off the summit.

slack, then jerked on the rope for Gombu to come up after me. Slowly, I coiled in the rope as he climbed up alongside me. We sprawled flat and took another break.

Finally Gombu and I stood again and turned. Moving once more, and near complete exhaustion, I suddenly realized I was sucking on an empty oxygen bottle. Gombu, smaller than I, had used less oxygen and still had some left, but he would be out soon, too. If my brain had been functioning normally, I probably would have been frightened. Instead, the only thing that registered was "Keep moving." And we were close, with only a gentle slope ahead of us.

Sherpas revel at the summer festival of Dumji, near Namche Bazaar,
gracing each other with barley flour and the well-wishing phrase:
"May you live to be old and grow a white beard!"

About 50 feet from the top, I coiled in the rope again, and Gombu came up beside me. I leaned toward him and shouted against the wind, "You first, Gombu!"

"You first, Big Jim!" he shouted back. Even with his oxygen mask I could see him grinning.

We compromised. Side by side, we staggered the last few feet until, at 1:00 p.m. on May 1, 1963, we stood together at the highest point on earth. The sky above us was that deep dark blue you only see when you have climbed above most of the Earth's atmosphere. We were on the edge of space, but I did not feel expansive or sublime; I felt only, as I said later, "like a frail human being."

People—mostly nonclimbers—talk about "conquering" mountains. Nothing could be further from the truth. We do not conquer mountains, but rather we conquer ourselves, as—to paraphrase Tennyson—we seek, strive, and do not yield. Standing on high mountains the world over, the climber can glimpse the magnificent glaciers of snow and ice slowly descending from the peaks, eventually melting, forming creeks and rivers, flowing into the ocean.

Twenty-seven years after climbing Everest, I found myself heading toward Chomolungma again. This time, however, I was compelled by the desire to draw awareness to the fragility of the earth and the importance of waging peace rather than war.

Two climbing partners, Bud Krogh and Warren Thompson, joined me in a plan to hold a true summit meeting between citizens of the Soviet Union, China, and the United States. We wanted to demonstrate what people could do through friendship, cooperation, and trust—with hopes that three Cold War enemies, roped together, would reach the top of the world.

On March 1, 1990, our Earth Day International Peace Climb arrived in Lhasa and, within the week, we had set up our base camp at the foot of the Rongbuk Glacier. This time the expedition consisted of five climbers—four men and one woman—from each country.

On the morning of May 6, after weeks of storms and medical problems, our first summit team of two Soviets, two Chinese, and two Americans stood on top and planted our expedition banner, bearing a logo with three flags and imprinted with the word "peace" in three languages. Over the next three days, fourteen more climbers summited, five without bottled oxygen. Although the weather was not conducive for us to make a summit attempt on the 20th anniversary of Earth Day, we did our best to lessen the impact of humans on the mountain. We removed two tons of garbage that had been left by climbing expeditions dating back to the first attempt in 1921, and we left our base camp immaculate.

Ekaterina Ivanova, a member of our team and the first Soviet woman up Everest, delivered an impassioned message on the summit: "I stand on top of the highest mountain on Planet Earth, for all the women of the world. Let there be no more borders, no more war. Let us make a safe and clean world for our children, and for our children's children."

Her message still rings true. Today, as the snow and ice from the great peaks above flow through the valleys and into the rivers and oceans of the world, connecting us all, my hope is that we will understand the magic of the Earth and our roles as its stewards and protectors.

A GODDESS'S BLESSING

Apa Sherpa

Apa Sherpa is recognized as one of the greatest living mountaineers. He holds the world's record for having climbed to the top of Mount Everest 16 times. He lives with his wife and three children in his hometown of Thame, in the Khumbu region of Nepal.

STANDING AT THE *LHAP-SO*, OUR MAKESHIFT BUDDHIST SHRINE at Everest Base Camp, I thanked Miyolangsangma, the goddess who lives here, for welcoming me into her home, as she has over a dozen times. If she invited me in again, this would be my 15th summit. I headed upward through the icefall to meet the members of our expedition at Camp II. Bounding across ladders over deep crevasses, I noticed ice screws loosening in the late May sun. On Everest, sunshine is a blessing and a curse. The sun's warmth is welcome, but it causes the ice to melt. Large seracs crumble, overhangs avalanche, and pinnacles topple.

We had spent almost eight weeks waiting for the summit window, the longest delay I had ever experienced. Climbers had lost weight and muscle strength, and they spoke increasingly of changing weather patterns and global warming. Perhaps Miyolangsangma, weary of playing the perennial hostess, needed a rest.

For Sherpas, Miyolangsangma is the traditional supplier of food and wealth. But by allowing us to climb Everest, she has provided us with more than this. She has given our people education, medicine, and opportunities to work, and she has opened our eyes to a world beyond our valley. Without her blessings on mountaineering expeditions, we would have remained isolated in our Khumbu villages with little means of improving our future.

At Camp II, I heard the summit weather forecast for the coming days: 50 mph winds, snow, and a wind chill factor of 20 degrees below zero. It would require another two days of climbing for our expedition members to be in place for a summit attempt and, given the weather predictions, it did not look favorable.

Miyolangsangma, however, often changes her mind. Two days later we climbed to the South Col, Camp IV, the last stop before the summit. The team members rested fitfully in tents blown nearly flat by a freezing wind, while I peered out at clouds that broke like ocean waves across the peaks below us. It would be a cruel and unforgiving night—

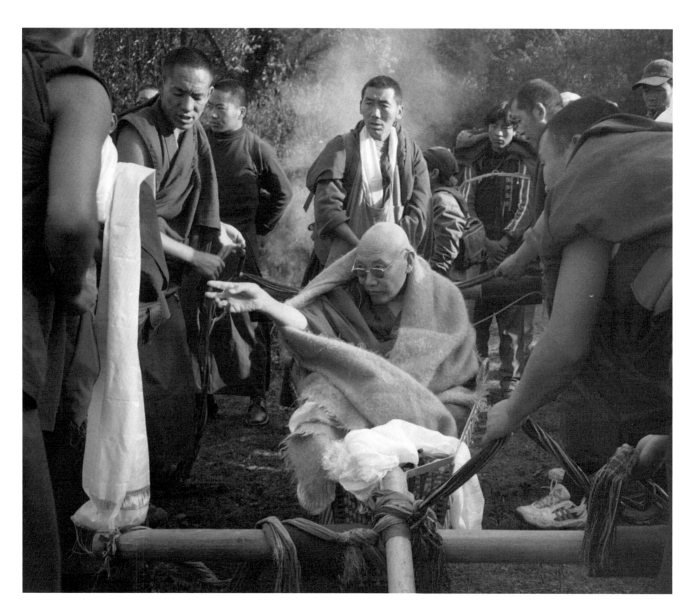

Monks set down the palanquin so that Trulshig Rinpoche, a Buddhist lama highly respected by Sherpas and Tibetans, can greet supplicants on the trail. Rinpoche, the former abbot of Rongbuk Monastery on the north side of Mount Everest, now resides in Nepal at Thupten Chöling, to the south of Khumbu.

I quickly came to understand that climbing Everest was primarily about enduring pain. And in subjecting ourselves to week after week of toil, tedium, and suffering, it struck me that most of us were probably seeking, above all else, something like a state of grace.

—Jon Krakauer, *Into Thin Air*

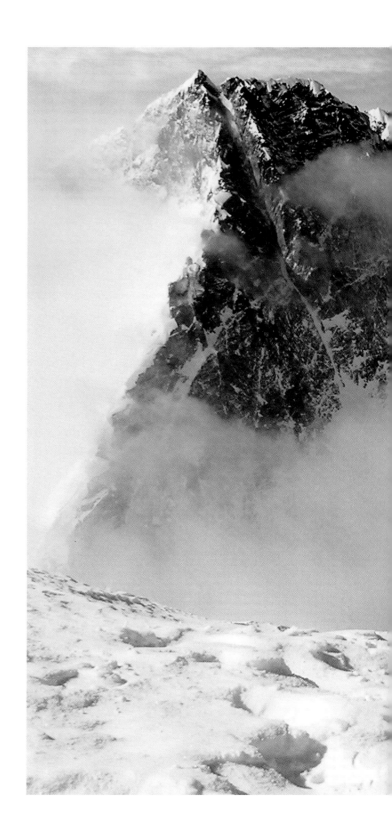

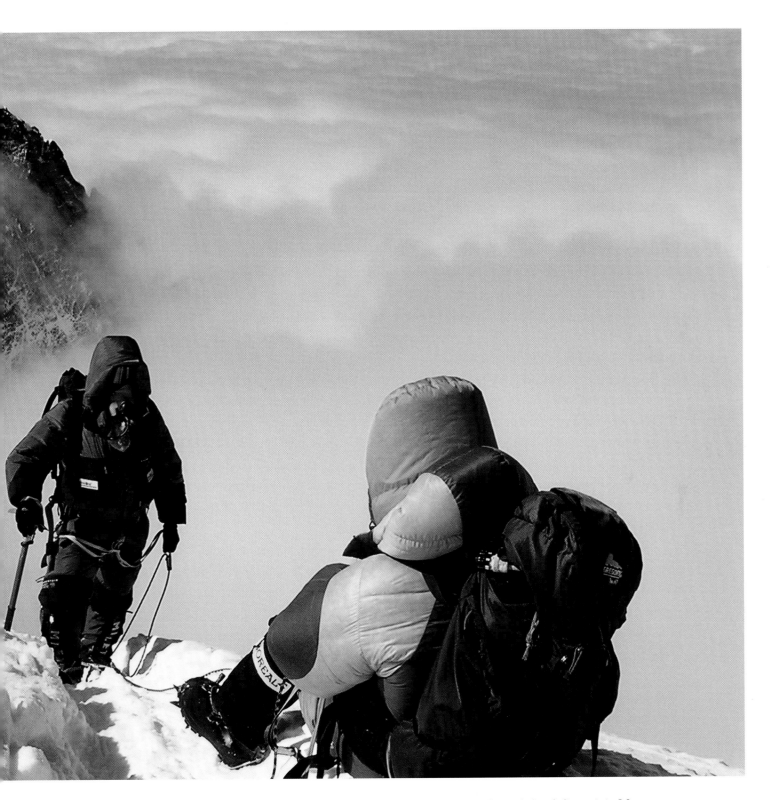

Apa Sherpa (right) watches American climber Will Cross approach Everest's South Summit in May 2005. The summit of Lhotse, fourth highest mountain in the world, pushes through the clouds in the background.

the worst I had seen high on the mountain. A few hours after sunset, the wind calmed slightly, and my team, with other expeditions' climbers, departed Camp IV for the summit.

Om mane padme hum hrih, I prayed as my friend Dawa Nuru, expedition member John Gray, and I trudged to our first point of reckoning, the Balcony, at 27,500 feet on the Southeast Ridge. We squatted alone in the darkness and switched oxygen bottles while trying to catch our breath. Below us, 30 beads of light twinkled from the headlamps of other climbers. I knew they were watching us, to see if we would turn around.

I prayed to Miyolangsangma for guidance and could hear the oxygen mask–muffled chants of Dawa, a former monk, also requesting permission to continue. In 1990, when I first climbed Everest with veteran climbers Rob Hall, Gary Ball, and Peter Hillary, Miyolangsangma welcomed me into her lap. Her invitation, however, is temporary.

Recently I have questioned whether I have worn out Miyolangsangma's welcome. If I do not climb Everest, however, there is no money to pay for our children's college education, and they, too, will be destined to climb mountains for a living. Yangji, my wife, worries about the family's welfare in my absence; the life insurance for high-altitude climbing Sherpas only provides so much.

Last season, Ang Nimi, our 13-year-old daughter, died suddenly from meningitis. Experiencing the pain of her loss reminded me, as Trulshig Rinpoche taught, that life, too, is temporary and impermanent. That is why each step we take, on the mountain or off, must be taken with respect and appreciation for the preciousness of our human birth.

Sitting on the Balcony, the responsibility of making the decision to continue up, or to turn around, weighed heavily on me. Yangji had urged me to come on this expedition with our friend John, to "keep him safe." Now I was caught by indecision—by a feeling that Miyolangsangma might be withdrawing her invitation.

As if sensing my dilemma, John gently reached a hand over to me and said, "Apa, are you okay? Are you warm enough?" The wind carried his words away, but I could see in his eyes that he was feeling strong, ready to push on. We would continue to the South Summit and, if conditions didn't improve, we would turn around.

Two hours above the Balcony, an amber dawn revealed the triangular shadow of Everest stretching to the western horizon—Miyolangsangma's welcome mat. It was now clear that we were invited guests and not interlopers. John, Dawa, and I ascended the exposed slope to the South Summit, where we again switched oxygen bottles. We scrambled up the Hillary Step, traversed the final snowy humps, and, at 6:35 a.m. on May 31, John, Dawa, and I stood on the summit. I said a prayer for Ang Nimi's rebirth and thanked Miyolangsangma for her hospitality once again. Then the three of us began the journey to our true destination: safe return to our families.

HEART OF THE HIMALAYA

Conrad Anker

Conrad Anker, born in 1962, has made first ascents in the Himalaya, Antarctica, and South America. As a member of a research expedition team in 1999, he discovered the body of George Mallory, the pioneering English climber who disappeared during an attempt in June 1924.

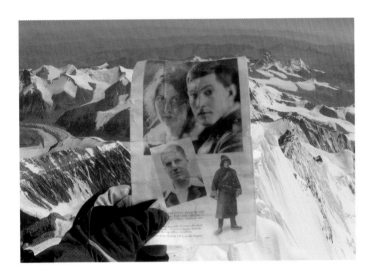

Did they make it? On Everest's summit, Jake Norton holds pictures of George and Ruth Mallory (above) and Sandy Irvine. Mallory and Irvine were last seen alive in 1924, headed toward the summit.

BEFORE I FIRST VENTURED TO THE HIMALAYA, I imagined that I would trek into a remote base camp, tackle a huge ice face or big wall, gain a summit, rappel through the night, and return a few pounds lighter and a few degrees tougher. The Himalaya would be like the Sierra, where I learned the craft of climbing, only on a grander scale.

About to embark on my first Himalayan trip, I conferred with my mentor, Mugs Stump, who was a tough climber and had been on several Himalayan expeditions. He remarked that it was the people, not the mountains, that made Himalayan climbing unique. Why did he choose to mention the people first? How could humans outshine

those brilliant, mighty peaks? In North America, in my youthful view, mountains were where we went to escape people. If I wanted to experience people, I'd go to a city.

But when I arrived in the Himalaya, I too found myself spending more time with the people who lived in the mountains' shadows than actually climbing. I soon realized that I was reliant upon the local people for my survival. I lived with them, dined with them, line danced with them—and climbed with them, too.

In 1988, I trekked with two newfound Kashmiri friends, a small entourage of climbers, and several donkeys to a base camp in the Kishtwar Himal, India. We traveled as people have for millennia: on foot, with domesticated animals, limited only by the terrain and hours of daylight. We passed hamlets nestled into steep hillsides, their thatched-roof houses surrounded by orchards and wheat terraces.

Almost imperceptibly, something in my worldview began to change. The comfortable life I had grown accustomed to was challenged by the hardship and simplicity of village life. Conveniences that I took for granted, such as a hot shower and a gas stove, were luxuries that my hosts only dreamed of.

For these Kashmiri hill people, climbing a snow-clad mountain was the last thing they would consider. Mountaineering is dangerous and expensive, an undertaking with no obvious purpose. Simple survival demands most of their energy—why make life harder? If one measures a life by material accumulations, these humble people were poverty-stricken. But if gauged by their connection to family and community—and by their buoyant optimism and happiness—our hosts were wallowing in riches.

On the return to the neighboring region, Jammu, our busses became trapped behind massive landslides, forcing us to shuttle our gear over long stretches of the mountainous road. Throughout, the perennially optimistic Kashmiris laughed and joked. Merchant, pilgrim, refugee, or tourist—we were all in the same plight. Only a collective effort could make life easier, and so we worked together.

For the alpinist, the invisible adversary is the wind, and on Everest the relentless high winds are the true guardian of her summit. The wind there can blow for weeks, destroying camps and eating away at one's resolve. In 1999, while climbing the North Ridge, two Sherpas and I had to pitch a camp at an altitude of 26,000 feet in howling, biting winds. As we hacked out a level spot from the frozen rubble, sharing a common, near-desperate goal, we sneaked glances at each other between gusts of wind. Their eyes, filled with humor, seemed to laugh out loud, conveying the feeling that as long as we were smiling, we would be fine.

In 1999, my friends Alex Lowe and Dave Bridges perished in an avalanche on Shishapangma, in Tibet. We were traversing a slope, only a couple of feet apart from

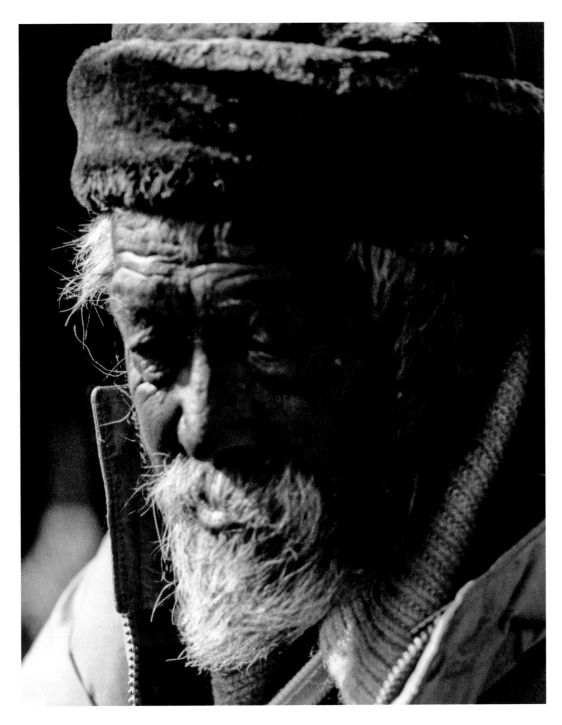

Sirdar *(or leader) Dawa Tenzing, one of the original "Tigers of the Snows," was a veteran of British Everest expeditions in 1924 and 1935 and of the 1963 American expedition. Regarded by mountaineer Gil Roberts as his Sherpa grandfather, Dawa Tenzing lived his final days near the Tengboche Monastery.*

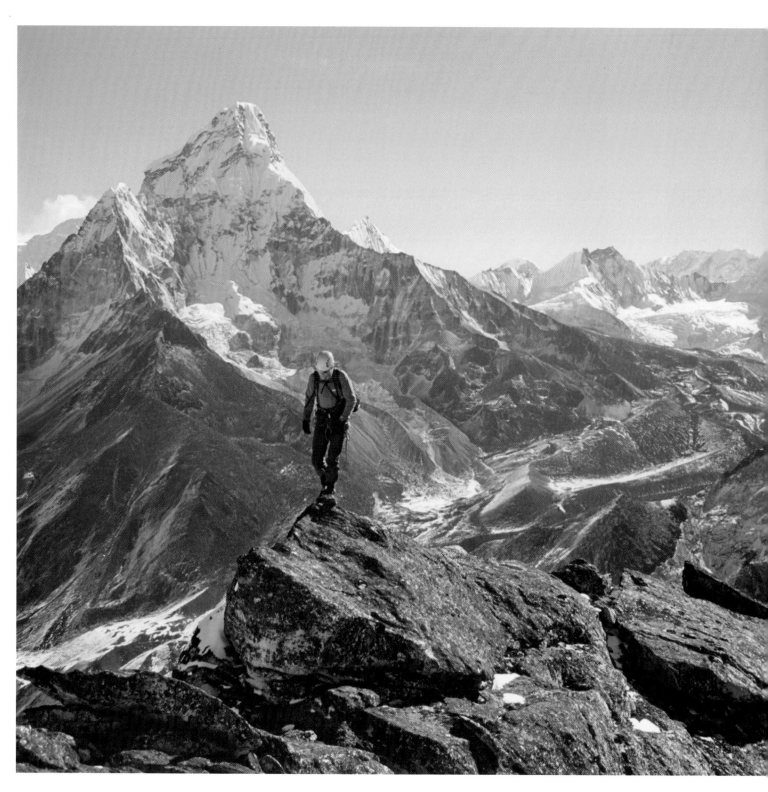

*Conrad Anker balances on a ridge adjacent to Tawoche, above the village of Phortse, in Khumbu, during
an outing with Sherpas from the Khumbu Climbing School. Rising behind him is the sculpted face of
Ama Dablam, first climbed in 1962 by Barry Bishop.*

each other, when an enormous ice avalanche came over a rise from above. We ran. I took off at a downward angle, stealing a glance back. I could see Alex and Dave above me.

Then the avalanche struck. When the spindrift cleared, all was silent. But my two companions, one of them my best friend, were gone.

In the aftermath, the Sherpas and Tibetans working with us were accepting, caring, and understanding. They didn't question our motivation or the nature of the accident, and they acknowledged death as an inevitable stage of life. Our team was devastated. For our Buddhist friends, however, Alex and Dave had simply entered a new life.

The Sherpas' empathy and compassion helped me make peace with the loss. Until then, I imagined that I controlled my own destiny. Now I know better. High in the mountains, the specter of death is ever present. To deny it is naive; to ignore it, dangerous. Accepting and understanding and dealing with death are part of the pact we make when we venture to such places where humans don't belong.

In 2002, Alex's widow, Jennifer, several Sherpa friends, and I formed the Khumbu Climbing School, a vocational training program dedicated to making climbing safer for the Nepalese who work as high-altitude porters. Sherpas suffer a disproportionate number of climbing-related deaths in the Himalaya, and they often leave behind families dependent on their income. By making climbing safer, we hope to reduce the risks these humble people face while easing the burden of their loss on their families and communities.

As the students in the climbing school learn safety, they also share their humor, hard work, and joy over being in the mountains with climbers from around the world, in an environment where work and recreation merge into one. In a way, the success of the climbing school helps me venerate Mugs's sage words of 25 years earlier, that the people are the most important part of the Himalaya. They have given me much. Connecting over a cup of tea and a boiled potato has as much meaning as the fleeting moments on a summit. And for this I am ever grateful.

It is my turn to give something back.

I've climbed a few high peaks and survived some exotic adventures, yet it is the smiling, laughing, caring, strong, and compassionate people of the Himalaya that have changed me.

Climbing a peak is a sliver of a dream, a temporary objective. The real goal is to be sitting near the hearth together with the local people, and to share. The mountains have taught me humility, but the people who live in the shadows of these mountains have taught me acceptance, respect, and kindness.

GIFT OF DHARMA

Sogyal Rinpoche

A world-renowned Buddhist teacher from Tibet, Sogyal Rinpoche is also the author of the highly acclaimed *Tibetan Book of Living and Dying*. The founder and spiritual director of Rigpa, a thriving international network of Buddhist centers and groups, Rinpoche is known for his gift for presenting the essence of Tibetan Buddhism in a way that is both authentic and relevant to the modern mind.

THE HIMALAYA IS MY HOMELAND, and I can think of no place on Earth more inspiring or uplifting. For me, these mountains, unshakable, immaculate, and majestic, embody the teachings of the Buddha and evoke the highest peaks of understanding. In my mind, the Himalaya is inseparable, too, from the great Buddhist masters I have known, individuals who have attained the most profound spiritual realization.

I was born in Tibet and raised there by my master, Jamyang Khyentse Chökyi Lodrö. In 1955, when political conditions were deteriorating in our eastern province of Kham, I left with him on a pilgrimage to the great Buddhist monasteries and sacred sites of Central Tibet. From there, we crossed the Himalaya and visited the holy places of India and Nepal, finally settling in Sikkim, an autonomous Himalayan kingdom, at the invitation of the king. After my master passed away in 1959, I continued to study with other eminent Tibetan Buddhist lamas, who lived and taught in Nepal, Northern India, Sikkim, and Bhutan. Even after having made my home in the West, I have always been drawn back, every single year, to the Himalaya.

Hindus, Jains, Buddhists, and the devotees of Bön, the pre-Buddhist religion of Tibet, all revere the Himalayan mountains as sacred and see in them the dwelling place of deities of every kind. For followers of the Buddhist tradition of Tibet, the whole Himalayan range is filled with the blessings of buddhas, bodhisattvas, and enlightened beings. This vast area is alive with the presence of Padmasambhava, the Lotus-born Guru, who established Buddhism in Tibet and the Himalaya in the eighth or ninth century. He traveled everywhere, infusing his blessing into the entire Himalayan landscape.

Foreseeing the future, Padmasambhava concealed numerous spiritual treasures, *termas*, to be revealed at the appropriate time by his successors. He prophesied havens for spiritual practitioners in times of need, such as "the hidden land" of Sikkim and the sacred

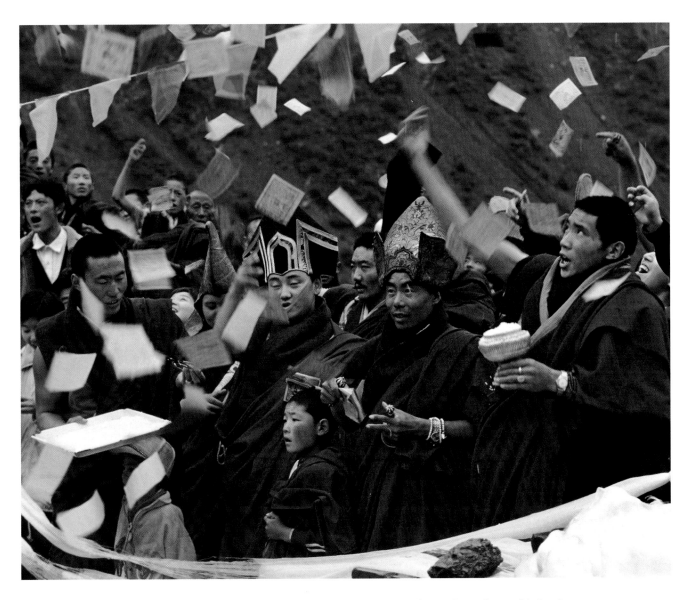

Lamas and monks of Shechen Monastery, in eastern Tibet, cast into the wind countless multicolored squares of paper, each imprinted with hundreds of Buddhist prayers—a small portion of a consecration ceremony for the building of a chapel dedicated to Chenrezig, the Tibetan name for the Buddha of Compassion.

land of Bhutan. Padmasambhava's compassion, blessing, and all-encompassing vision give the Buddhist tradition of Tibet and the Himalaya its vitality and success, and the Buddha's teaching pervades the fabric of the existence of the people of these lands, every facet of their everyday life, almost like the very air they breathe.

The Himalaya has rendered a special service to Buddhism. From the ninth century onward, the complete teachings of Buddha were imported into Tibet, a huge national translation project unlike any that the world has known before or since. By the end of the 12th century, Buddhism was destroyed in India. Yet, sheltered and protected by the Himalaya, for a thousand years in Tibet and its surrounding lands, the inner sciences of Buddhism were practiced and perfected.

This is why sacred sites, power-places, holy shrines, meditation caves, and pilgrimage routes abound throughout the Himalaya. In Tibet alone, there used to be more than 6,500 monasteries and nunneries. The mountain wilderness has forever afforded the inspiration and seclusion vital for intensive spiritual practice and retreat. My mind turns at once to Tibet's great enlightened saint and poet, Milarepa, who has inspired millions of practitioners throughout the centuries. Longchenpa, peerless master of the deepest teachings of Tibetan Buddhism—Dzogchen or "The Great Perfection"—explained:

High up among the mountains, mind grows clear and expansive:
Perfect as the place to bring freshness when dull, or to practice visualization.
Snow-clad regions make meditation limpid, awareness bright and lucid,
Ideal for cultivating insight, and where impediments are few.

All my masters, who belonged to the last generation of lamas to be trained and attain spiritual realization in Tibet and the Himalaya, devoted years of their lives to solitary retreat: Jamyang Khyentse, Dudjom Rinpoche, Dilgo Khyentse Rinpoche. They embodied the living lineage of wisdom of Padmasambhava, Milarepa, and Longchenpa. After the fall of Tibet in 1959, these masters and their disciples found homes elsewhere in the Himalaya, and so these mountains have continued to nurture, inspire, and produce extraordinary practitioners of the Buddhadharma.

When the Tibetans came into exile, the Buddhist teachings were catapulted into the modern world, where their universal application and transformative power have been increasingly recognized by thinkers, scientists, and ordinary people worldwide. In the course of my own work, I have been deeply moved by their impact on the lives and welfare of so many individuals. His Holiness the Dalai Lama explains, "In Buddhism, the highest spiritual ideal is to cultivate compassion for all sentient beings and to work for

their welfare to the greatest possible extent." It is from the Buddhist teachings that he has developed his remarkable message of universal responsibility, a secular approach to ethics, marked by compassion and a readiness to serve others, which he knows the world needs so urgently today. The Buddhist teachings tell us it is possible to train the mind in compassion and wisdom. This has been highlighted recently by scientific studies of a range of Tibetan Buddhist meditation methods and their effect on brain structure and function, for example those carried out at the University of Madison in Wisconsin.

I believe there is no limit to the ways in which the Buddhist teachings can benefit the world and can be put into practice in all kinds of life situations. One of our great

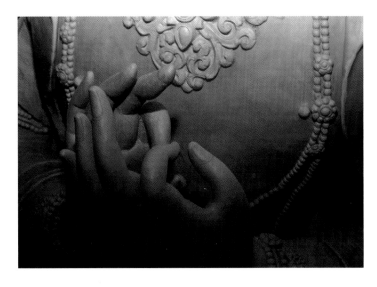

A clay statue dries in Tengboche Monastery, its hands in the mudra (*position) of teaching, or "turning the wheel of dharma."*

needs today is to understand more about dying. Around the world, my students and I have developed an education program that has proved of real help to those who are seriously ill or approaching death. In Ireland, we are constructing the first purpose-built "respite center," where the compassion and wisdom of the Buddhist teachings on death and dying can be put into action, to bring solace to people of any or no faith.

As one of my masters, Nyoshul Khen Rinpoche, said, "We think of our tradition of Buddhism as a gift we have to offer the world." Yet as we make use of it and benefit from it, let us also remember the struggles that the people of the Himalaya have gone through to guard this gift, and so hand it on to all humanity. ≋

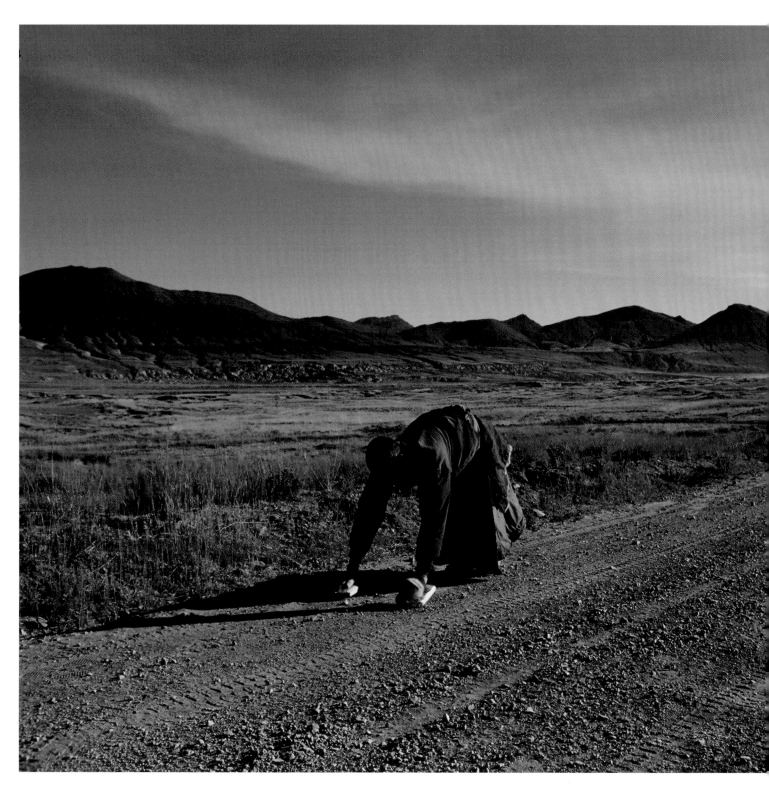

Prostrating by body length, a pilgrim traverses the breadth of Tibet to Mount Kailash, the holiest of mountains for half a billion people. Thousands make the arduous journey each year on foot or by truck.

We court our shackles.
We sharpen our tongues.
The seven bowls in our shrine
are full of water. We're wearing
skin of ignorance and
eyes that will not forget.

—Tsering Wangmo Dhompa

THEY TOOK ME IN

David R. Shlim

David R. Shlim, M.D., spent 15 years in Nepal running the CIWEC Clinic Travel Medicine Center and providing medical care for a large Tibetan Buddhist monastery. There, his friendship with the head lama, Chokyi Nyima Rinpoche, led to their collaboration on the book *Medicine and Compassion: A Tibetan Lama's Guidance for Caregivers.*

WHEN I FIRST SET FOOT IN THE HIMALAYA, in the spring of 1979, I harbored a secret. I was trekking from Lukla to Pheriche to begin a three-month stint as a volunteer doctor with the Himalayan Rescue Association. Walking along, I nurtured a fantasy of being singled out at a monastery by monks who—recognizing my great potential for enlightenment—would invite me in, offer tea, and impart the insight that would allow me to abandon my worries and achieve a stable, happy mental state. I figured this would take about 20 minutes.

The monasteries themselves were a complete mystery to me. I knew nothing about Tibetan Buddhism, other than that the Tibetans had tried to keep foreigners out of Tibet for a very long time. Why? What was so secret? As I walked along, I was confronted with the spiritual efforts of the local people—flapping prayer flags, carved mani stones, and painted chortens. The local people themselves seemed to embody qualities that we Westerners would like to emulate: equanimity, compassion, and competence. I wondered how someone like me could get to be like that.

After several days of trekking I arrived at the Tengboche Monastery. I climbed the broad stone steps to a courtyard, then ascended again to an antechamber painted vividly with ghastly-looking creatures, perhaps guardians of some sort. I removed my shoes and felt the cold wood under my stockinged feet, damp with sweat. Butter lamps emitted a mellow, flickering light that illuminated golden statues.

I heard a noise and turned to see a young monk in maroon robes who had appeared in the doorway behind me. He made a gesture in my direction, and I looked to see if there was someone nearby. He was gesturing to me! Yes! It was happening. I hastily slipped on my shoes and followed him through a maze of hallways and low doorways, deeper into the monastery. We entered his private room, and he motioned for me to sit on his bed.

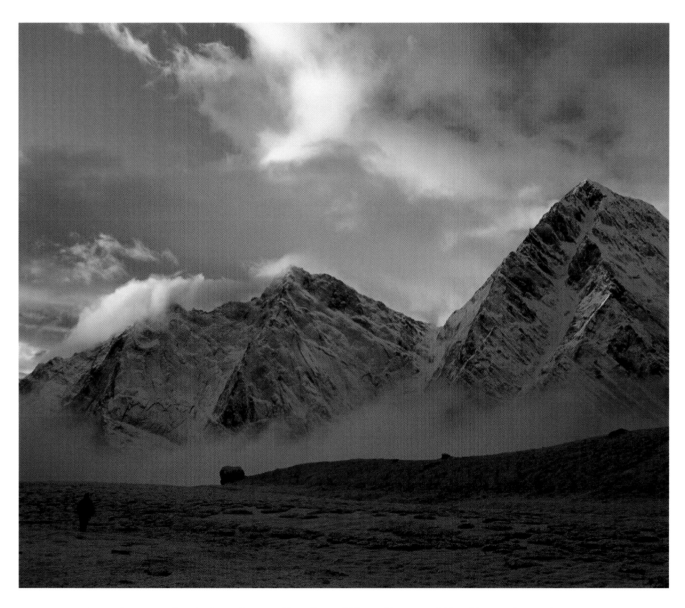

A traveler approaches the Kangshung, or East Face, of Mount Everest, in Tibet. For one thousand years, Buddhism flourished on the Tibetan Plateau, which was protected in part by its isolation. The Chinese occupation forced Buddhist teachers into exile and into contact with Westerners curious to learn of Tibet.

Newar Buddhist devotees light candles during the Seto Machhendranath Festival in Asan Tole, Kathmandu.

Throughout the Himalaya, communal spiritual practices such as this are carried out with humor and grace.

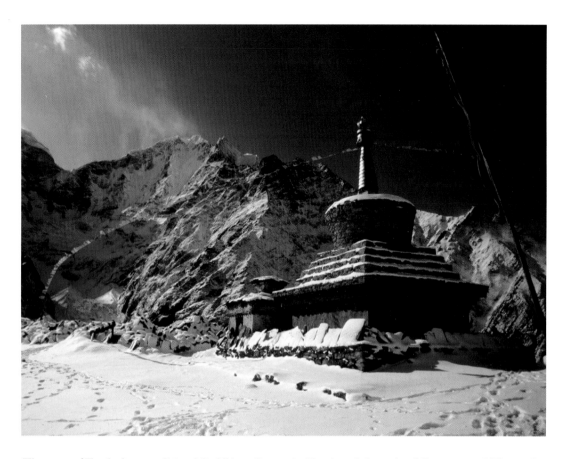

The stupa of Tengboche, a traditional Buddhist reliquary in Nepal, and the peaks of Kangtega and Thamserku welcome Sherpas, trekkers, and pilgrims after the climb from the Imja Khola, 2,000 feet below.

Smiling, he opened an ancient chest darkened with a veneer of soot and smelling of sweetly rancid butter. He removed some handmade paper scrolls and unrolled them. They were drawings of Buddhas and Buddhist deities, drawn primitively and recently with crayons. He looked at me.

"You want to buy?" he asked in English.

I felt an intense jab of disappointment. My elaborate fantasy crumbled. I was not a worthy disciple—just another tourist.

Even as I walked away, I reflected that my expectations had been unrealistic. But how would I find out what Buddhist teachings really were? What were the secrets hidden in the monastery?

Four years later I moved to Kathmandu to work as a doctor in the CIWEC Clinic Travel Medicine Center, the world's busiest destination travel medicine center. My secret

craving had waned. I had, however, decided to offer free medical care at a Tibetan monastery headed by Chokyi Nyima Rinpoche. During weekly sick call, I treated monks from ages 5 to 80. Before and after seeing the monks at the clinic, I would sit and talk to Chokyi Nyima Rinpoche, simply as a friend. Gradually, though, I began to seek his advice on matters of relationship or work, and his wisdom and insight always seemed to help. When he taught more formally, he expounded the benefits of learning to meditate. Finally, I asked him if he could teach me how to meditate. He nodded, then showed me what to do.

I began by meditating at home each day. Each week, I reported to Chokyi Nyima Rinpoche on my efforts and received further advice. Over the years I had heard friends talk about going on retreat, but I didn't know what this really entailed, or whether I would be able to do it. I went to ask Chokyi Nyima Rinpoche about doing a retreat.

"Oh, very good. A retreat would be very good for you," he said.

"Well, why didn't you suggest it to me earlier?" I replied.

"It's better if the idea comes from you."

A few weeks later I climbed the edge of the Kathmandu Valley to Nagi Gompa, to begin my first meditation retreat. Nagi Gompa is a nunnery and was the home of Chokyi Nyima Rinpoche's father, Tulku Urgyen. I had been Tulku Urgyen's doctor for the past couple of years, but I had only recently discovered that he was one of the most revered meditation teachers in the Tibetan tradition. I would be staying alone for five days in a single, small room. The nuns would bring me my meals, and I would go to see Tulku Urgyen each night to discuss my efforts. On the third evening, I sat at a window looking out at the lights of the Kathmandu Valley. I felt lonely, wondering why I was sitting all by myself, trying to do something as abstract as meditate, when I could be down in the valley relaxing and visiting with friends.

Then it hit me. The secret dream I harbored when I ventured into the Tengboche Monastery had been fulfilled. They had taken me in! I had been introduced to Buddhist teachings by genuine teachers. It was taking longer than the 20 minutes or so that I had imagined, but I knew I was on the right path. I could feel myself becoming more relaxed, more stable, and better able to help my patients.

A nun knocked on the door. It was time to see Tulku Urgyen. As I entered his room, I did three prostrations. He looked at me with open affection, and as we touched heads, an intense feeling of gratitude flooded through me. My loneliness vaporized.

The feeling that one had to be invited into the monastery in order to gain teachings had obscured the reality. It had taken eight years, but I had finally found the secret. To get the teachings you desire, all you have to do is ask for them.

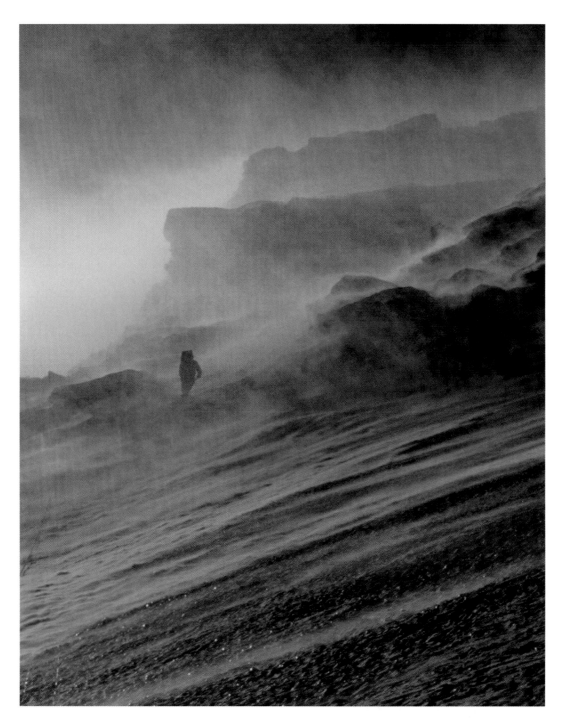

Two mountaineers battle upward in a maelstrom of wind and snow on Mount Everest's West Ridge, facing a windchill of more than -60°F. Frostbite can strike within minutes, especially at high altitudes, where hypothermia and hypoxia impair both circulation and judgment.

BORN TWICE

Maurice Herzog

In 1950 Maurice Herzog was the first foreigner to receive a visa to visit Nepal. That year, he and a French team made history by climbing an 8,000-meter peak. His book on that climb, *Annapurna*, has become a classic of mountaineering literature. He has served in the French government and has worked with UNESCO on environmental and cultural conservation efforts.

> *Truly, truly, I say to you, unless one is born anew,*
> *he cannot see the kingdom of God.* —JOHN 3:3

IN 1950, I REACHED THE SUMMIT of one of the highest mountains on Earth, Annapurna, in the very middle of the Great Himalaya Range. But the effort nearly killed me. I returned to France unable to walk, my hands and feet frostbitten. I was despondent. It would be a long time before I could appreciate the enthusiasm, admiration, and compassion that greeted my return.

My childhood was marked by the Great Depression, and I faltered along with my seven brothers and sisters amid the misery of the lower middle classes. At home, our family played music, sang, and laughed as a way to forget that we had no food. As the eldest, I presided over this little world, acting taciturn and proud, sometimes violent. But I was feared, not loved. I was an example, but I was out of reach.

I took my isolation to the mountains. World War II broke out, and I directed my officer training and mountaineering skills to high mountain warfare. When the German Army occupied France, in the heart of the Alps, I gathered volunteers, and we resisted by fighting clandestinely. When peace returned, I worked as an engineer, but it was not enough to satisfy me. Again, the mountains were where I came alive. And so I climbed, sometimes recklessly. Mountain climbing had become like the war for me: Win or die.

But like an injured soldier, I now lay in a hospital in Paris. My hands and feet, or what remained of them, were buried in a mass of bandages. Then the bandages were removed, revealing stumps infested with maggots. At one point I lost blood so quickly that I was given only a few hours to live.

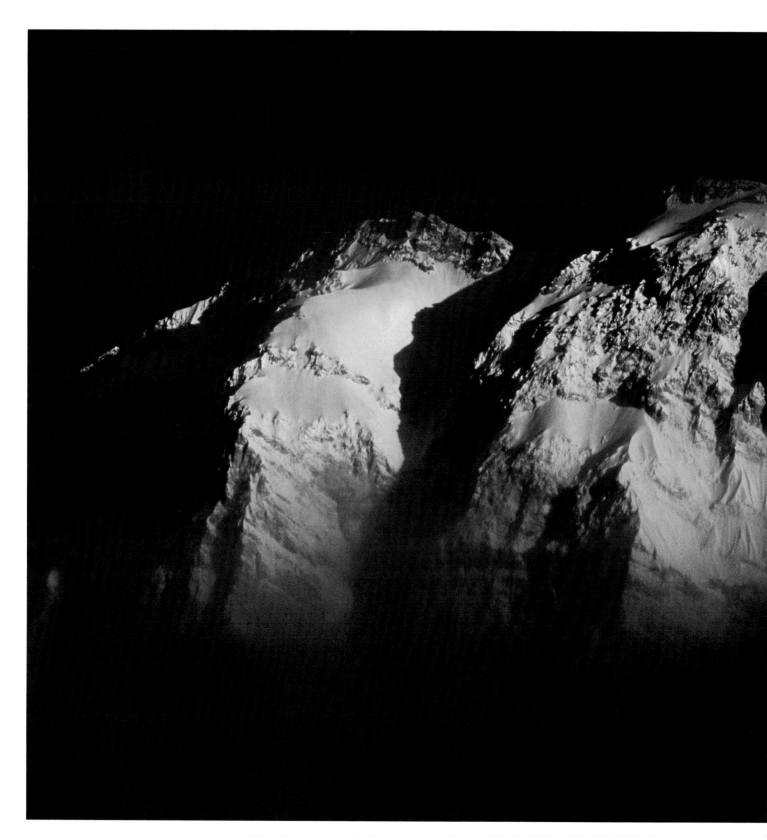

First light bathes the south side of Annapurna I (26,545 feet), first climbed by Maurice Herzog and

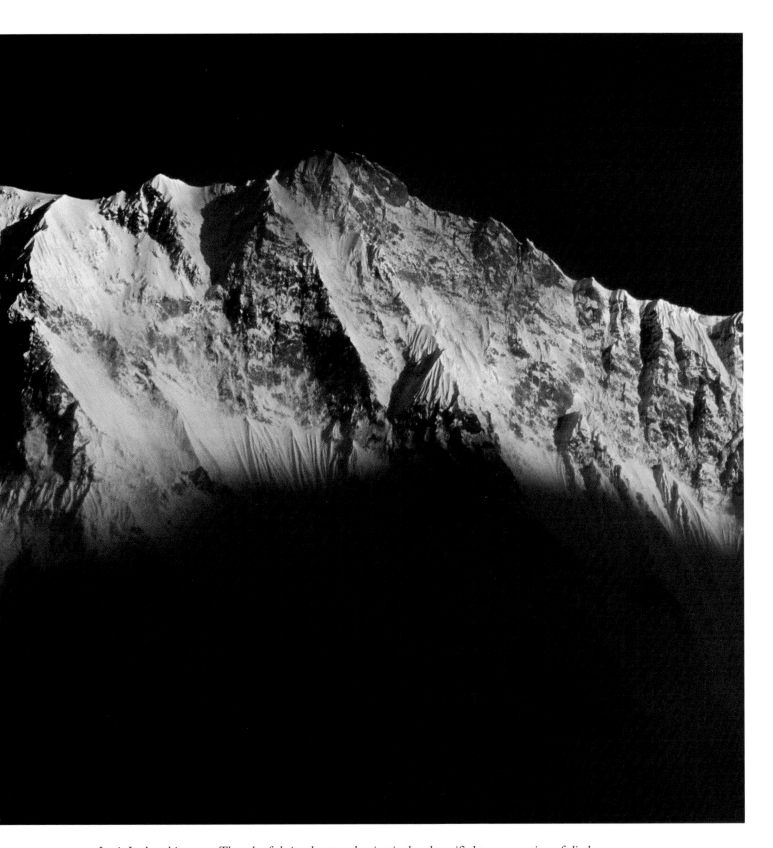

Louis Lachenal in 1950. The tale of their adventure has inspired and terrified two generations of climbers.

I felt desperate and alone. The expedition was over, and I had come to the conclusion that my life, too, was finished. The doctors had openly said that I would never again be able to walk or use my hands. I was tempted to let go, to stop fighting, to let myself die. At the least, I decided, I would retreat from the world and join a monastery. But I also resolved to not be a burden on society.

One day my nurse, Irene, convinced me that despair was not an inevitable product of my wounds and amputations.

"It's all in your head," she declared. "Your life isn't over. It will begin anew, more exciting than before." She urged me to set a near-term goal: to dictate the Annapurna story. Any income would help cover my hospital fees, too, and I was penniless. She helped me to believe that my mutilated body could be a springboard, not an obstacle, and she inspired me to strive to regain my mobility and autonomy.

A pen was affixed to my bandages, and I managed to write, through excruciating physical pain. Slowly, as my taste for life returned, I could resurrect the crucial moments of the climb and feel again the intense joy of standing on the summit.

While recalling the summit, I was also consumed by images of the retreat. I struggled with visions of lying in the bottom of a deep crevasse, offering what was left of my life to save others. Then I saw myself again, lashed to the back of a barefoot porter, my head swaying from side to side, body soaked and dripping from the incessant monsoon rains. My soul had departed from my body…

When I saw the movie footage shot during the expedition, I burst into tears. The film vividly transported me to the Indian airplane, when the crew refused to let me on board because the sight and the smell of my rotting flesh was deemed unbearable for the passengers. It took me back to being carried from the Himalaya on a stretcher, as an eagle swept down, hoping to pick me up with its huge talons. And to the moment when a tiger, attracted by the smell of my decaying flesh, jumped through the window of my coach and out the other side of the train.

After one year and ten painful operations, I was able to leave the hospital, hesitantly. Every window was filled with nurses waving handkerchiefs. Once, I had reached the goal of the top of Annapurna. Now, maybe, I could reach my new goal of surviving with dignity.

One day, I fell in love with an irresistible young woman, Nina de Montesquiou. A devoted Catholic, she helped me reintegrate into society and guided my redemption.

"What should I do with my life now?" I asked her in her Paris town house.

"Keep writing," suggested Nina.

"Go back to being an engineer," said a visiting friend.

"But no politics," they both agreed.

That's when General de Gaulle appointed me Secretary of State for Youth and Sports. Over a period of eight years, I tried to restore in the youth of the postwar period the ideals they had misplaced—values of honesty, generosity and enthusiasm.

"It is better to be true than to be strong," I would say, reiterating what I had learned for myself. Each year, 300,000 young people participated in exchanges between Germany and France. At a High Mass celebrated in Verdun—the first time in France since the First World War—"Deutschland über Alles" was sung loudly together with "La Marseillaise."

Residents of Braga village live, farm, and herd livestock on the steep slopes of Annapurna. They cluster their houses to save on materials, conserve energy, and gain protection from the elements.

My aloneness and desperation is gone now. But am I the same person?

The Karmapa, one of the most venerated Buddhist leaders, blessed me with an adage that has become like a mantra: Because you have suffered much, you were born again. I am the same now, but different. I look at the world and my fellow human beings through changed eyes. I believe that where I once was proud, now I am true. Where I was inflexible, I am now more human. Love has supplanted strength.

Such was the destiny of the man of Annapurna. And may such a fortuitous life be shared by all who are similarly incapacitated, unfortunate, or wounded—indeed, for all who can be termed children of God.

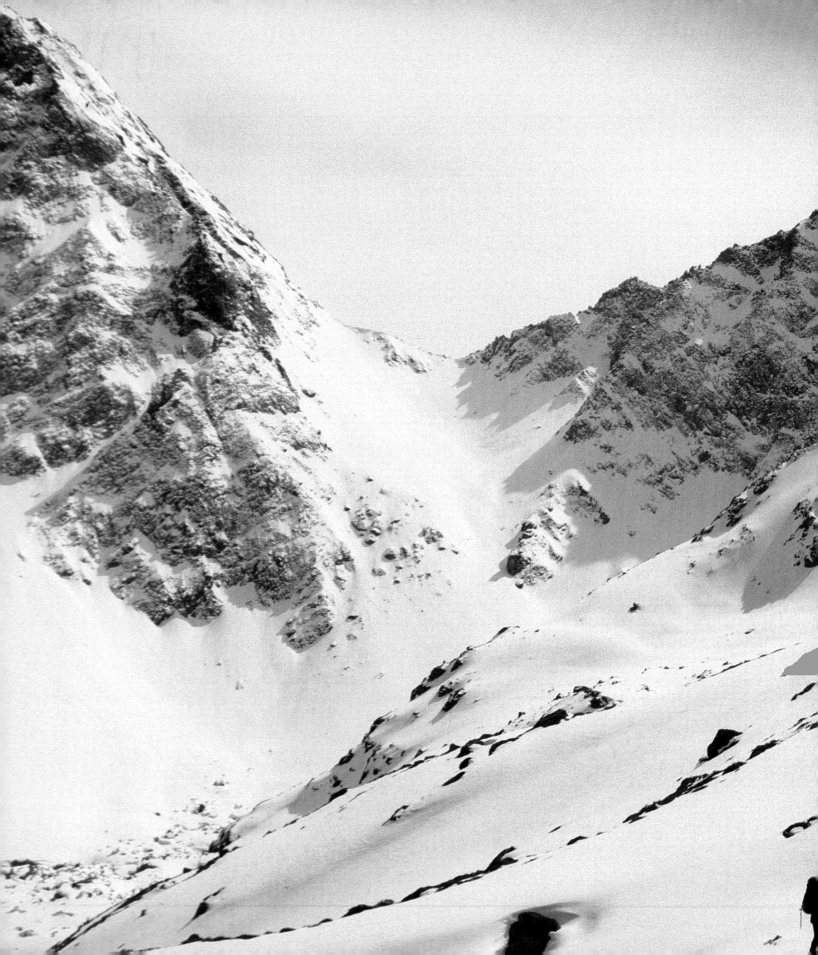

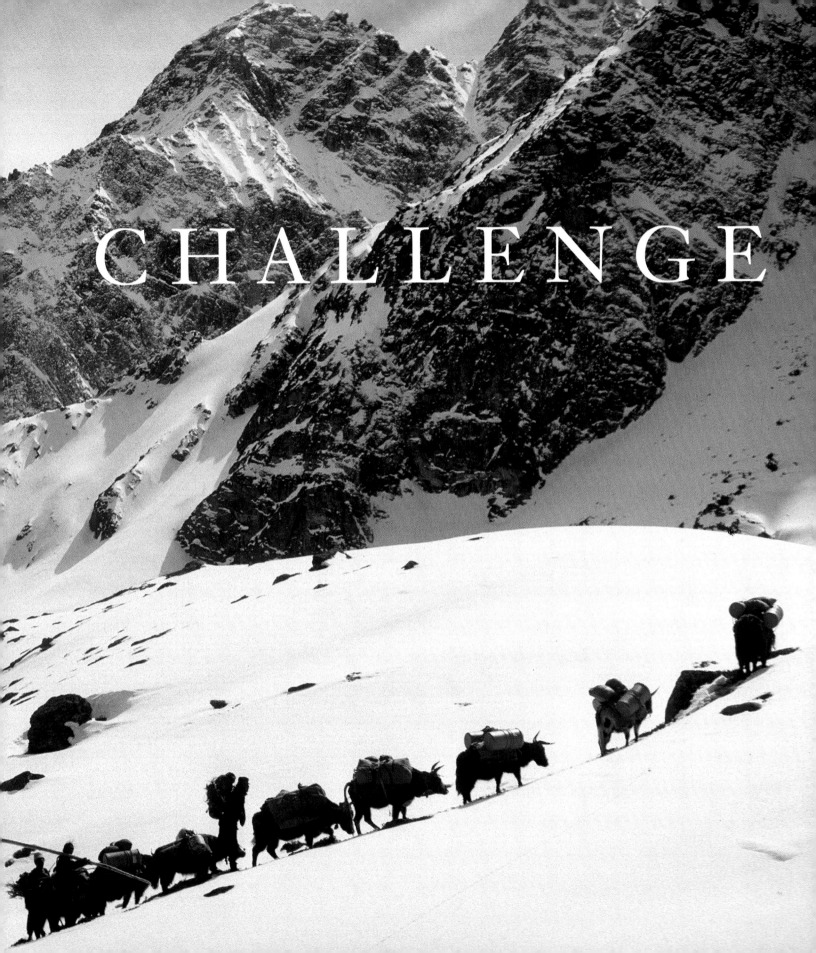

CHALLENGE

STORIES OF CHALLENGE

Even in the old country grass was boiled for dinner.

We learn from our elders so when they said we were poor,

we knew our job as children. The eldest gave up school

so the youngest could be polished for reward.

—Tsering Wangmo Dhompa

IN THE 1950S AND '60S, THE KATHMANDU VALLEY bore the exotic, Middle Ages character that defined it for centuries: urban farmers carrying their crops into town, wandering street cows, incense and temple bells, organic smells. It had a calmness, as if there had never been, and never would be, a reason for urgent concern. Time was measured not in hours or days, but in seasons. The most threatening presence was the occasional Ambassador taxi, painted in tiger stripes to scare villagers from its path.

Legend says that Lord Manjushri created this valley when he spied a crystal clear lake in the middle of the Himalaya and drained it with one pass of his sword. One of Asia's richest cultures sprang from this fertile lake bed.

That fertility may have also nurtured the angst of a nation of mostly rural, isolated farmers who have arisen against their king. Lord Manjushri's sword has again smitten the rim of the Kathmandu Valley. The politics of Nepal promise to gyrate wildly for some time, but no longer will the capital, and the people, interrupt their lives for a royal motorcade on a road divided by a white line freshly laid by nine workers who were issued only one paintbrush.

PRECEDING PAGES: *On the approach to the Kangshung—the East Face of Everest—a team of yaks and their drivers ascend deep, late-winter snow to Langma La, the 18,000-foot-high pass near Kharta, Tibet.*

Thousands have attempted to climb Mount Everest since the first ascent in 1953, but the mountain has become no less dangerous. Nearly every Sherpa family has lost a relative to Himalayan climbing, if only due to prolonged exposure to the mountains. Admirably, the Sherpas have learned to absorb and benefit from the tide of climbing expeditions and adventure travel that has swept across their land, through their villages, and into their homes—though not without challenges to their economy and culture.

Meanwhile, Chinese immigrants are inundating Tibet, pushed westward by China's economic supermachine. Marginalized in their own country, haggard groups of Tibetan refugees, a thousand or more each winter, trudge and clamber over the Himalaya. They are headed for Dharamsala, India, for an audience with His Holiness the Dalai Lama, for a decent education, and, they hope, for a better life in exile.

Snowstorms often catch them ill-prepared on glacier traverses, and many are arrested by overambitious police. In their irrepressible desire for freedom, Tibetans risk frostbite, injury, death, and deportation, despite United Nations protections—severe tests of their Buddhist faith. But as the writings in this section attest, their spirit is far from broken.

Dizzying development and growth across the lush Himalayan belt have yielded higher incomes and improved standards of living for some—but at what cost? Rivers are becoming polluted, hillsides deforested, pasturelands overgrazed. Medicinal plants are being collected to near extinction, and endangered wildlife such as the royal Bengal tiger, the Asian one-horned rhinoceros, and the Tibetan antelope are being decimated by poachers and loss of habitat.

"We get so much aid from America," one villager said, "but can we get snow leopards from your country once they are all gone from our Himalaya?"

For most people of the Himalayan arc, their health and well-being has not materially improved. Cities show off their latest generation of medical technology and equipment, while nearby rural areas lack medical staff or even a clean scalpel. Private schools have begun to flourish in what appears to be a healthy trend, yet government schools, fated to cater to the great majority, commonly languish, neglected. Who is on watch as the rural poor set out in search of better circumstances, chasing either jobs in distant countries, or promises of justice—and two meals a day—offered up by political insurgents?

Change, movement, birth, and death are woven into the fabric of the Himalaya, and these will continue to shape the region's people and environment. But the cultures, the mythology, the swirl of politics, and the palpable image of Lord Manjushri's sword may well live beyond the legendary Milky Way of years, times thirty-three.

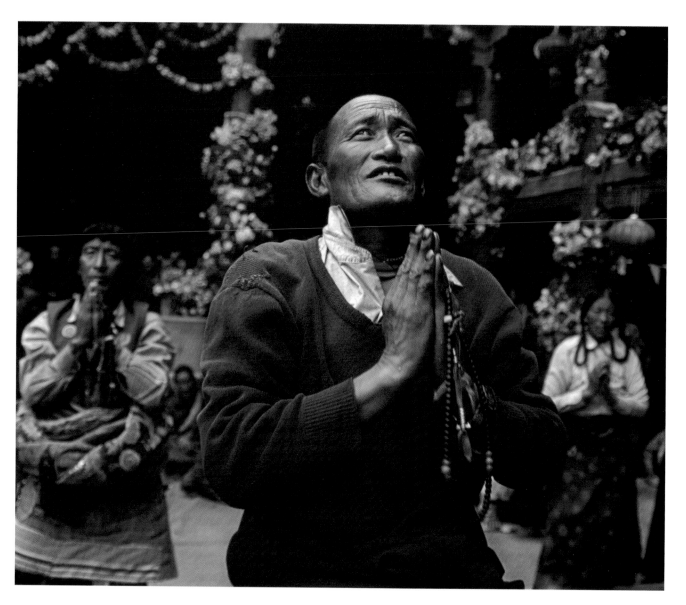

Devotion lights the face of a pilgrim at Larung Gar in eastern Tibet. In 2001, China expelled several thousand monks and nuns from this sprawling religious encampment. Today, although religious oppression continues, a growing number of educated Chinese are seeking the teachings of Tibetan Buddhist lamas.

HIMALAYAN CROSSINGS

Lodi Gyaltsen Gyari

Lodi Gyaltsen Gyari is a senior Tibetan diplomat and serves as the special envoy of His Holiness the Dalai Lama. He is currently tasked with leading the Tibetan delegation in its negotiations with the People's Republic of China. Born in eastern Tibet and recognized at the age of three as a reincarnate lama, he is also known as Gyari Rinpoche.

I WAS BORN IN 1949 IN THE GRASSLANDS OF KHAM, the vast eastern region of the high Tibetan plateau. My mother, Norzin Lhamo, a courageous and gentle woman, gave birth to me in a specially made tent in an immense open space encircled by virgin forest and snow peaks. Several months earlier her uncle, the Mindroling Khenchen, a high reincarnate lama, had sent instructions from Chamdo, where he was visiting at that time, that my birth should take place in a pure environment.

Until much later, I thought that my biological mother was Dorji Youdon, my mother's younger sister, because she was the one to care for me. But today I consider both Dorji Youdon and Norzin Lhamo as my *ama* (mother). My younger mother was not only the most prominent Tibetan woman resistance leader, but also one of the first Tibetans to take up arms against the Chinese. She must have been inspired by my grandmother, her mother-in-law, Gyari Chime Dolma, who at the turn of the last century also fought against Kuomintang regional warlords and was executed by them. Her heroic deeds and sacrifice deeply inspired Tibetan revolutionaries such as Baba Phuntsok Wangyal, who wrote songs to praise her and awaken the Tibetan spirit against injustice.

We can never predict the twists and turns of our lives. In 1956, I fled Nyarong, my native region, under cover of darkness, at constant risk of capture and death at the hands of the Chinese forces. By contrast, during my visit to Nyarong in 2004, as the Dalai Lama's Special Envoy, the Chinese officials accompanying me treated me with a measured respect and formality.

Some say that our nomadic lifestyle in these rugged conditions gives us Khampas from eastern Tibet a warriorlike toughness. Living in such close proximity to these mountains, which are known as the sacred realms of the guardian deities, spirituality and religious devotion have become intertwined with our daily lives.

There has survived in them
something numinous,
not made by hands,
of which the Chinese
have no comprehension.

—Hugh Richardson,
Ceremonies of the Lhasa Year

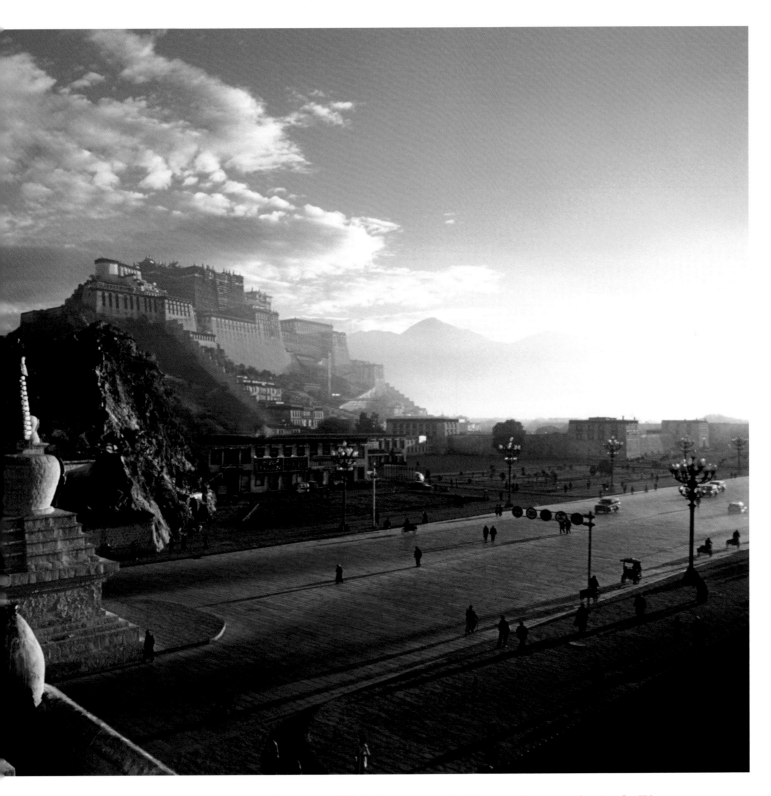

The Potala Palace in Lhasa, home of His Holiness the 14th Dalai Lama before he was forced to flee Tibet, was built in 1694. Converted into a museum, it is now visited by nearly half a million Chinese tourists a year.

As a small child, I was recognized as a reincarnate lama and was taken to Lhomorab Monastery, about two days by horse from my home. Outside its confines, the political situation was worsening, and my parents, who were leading one of the fiercest resistance groups in the Kham region, were in increasing danger. One afternoon in 1957, I was summoned from my monastery and taken to my grandmother's house, nearby. In the middle of that night, a group of my father's most trusted lieutenants arrived on horseback and took me to join my parents. I had not been told we were leaving to join the resistance. My parents were worried that, because I was a young child, I might say something to the monks that would arouse suspicion.

So we began our journey into exile, traveling at night through deep valleys and across grasslands, hiding during the day. Chinese troops pursued us and I witnessed many violent gun battles. On two occasions, in the darkness and through whirling snow, men riding ahead of me were shot before my eyes and crashed from their horses to the ground. We couldn't stop, or we would all have been lost. I remember the hunger more than the fear. There were times when we experienced weeks of terrible, gnawing hunger. Though I was quite young, I was still respected as a lama and therefore required to carry out religious activities for the families who accompanied us. I performed divinations regarding the most auspicious time to travel and recited mantras to stop the blizzards.

At times it was snowing so heavily that all sound was stilled but for the muffled thump of our horses' hooves. At night, it was so dark that we couldn't see our hands on the reins in front of us. It was as if we were suspended in space and time.

One evening we saw fires burning from a village. We sent a horseman to scout. He returned, astonished. We had traveled hundreds of miles farther than we possibly could have, by any calculation. We had departed remotest Kham just that morning, yet we had arrived in what is now Qinghai province. This should have taken six days of traveling, but only a few hours had passed. There was no doubt about it—yet no one could explain it.

My father realized that if this had not happened, we might not have safely completed our journey into exile. A large contingent of troops had been sent to pursue us, and somehow we had simply slipped through an area with intense concentrations of military personnel. Once we reached central Tibet, we completed the final stages of our journey on foot across the Himalaya. I remember arriving in Tawang (in present-day Arunachal Pradesh) with only one shoe.

Forty-six years later, my journey into exile across the most majestic and treacherous mountains on Earth is still fresh in my mind. It is a journey still made today by several thousand Tibetans each year, escaping from their homeland, risking their lives to reach freedom. They walk, often in knee- or shoulder-deep snow, facing hypothermia, frostbite

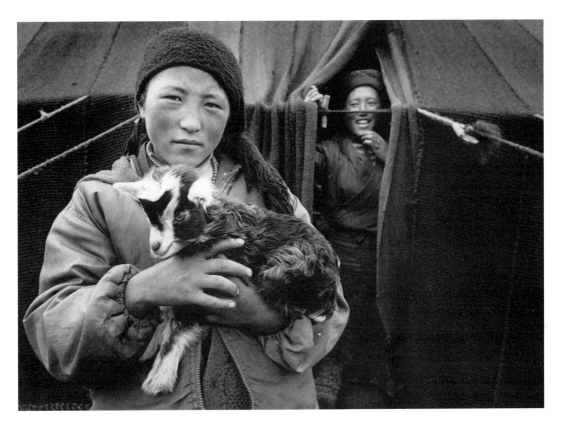

A drokpa (nomad) girl and her sister on the Chukortang Plain in Tibet's Lhasa Valley. Their traditional lifestyle has been all but subsumed by a tidal wave of immigration and modernization from China.

and snow blindness, and a twisted kneecap or sprained ankle can mean being abandoned by the group. Many Tibetans travel without sufficient food, wearing only a thin jacket and sneakers. Some, particularly small children, do not survive the journey. Many Tibetan refugees are monks and nuns, seeking a religious education that is not available to them in Tibet, due to the restrictions imposed by the Chinese state. Many more are children seeking enrollment in Tibetan exile schools, sent by parents who feel it is their only chance for a reasonable education.

It is because of the tragic loss of the cultural identity of my people in Tibet that I feel there is such importance and urgency in doing whatever one can to restore it, in whatever way possible. I feel gratified to see the vibrancy of a common Tibetan culture in areas across the Himalaya, outside of Tibet. The contribution of AHF in these efforts has been significant. I hope that the people in these regions understand how precious their culture and environment are and do not neglect to preserve them.

THE ROAD TO TIBET

Dianne Feinstein

Dianne Feinstein, Democratic Senator from California, has long been interested in the Asia-Pacific region. As mayor of San Francisco, she built the first U.S.-China sister city relationship, with Shanghai. She has worked toward permanent normal trade relations between the U.S. and China and has advocated for Tibet in the U.S. and around the world.

THE YEAR 1978 WAS THE MOST TRAUMATIC OF MY LIFE. In April my husband, Bertram Feinstein, passed away after a long illness. At the end of November, San Francisco Mayor George Moscone was assassinated. Since I was the president of the San Francisco Board of Supervisors, I became acting mayor, and then mayor, of San Francisco. In the middle of that traumatic year, I had also met Richard Blum, an investment banker and chairman of Mayor Moscone's Fiscal Advisory Committee. The attraction was instant and mutual, and we have now been married for 26 years.

Richard has always had a love for the Himalaya and had been to the region numerous times. In the fall of 1978, he asked me to join him on a planned trip to India and Nepal and I accepted.

We first went to visit the Dalai Lama at his home in Dharamsala, India. The purpose of this meeting was to deliver an invitation for His Holiness to visit the city and county of San Francisco. The Dalai Lama was appreciative of the invitation. At that time, he had never even been to the United States. Facing the threat of Chinese occupation, His Holiness had fled his Tibetan homeland in 1959 and taken up residence in India, where he continued to lead the Tibetan Government in Exile. For political reasons, the Chinese objected to his visiting the United States, and our government, which was in the process of normalizing relations with the People's Republic of China, was sensitive to these concerns. While the trip was postponed temporarily, as mayor I was delighted to receive the Dalai Lama and present him a key to the city upon his arrival in San Francisco in September 1979.

By then, Richard had known the Tibetans, Sherpas, and Nepalis for a decade and was very fond of them and interested in their plight. It didn't take long to understand why. In our talks together, His Holiness explained that, at its core, Buddhism espoused

A festival that includes traditional dances and horse races is held in honor of a high lama, Khyentse Norbu Rinpoche, who has returned to his monastery in Dzongsar, in Kham, eastern Tibet. Dzongsar was destroyed during the Cultural Revolution but has since been partially rebuilt by the local Khampas.

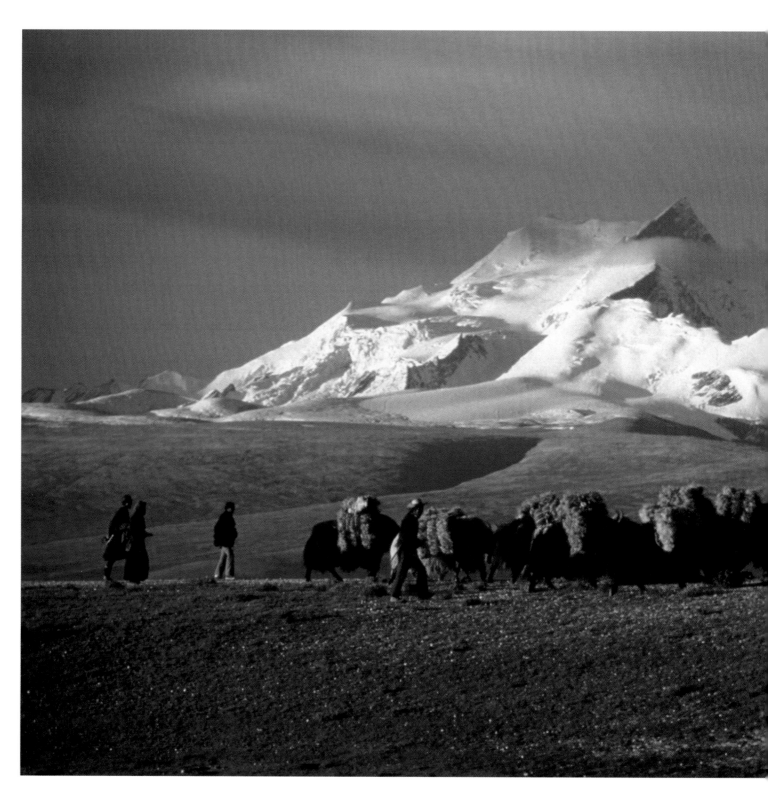

Yaks carry grass fodder beside Shishapangma, in western Tibet. The 14th highest peak in the world at 26,290 feet, it is known to Hindus as the sacred peak of Gosainthan. The Chinese first climbed it in 1964.

*Standing at this convergence of snow
and sky, I lift my face and feel afloat
like a passing cloud. Spirits soar in such
infinite space, one feels euphoric
in the cold clarity of the peaks,
and the silence speaks to the soul.*

—George B. Schaller

reaching out to help others, particularly the less fortunate. And it encourages us all to be more kind and compassionate. The Dalai Lama's persona exudes these qualities. He has a great sense of humor and responds quite spontaneously; his message of nonviolence is truly Gandhian. I have visited with him many times since 1978, and while his principled beliefs have never wavered, his teachings have become more expansive. His message has never been more relevant in our troubled world.

Richard and I met with many Tibetans in India and in Nepal. We spent about ten days trekking in Khumbu, or the Everest area of Nepal. The Sherpas there came from Tibet some 500 years ago. Their cultures are quite similar and their religious beliefs are almost identical to the Tibetans'. Everywhere we went, the local people were gracious, kind and deeply spiritual. In spite of the fact that the old Tibet was a feudal state and in deep need of political reform, the destruction of over 6,000 monasteries and the death of 1.2 million people in the Chinese takeover of Tibet under Mao is one of the great tragedies of our time. It should not be forgotten that until a century ago, China was a feudal state as well.

In December 1978, during my first week as mayor of San Francisco, Chai Zemin, the first Chinese ambassador to the United States, came to my office. Despite the fact that we spoke through a translator, we struck up a friendship that exists to this day. This somewhat chance meeting led some months later to the establishment of the first sister city relationship between a Chinese city, namely Shanghai, and an American city, which of course was San Francisco.

Following my first official visit to Shanghai in June 1979 as mayor of San Francisco, economic and cultural ties between our two cities moved rapidly ahead. The first Chinese direct air service soon came to San Francisco, and Chinese cargo ships began arriving at our port. The first Chinese consulate in the U.S. was also established in San Francisco. Two mayors of Shanghai, who became good friends of mine, went on to become senior leaders in the Chinese government, namely Jiang Zemin, as party secretary and president, and Zhu Rongji, as premier. Since 1990, my husband and I have had many discussions with Jiang Zemin and other Chinese officials about the status of the Dalai Lama and the plight of the Tibetans in and outside of Tibet.

Over the same period of time, because of his message of compassion and non-violence, the Dalai Lama has become one of the world's most acknowledged moral and spiritual leaders and is a recipient of the Nobel Peace Prize. In 1988, he officially renounced Tibetan independence. His desire is for peace and prosperity, and for his people to be allowed to retain their unique culture, language, and religious traditions. On three occasions I have hand-delivered letters from His Holiness to the Chinese

Children play in the courtyard ruins of Shide Monastery, in Lhasa, 1995. After the Chinese occupation, thousands of monasteries, nunneries, and chapels were destroyed, their contents removed to China.

leadership, asking for direct talks and reiterating that he did not seek independence for Tibet. I know that at the same time President Bill Clinton, President George W. Bush, and many others in our government have also encouraged a meaningful dialogue. For the most part, these efforts have had little success.

The Chinese mistrust of the Dalai Lama remains tragically misguided. If His Holiness the Dalai Lama were to return to Tibet, his wish is, as he says, to be a simple monk and to be involved only in religious and cultural matters. China will be a better nation if it will embrace the aspirations of its Tibetan people. In the meantime, organizations like the American Himalayan Foundation work to make life better for the Tibetans, wherever they are. The AHF has funded, and in many cases helped manage, hundreds of projects in the Himalayan region over the past 20 years.

I am very proud of my husband and the dedicated and talented team at the American Himalayan Foundation for what they have accomplished, and I commend all of those who have devoted their time and effort to better the lives of not only the Tibetans, but everyone living in the incredible region of this world called the Himalaya. ≜

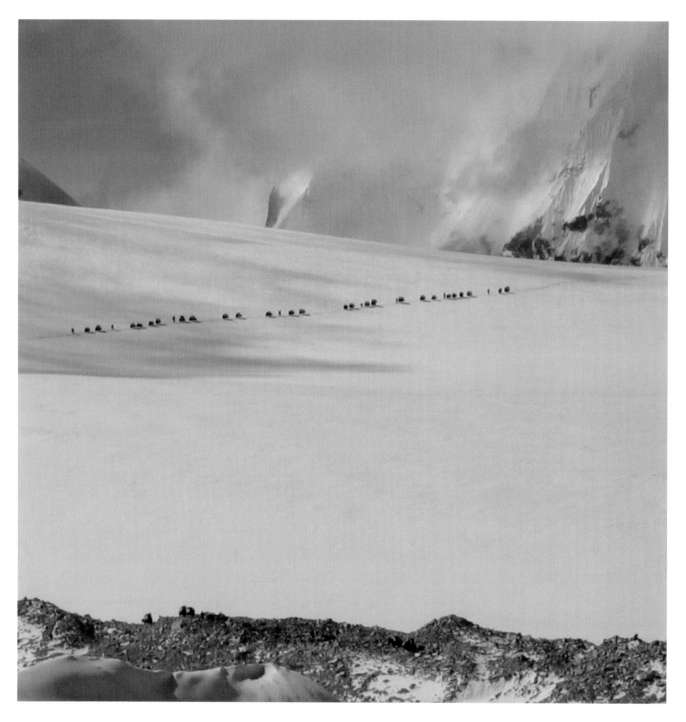

For cross-border trade, Tibetans and Sherpas negotiate the Nangpa La, a pass 18,750 feet high between Tibet and Nepal. Tibetan refugees seeking escape into exile also cross here, generally in winter. Some succumb to storms, suffer frostbite, or are arrested on the Nepal side of the frontier.

ESCAPE INTO EXILE

Tshering Dorjee

Tshering Dorjee, also called Tsedo, is a Tibetan born in exile in Nepal. As associate field director for the American Himalayan Foundation, he works closely with the Tibetan Refugee Reception Center, with the Tibetan Government in Exile, and with other Tibetan organizations in Nepal and India. He has also guided many trips to the Himalaya.

IN THE WINTER OF 1997, A YOUNG 22-YEAR-OLD MAN named Taga joined 15 other Tibetans from his native district of Kardze, in eastern Tibet, on a journey to escape Chinese Communist repression. They chose to make their escape in winter, because the rivers were frozen and easy to cross and the borders were less heavily patrolled. Winter is also the pilgrimage season, when the weather in India is mild and His Holiness the Dalai Lama confers teachings.

To reach Nepal and India, however, Taga's group had to traverse one of the world's highest—and most dangerous—border crossings, the 19,000-foot Nangpa La, a pass located to the west of Mount Everest on Tibet's border with Nepal.

After paying 800 yuan (about $100) each to a guide, Taga's group were led on foot from the plateau town of Dingri. They walked by night and slept during the day in order to avoid the Chinese border patrols. In canvas shoes and scant clothing, carrying biscuits, roasted barley, and dried yak meat, they departed across the expansive and desolate Tibetan plateau. After several nights of walking, they reached the Nangpa La.

"The sky was filled with stars and the weather was clear," Taga later recalled. "We felt relieved to reach Nepalese soil. Local yak herders told us that a snowstorm was expected, so we lay down on the snow and rested for four days."

The weather appeared to clear, so they resumed walking. But clouds rolled in and heavy snow again began to fall. The group tried to keep warm as they trudged on quietly, not knowing how far they would be able to go—or even if they would survive.

"After walking through the snow for two days," Taga said, "two girls in the group dropped to the ground, exhausted. Aged eight and ten, both had been sent from Lhasa by their parents, with no relatives accompanying them. I bent down and touched their trembling bodies. They were hard and cold, and blood was coming from their noses."

The next day, the guide goaded the group to move faster, in order to reach the dry terrain below snow line. The two girls could not keep up. But if the group waited for the girls, the guide said, the rest of them would risk freezing to death. The girls only cried out in helplessness, not having enough strength to even plead with the guide. In an excruciating moment, the guide decided to continue on. But Taga couldn't imagine leaving these two young girls in the mountains to die.

"I argued with the guide," Taga said, "then offered to stay behind with the Lhasa girls. Chimi, my childhood friend, insisted that she stay with me, too, but I forced her to go ahead with the group. The two girls and I watched as the rest departed."

The girls cried, and Taga held them tight for warmth. After they gained a tiny amount of strength, the three began walking slowly. Taga carried the younger one on his shoulders while holding the hand of the older. For three days they slogged through the snow, taking shelter in caves. On the morning of the fourth day, the ten-year-old girl did not awaken. She was cold and motionless. She had died.

For two more days, the eight-year-old and Taga pushed their way through the snow, but she continued to lose strength. Then one morning she, too, didn't awaken.

"The faces of these two innocent girls were incredibly painful for me to see," Taga said. "It's an image burned into my eyes. Even today, my thoughts wander to those nights in the mountains, and they haunt me."

The night after the second girl died, Taga lay alone in a cave. His legs had grown numb, and then hard, and his pants froze to his thighs. Soon he couldn't stand.

Two yak herders who were transporting goods from Tibet to Khumbu came to take refuge in the cave. They had lost many of their yaks in the blizzard. Seeing Taga's inability to move, they placed him on a mattress pad and dragged him on the snow to a village. As they were dragging him, Taga saw the body of Dolma Chozom, a 13-year-old girl from Kanze who had been part of the group he set out with. Unable to help her, the Tibetan refugees had left her behind in the snow as well. A few hours later, he saw another body on the snow—a 15-year-old girl from Lhasa. Their group had lost four young girls.

Eventually, the yak herders and Taga reached a village where he was reunited with the group. He found his beloved childhood friend and future wife, Chimi, and they cried and hugged each other. The group was exhausted and deeply saddened by the loss of the girls. It would take an additional seven days to reach Lukla and begin the trip to Kathmandu. Taga's legs were still numb, and Chimi carried him most of the way. Along the path to Lukla, the group lost yet another member when a 17-year-old boy, Sonam Tashi, died after his neck became severely frostbitten.

In Lukla, Taga was placed on a wooden stretcher, and three people in the group carried him southward into the subtropical jungle. From there he was evacuated to the Tibetan Refugee Reception Center in Kathmandu. Nurse Tsering Lhamo of the reception center called to tell me the story of Taga and his ill-fated group. We took him to the hospital, where Dr. Ashok Banskota provided care to him. But both Taga's legs had been frozen, and they had to be amputated.

In northeastern Tibet, seminomadic villagers feel fortunate to snag a lift in an open trailer. Life on the Tibetan Plateau is characterized by abrupt weather changes—from sandstorms to snowstorms, from searing heat to bitter cold.

After the amputation, I saw Taga in his hospital room and found him smiling and happy, overwhelmed with gratefulness for the care and help provided by the Tibetan community in exile and by Dr. Banskota. "It feels like home, here," Taga declared. Then tears welled in his eyes as he thought of those who died en route. "Why did others have to suffer and to die?" he asked. "Why couldn't I have been the only one to suffer?"

Now Taga had to start anew, in another world. After several months of treatment, he was fitted with artificial legs. Then he and Chimi departed for Dharamsala to receive blessings from His Holiness the Dalai Lama and begin their new life.

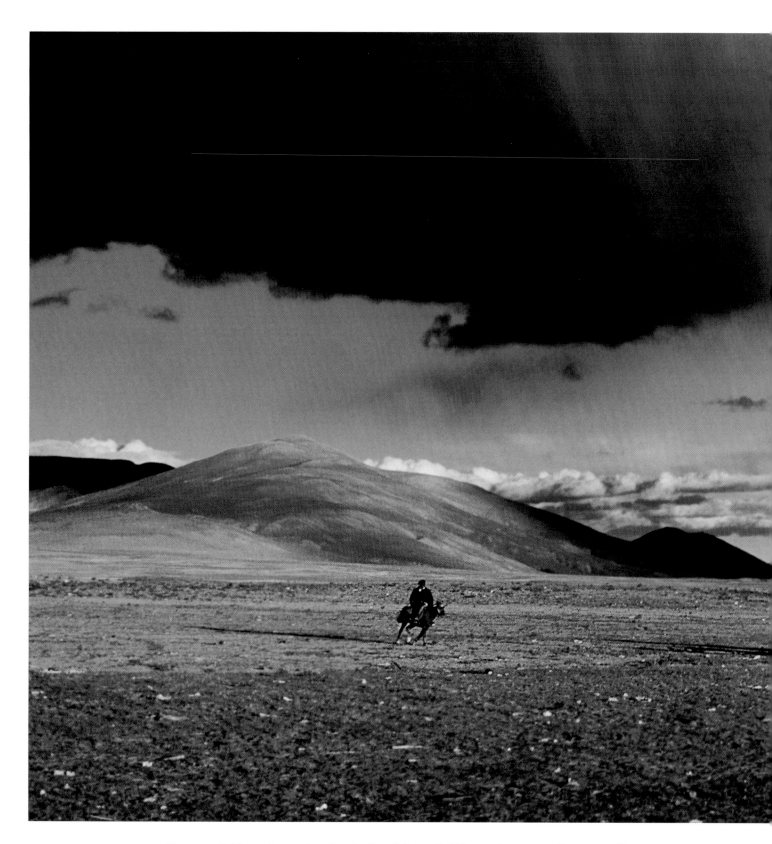

Horses gambol beneath ever-changing clouds and sky on the Tibetan plateau near Bayang, a village at over

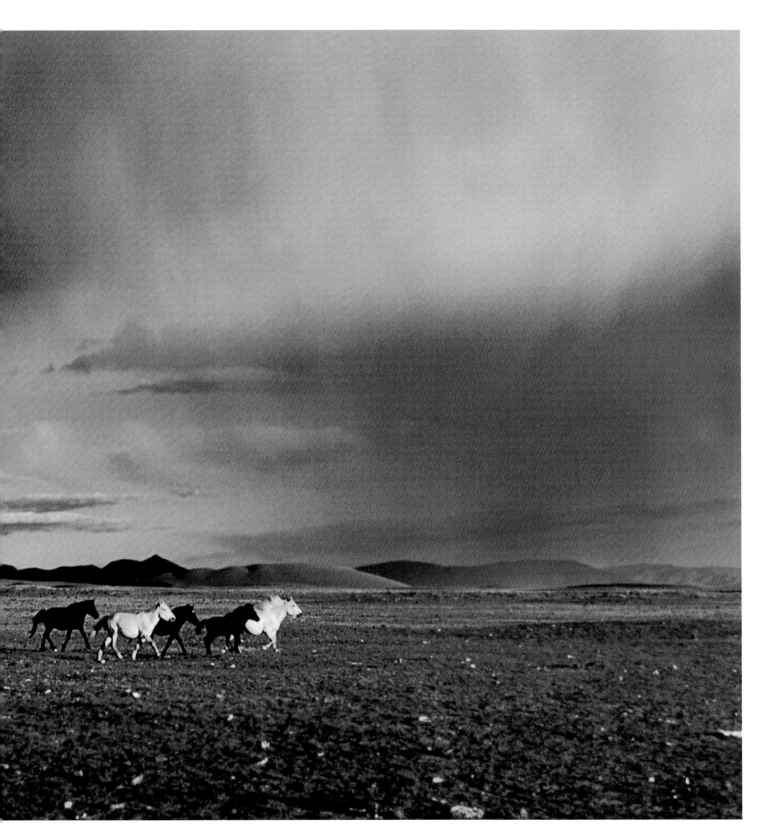

15,000 feet elevation along the pilgrimage route to Khang Rinpoche, or Mount Kailash, in western Tibet.

In Dharamsala, Taga was granted admission to the Norbulingkha Institute, so he could enroll in a six-year intensive course in painting thangkas, or traditional Buddhist scrolls. At the same time, Chimi learned sewing and tailoring. Supported by the American Himalayan Foundation, Taga is now in his sixth year as a student at the institute, while Chimi runs a small café nearby. They have two daughters, aged three and five.

"I miss my native home in Tibet but am content to be living close to His Holiness the Dalai Lama. It is because of His Holiness's blessings that we have hope," Taga recently said. "I wish that all the Tibetans in Tibet will soon be able to be free." Pausing, he added, "I have no regrets about losing my legs. I mainly regret that I was unable to save the two girls."

Every year, 2,000 to 4,000 Tibetans travel from Tibet over the Nangpa La and other high passes through the Himalaya. Many of those who make the journey are children. Most of them are not as lucky as Taga, even if they make it safely to Nepalese soil. Some are arrested by the border patrols, interrogated, tortured, and imprisoned. Some are fired upon by security forces. After long incarcerations they are sent back to their Tibetan villages, and they still must pay a huge fine. But they continue to come, seeking what the Chinese have deprived them of at home, despite official policy: religious freedom, economic opportunity, and a decent education in their own language.

The fortunate ones who make it to Kathmandu arrive at the Tibetan Refugee Reception Center and, with support from the United Nations High Commissioner for Refugees, they are clothed, vaccinated, and interviewed. From there, they travel to India for an audience with His Holiness the Dalai Lama and often enroll in a school or monastery and begin a new life. Many of their stories go unreported, due to the refugees' fear of capture.

But every winter, families from all over Tibet continue to send their children on the same journey taken by Taga and Chimi. All of those people, parents and children alike, remain hopeful of receiving blessings from His Holiness the Dalai Lama and an opportunity for a free life.

Tibetans in Tibet are continuing to feel marginalized and vulnerable, and find it difficult to live in their native land. In 2005, 3,400 Tibetans passed through the reception center. I feel fortunate to be working to improve conditions in the Tibetan refugee camps, but work at the reception center is the most rewarding, as it provides an opportunity to help those brothers and sisters who have recently escaped from Tibet, just as our parents did some 46 years ago.

JOURNEY TO MY HOMELAND

Dechen Tsering

Born in Nepal, Dechen Tsering was educated in India and completed her master's degree in public health in the United States. She worked for six years as program manager for the Seva Foundation in Berkeley, California, which pioneered eye care in the Himalaya. She is currently a program officer for the Global Fund for Women, which supports women's rights organizations around the world.

Tibetan women from Kham laugh together in the Barkhor, the market around Lhasa's central cathedral.

As I drove from the Gongkhar airport to the heart of Lhasa, small Tibetan villages floated past me like images from a dream—traditional flat-roofed, stucco houses with windows trimmed in black. Prayer flags in colors representing the five elements fluttered in the crystalline wind. Ruddy children in yak-skin *chubas* played in open courtyards. And for the first time in my life—yaks! My eyes dwelled on these shaggy animals and their red tassels, woven into the hair on their heads. I envisioned my parents' growing up not far from here; my father could have been one of these scruffy boys.

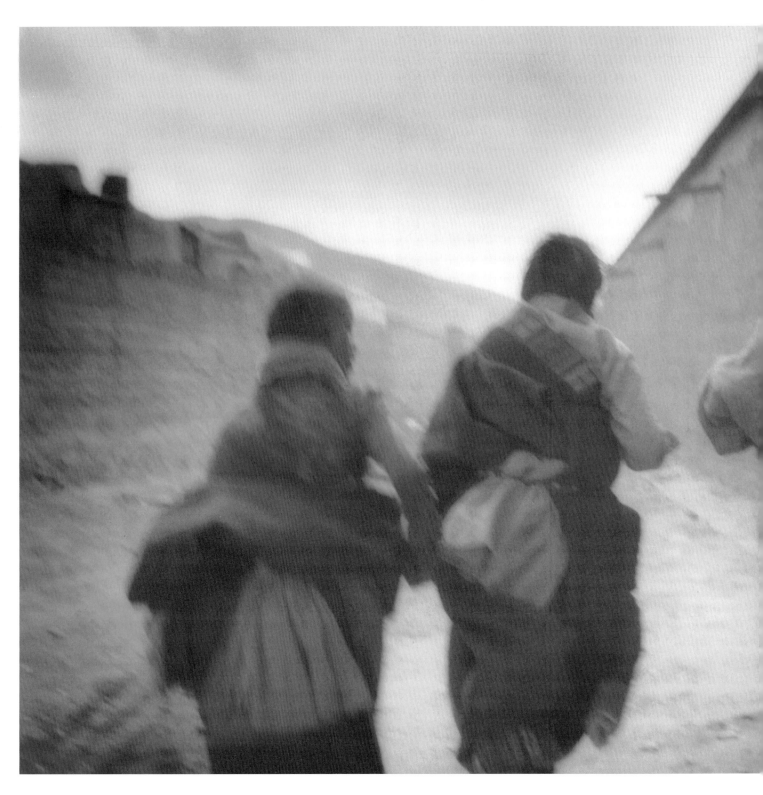

Tibetan girls at Labrang, a Gelugpa sect monastery in Amdo, Tibet, race through back alleyways to meet up with a procession of lamas at the Monlam "Great Prayer" festival, held each summer.

The greater the force of your altruistic attitude
toward sentient beings,
the more courageous you become.
The greater your courage,
the less you feel prone to discouragement
and loss of hope.
Therefore, compassion is also
a source of inner strength.

—His Holiness the Dalai Lama

Miles before reaching Lhasa, I caught sight of His Holiness the Dalai Lama's Potala Palace. Even from that distance, the majestic and legendary edifice, spiritually important to all Tibetans, towered over the landscape. The cloudless sky was brilliant blue, the lake we rested near was refreshingly clear, and the mountains behind the Potala loomed large, graced with a film of snow as if waving a silk *kata* scarf over the city. A landscape bathed in natural holiness.

Let us try to recognize

the precious nature of each day.

—His Holiness the Dalai Lama

I was here to research the impact of western medical theories on the practice of traditional Tibetan medicine, but the trip also provided the opportunity to deepen my Tibetan roots. My parents had fled Tibet in 1959, and I hoped my summer here would help me see a little of the Tibet they had known.

The Mentzikhang, Lhasa's traditional hospital, was a good starting place. I was asked to interpret for a Western ophthalmologist from the Seva Foundation who was conducting surgical training for traditional Tibetan doctors.

As I had never observed bloody eyeballs, someone prepared me with a bottle of water and candies to keep me from fainting. For most of the morning, I stood peering over the surgeon's shoulders, interpreting for the Tibetan doctors every surgical step he was performing. The complexity of the procedure was fascinating and with each additional surgery I grew more comfortable. Two days after the surgeries, the patients gathered again to remove their eye patches. Their disbelief at rediscovering the miracle of sight brought tears of gratitude and beaming smiles of joy.

During the research, I observed the continuing reliance on traditional forms of treatment and the popularity of adding modern technology. There were three generations of Tibetan doctors at the Mentzikhang: those trained as medical apprentices of historically renowned traditional doctors; those trained in the Chokpuri School of Medicine near the Potala Palace; and the final group trained after the Chinese occupied Tibet. Traditional medical practices continued, yet there appeared to be a de-emphasis of the spiritual rituals practiced by the senior generation of doctors. Tibetans of my generation living in Tibet were learning to straddle the world of tradition and change, much as I have been, living in exile.

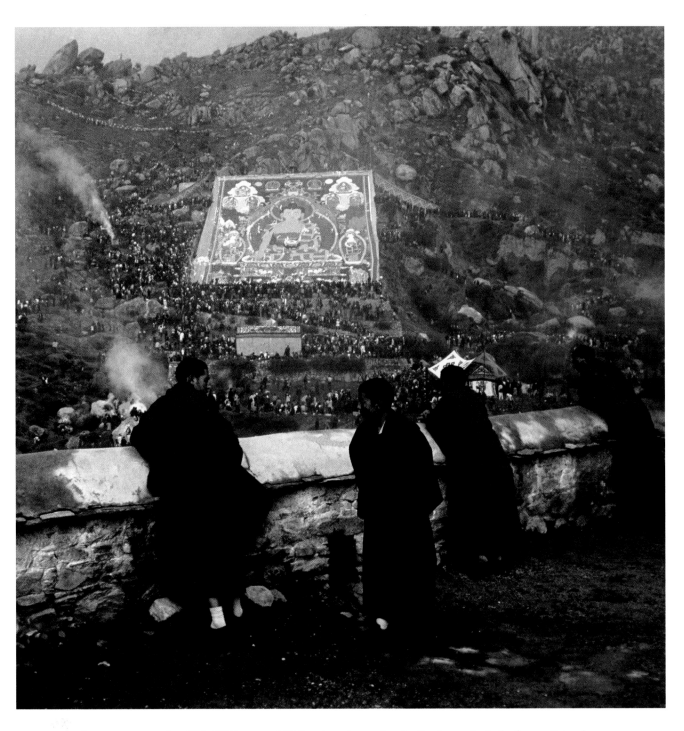

In recent years, a handful of Chinese prohibitions have been relaxed, allowing revival of a few traditional ceremonies and festivals. At Drepung, Tibet's largest monastery, near Lhasa, thousands of Tibetans gather to witness the annual summer unveiling of a kigu, *a giant appliqué thangka.*

Growing up, I heard that we had many relatives still living in Tibet, and my parents were always hosting guests from Tibet. Some were real relatives, others were close family friends; we were never alone. However, it was not until I arrived in Tibet that I realized the full extent of my extended family. I was among the first to visit Tibet since they had escaped into exile in 1959.

Keen to find my mother's birth home, I ventured to the town of Shigatse, where she was born and raised until she fled Tibet. The dialect in Shigatse is sweet and endearing, with a singsong ring. I had grown up speaking only the central Tibetan dialect, but I got by with feeble attempts at the Shigatse speech as I walked through the Tibetan market. There, *amalas* and *achalas*—mothers and elder sisters—wore beautiful ornaments, many of which looked "newly old."

My mother had mentioned that those most likely to remember her family were the elders, but it was a young woman who recognized my family name, and she led me to her grandmother, who knew my maternal family. I was thrilled. The amala's speech became more and more animated and her dialect more strong, until I could barely understand what she was saying—though I could tell it was good. I followed her bent-over body down a winding alley of dirt path between several traditional Tibetan homes. We meandered between earthy stucco walls, some patched with circular slabs of fresh yak dung. Its smell, the incense, the scent of the mountain earth, and the playful laughter of Shigatse children conjured images of my mother running around in her little bare feet as a child.

On the mazelike path, my guide shared with me that my maternal family were respected members of the community, and that my grandmother was always generous toward others. But times have changed, my guide put it cautiously. Eventually, she indicated a large gate that looked like a monastery doorway with large bronze ring handles with colorful tassels. I peered curiously through the slim openings between the locked gates, and though the original house had been torn down several decades ago, for a brief moment I enjoyed a vision of my mother as a little girl running through the courtyard. I felt a warmness experiencing my mother's home, and felt blessed at being able to share my image of it with her upon my return.

My journey to Tibet was a personal pilgrimage of discovering, paying homage to, and experiencing the land of my ancestors. The journey deepened my Tibetan identity in ways that were subtle but certain. As I drove past the ruddy chuba-clad boys on the way back to Gongkhar airport, I knew that my parents would vicariously experience their reconnections to Tibet through my stories. Times had indeed changed. In a strange reversal, I was the one bringing Tibet to my parents.

SHERPAS IN THE NEW WORLD

Ngawang Tenzing Zangbo

Ngawang Tenzing Zangbo, the Incarnate Lama of the Tengboche Monastery in Khumbu, took his Buddhist training in Tibet at the Rongbuk Monastery, on the north side of Mount Everest. He returned to Tengboche and, in addition to overseeing more than 40 monks, for half a century he has been meeting climbing expeditions from around the world, beginning with the Swiss Everest expedition in 1952.

Om Mane Padme Hum Hrih—*Hail to the Jewel in the Lotus. At Tengboche, in Khumbu, a hand traces the features of a* mani *stone incised with Tibetan Buddhist prayers.*

BEFORE SHERPAS IN KHUMBU WERE INTRODUCED to the modern world, they lived a life that was closely connected to nature, a life that had to focus entirely on survival and basic needs. In a sense, they could be considered as living in ignorance—but a beneficial sort of ignorance in that it provided them with direction; it gave them a focus.

In those days, the Sherpas were a simple, straightforward people, and they were protected from misfortune in part because of Khumbu's location within a *béyul*, a hidden valley, a peaceful sanctuary where the teachings of Buddha could thrive. But their

*In Sanskrit, Himalaya means
"abode of snow," and in Tibetan we call it
Gangchen Jhong, or "Land of Snow."
The mountains, and our land,
shape our identity as Tibetans.*

—Lodi Gyari Rinpoche

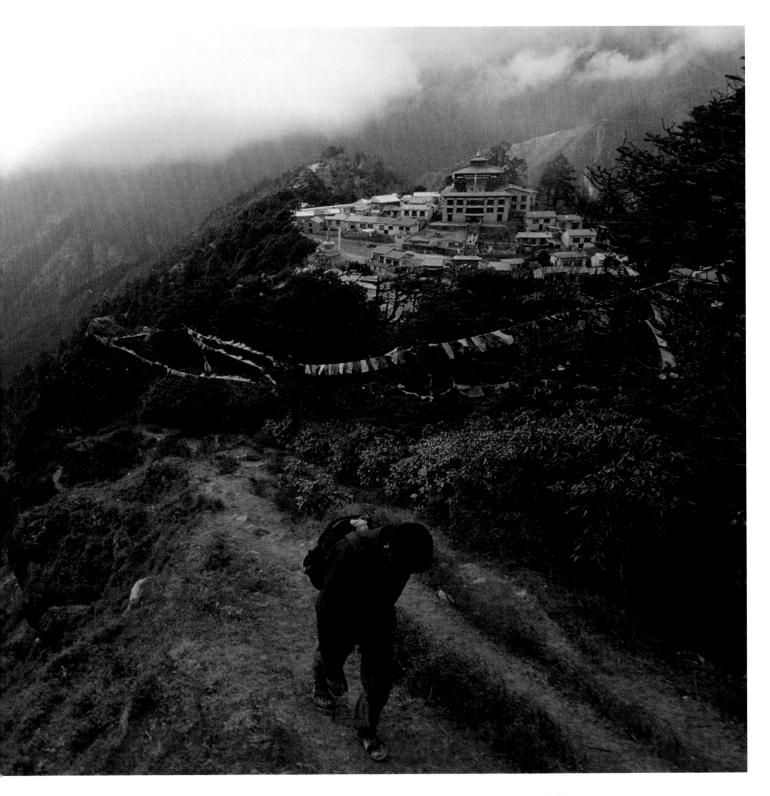

Tengboche Monastery, built in Khumbu in 1912 by a lama from Tibet's Rongbuk Monastery, is a center of Buddhist teaching for the Sherpas and a highlight of the trek-pilgrimage to Mount Everest.

ignorance came with a great risk. When new people, ideas, and influences, especially regional and national politics, began to enter the area, the Sherpas had little facility for distinguishing good from bad, or real from fake.

In Tibet, it may be that the practice of Tibetan Buddhism, or dharma, over the past couple of centuries drifted away from the true spiritual ideals that were being taught. It may be that the collective karma of Tibet created an opportunity for the Chinese to occupy their country. Distressingly, a similar series of circumstances and developments seems to be occurring in Nepal. I feel that the turmoil that Nepal is undergoing, and the individual suffering of many around the world from disease and warfare, is partly a result of this drift away from dharma.

In order to bring people back to dharma—and by that I mean the actual practice, the application of religious principles—we may have to reinvent religion to some degree. We need to establish and demonstrate a real connection between religious practice and real, sustained peace of mind. The best way for people to achieve this is to feel and experience the nature and workings of dharma firsthand. Those who are interested should investigate and question before they simply subscribe to Buddhism, or to any other religion, for that matter. If what they find in their inquiry truly helps them, they will have secured a long-lasting devotion that is rooted in belief and in personal experience.

This is a long process, however, and I wonder if people nowadays, amid all the distractions, have the necessary patience. Most agree with the advice of the Dalai Lama, for instance, and they urge others to follow his example. But how many really put his words into practice?

The call of the modern world, and change, are at the source of the challenge we all face. I'm not saying that we should reject all things new and modern and return to a village life of traditional subsistence. But we need to be careful about what we abandon in the pursuit of our livelihoods.

The velocity of modernity and change has reached the point now that we truly need to be especially concerned about losing our language and culture—the very foundation of our identity. Yes, Sherpa culture and language will probably continue in some form, but will it remain at the heart of who we are as a people? Or will other interests and other languages and cultures draw us away? Many Sherpas live outside of Khumbu most of the time now—in Kathmandu and in the United States and Europe—and even the Sherpas who remain here are increasingly drawn away in spirit and thought.

Dharma and religious practice are at the heart of our culture, and I fear this loss most. I'm not worried that donations to Tengboche or other monasteries of Khumbu might dry up. Support for our monasteries waxes and wanes all the time. I'm concerned

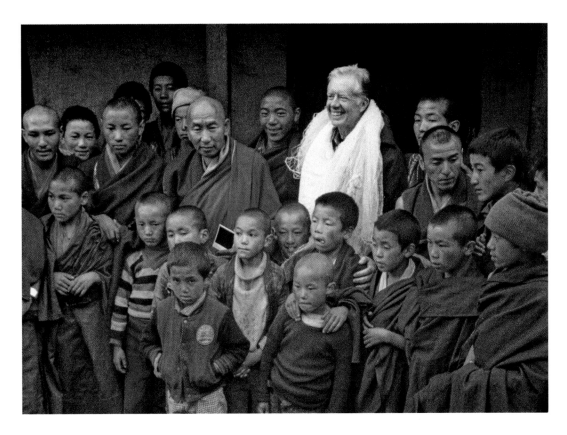

President Jimmy Carter is feted with blessing scarves by the Incarnate Lama and monks of Tengboche. Carter found the people and landscape of Khumbu to be startlingly vivid and unforgettable.

only that each individual's commitment to the Buddhist teachings and their practice of compassion and selflessness not be lost. Striving to preserve this engagement with dharmic thought and practice motivates all that I do.

Foreigners have the luxury of perspective, and they can see the loss of Sherpa culture—at the same time that they see their own role in this process. Fortunately, many Sherpas, too, are beginning to recognize what's at stake in the loss of their traditions, if only because they can see examples of it already happening.

This concern has inspired me, along with two accomplished monks from Tengboche, to write a comprehensive Sherpa language dictionary. Even if our spoken language is lost, at least we will have this record. Hopefully, it can act as a link for those Sherpas who have moved away and forgotten their language, and especially for their children. If Sherpas remember their language and culture, I feel they will also remember their Buddhist teachings and the value of dharmic practice.

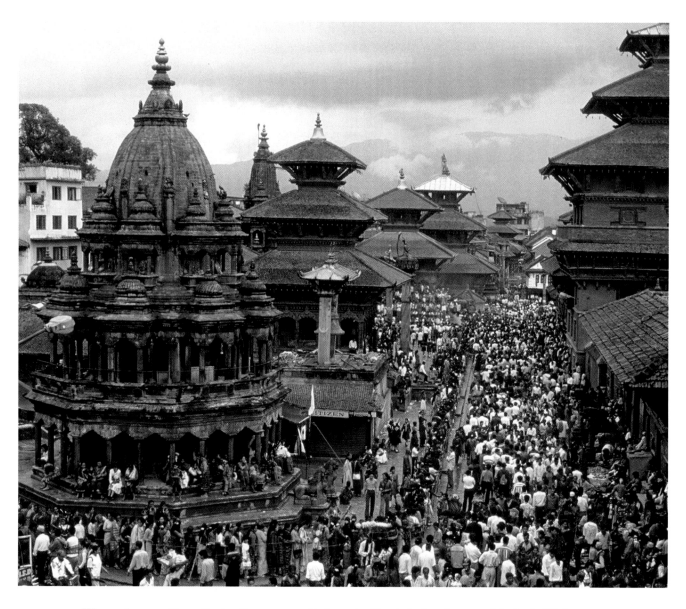

Women throng to Patan Durbar Square, near Kathmandu, Nepal, during the annual festival of Teej. Devout Hindu women, wearing their red wedding saris, engage in rituals to bring about a happy and productive marriage, good fortune, long lives for their husbands, and purification of their bodies and souls.

NEPAL'S DESTINY

Bhekh Bahadur Thapa

Bhekh Bahadur Thapa was born in 1937 in Nepal and has served as minister of finance and minister of foreign affairs for the kingdom of Nepal. He was the royal Nepalese ambassador to the United States and to India, and he worked in Sri Lanka as representative of the secretary-general of the United Nations.

WHILE A STUDENT IN THE UNITED STATES nearly 50 years ago, I was surprised to learn that whereas most Americans were aware of the Himalaya and had a vague sense that Shangri-la was located in these mighty mountains, few had heard of Nepal. Even in the late 1980s, when I served as Nepal's envoy to Washington, I recall President Ronald Reagan telling me, "I'm afraid, Mr. Ambassador, that my knowledge of Nepal is limited to *Lost Horizon*."

"Mr. President," I responded, "My king has sent me to your country to update that."

Today the land where Lord Buddha was born is more familiar to Americans and around the world, but it is also caught up in a war with itself and, unfortunately, is becoming known as "the land of the killing terraces."

In the 1990s, Nepal entered into a promising—and historical—political phase. Following a wave of protest by political workers and citizens, King Birendra instituted a new constitution. It declared the Nepali people democratically "sovereign" and designated the monarch as the "protector of the constitution." Parliamentary elections were held, and governance shifted to the majority party. As the Berlin Wall was being dismantled, Nepal, too, was embracing—and being embraced by—the global movement for democracy.

In spite of teething troubles, Nepal gamely forged ahead, moving from one polity to another in an attempt to establish a new social and economic order. But each elected government was barely more effective or honest than its predecessor. Around that time, taking advantage of signs of discontent among the people, the Maoist party of Nepal posed an unexpected and serious challenge to the new constitutional forces. In 1996, these Maoists launched an armed movement, with the objective of establishing a people's republic.

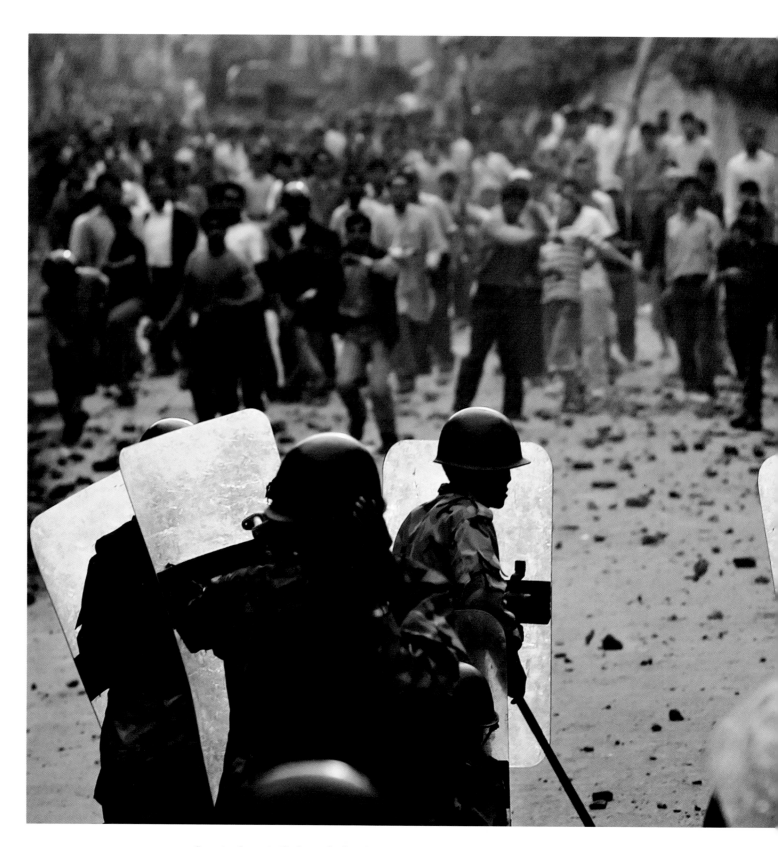

Security forces in Kathmandu face down demonstrators of the Jana Andolan, the People's Movement,

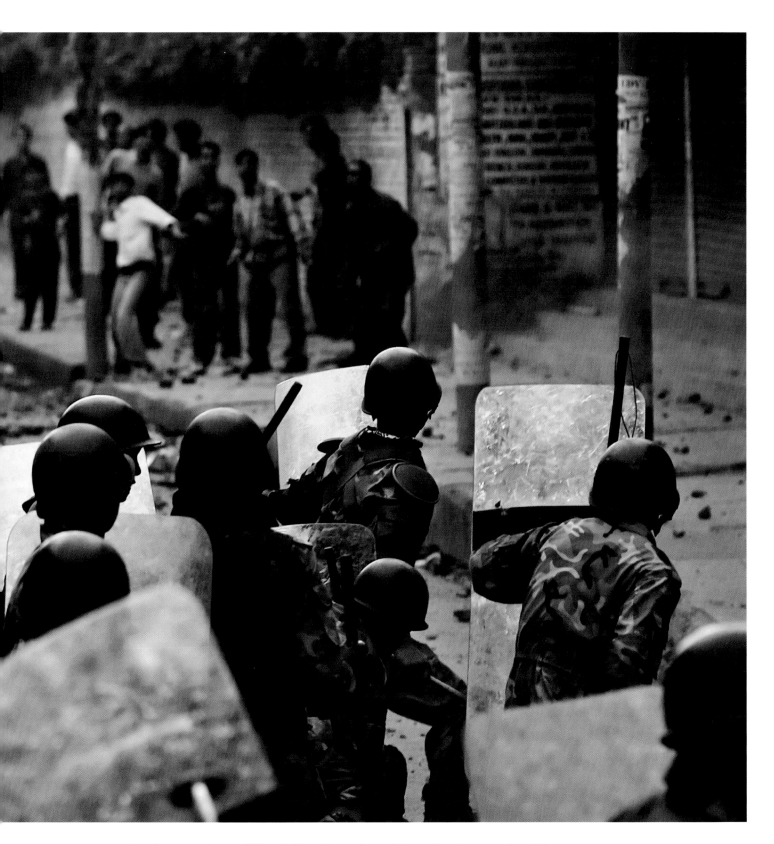

protesting the autocratic rule of Nepal's King Gyanendra and demanding the restoration of democracy.

In the ensuing decade, Nepal has seen over 13,000 citizens killed and countless more displaced from their homes. Nepal has lost its peace, its social harmony, and its economic balance.

Initially this conflict was bilateral, between the parliamentary forces and the Maoists, but in early 2005 King Gyanendra, brother to the deceased King Birendra, dissolved the parliament and took active control of the government. There were then three sides in the struggle, with each side claiming empowerment through public support. Of these three, the monarchy and the Maoists are armed, while the political parties are uncomfortably caught between the two.

At present, the country is operating on the margins of the constitution, and the need for a new constitution—or acceptable amendments to the present one—has become obvious. Now the divisive process of agreeing to this is at the heart of the conflict.

The war is not winnable by any party, and a protracted conflict will only weaken Nepal. There are indications that the Maoists recognize that India, China, and the international community will not support their objective of a one-party dictatorship, and therefore they could be looking for a political solution and accommodation. If this thinking indeed represents the changing view of the Maoists, dialogue and settlement can ensue.

No single formula will instantly bring everyone to the table, but the shared desire for peace should be a good starting point. The persistent calls for conflict resolution by Nepali citizens and the international community appear to have made some impact. The decade-long conflict has begun to reveal signs of fatigue—and even occasional glimpses of wisdom—on the part of the opposing parties.

In September 2005, the Maoists called for a unilateral three months' ceasefire, which was looked upon by the state with skepticism. In those three months, violence and the number of deaths declined sharply, while economic activities and social mobility revived. Also during this time, the Maoists and an alliance of seven political parties entered into a loosely drafted 12-point memorandum of understanding. It was designed to put pressure on the state to extend the ceasefire and accommodate the Maoists politically. These steps raised expectations among the people, but the prospects for dialogue and peace were dashed when government leaders boasted that the ceasefire was a sign of Maoist weakness and that the government had "broken the backs" of the Maoists.

This provoked the Maoists. Violence resumed in January 2006. There remains a palpable sense of disappointment over the lost opportunity for peace.

Nepal's political crisis has resulted in a human rights crisis. As our neighbors witness this ongoing tragedy, anxiety grows about possible spillover effects. Western democracies are becoming increasingly concerned about the erosion of human rights and democratic values. The Maoists have asked for mediation by the United Nations, but the state has consistently rejected the involvement of a third party. No nation, however, can survive in isolation from global trends, whether they are political, economic, social, or environmental. The network of world organizations and conventions to which Nepal is a party needs to be a part of the solution for peace.

Tentative hopes: In April 2006, Nepal's Seven Party Alliance, united in support of a popular uprising against the king, secured reinstatement of the Lower House of Parliament and a new constitution.

The confrontational course between the state, the Maoists, and the political parties has reached a difficult and delicate stage. All sides of the conflict are sticking to their agendas, pursuing their separate goals with alarming stubbornness. The prospect for peace appears dismal, and the future may bring more violence than the recent past. That is the reason all parties must search for a solution with vigor. By establishing a neutral common agenda as the basis of dialogue, the Nepali people can establish their own base camp, metaphorically, and move up the peak toward peace and prosperity together.

It is a challenge of Himalayan proportions—but not insurmountable.

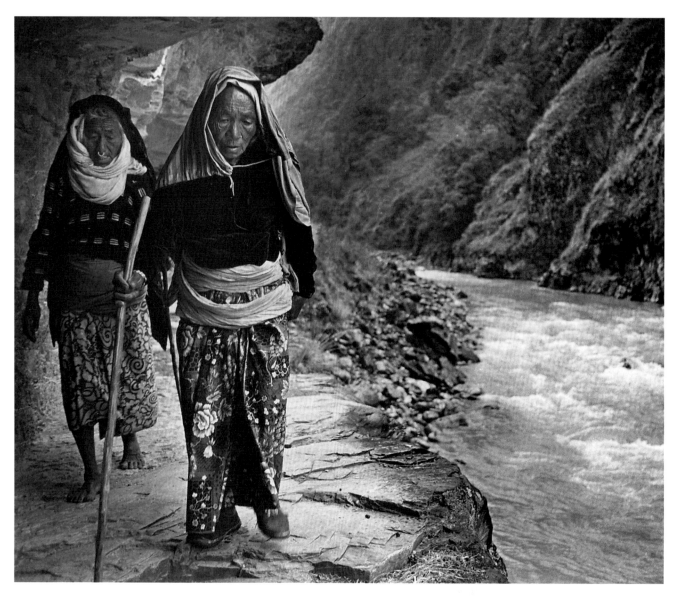

Aama and her cousin, of the Gurung tribe, trek along the Kali Gandaki River Gorge to the shrine of Muktinath.
The Gurung worship Hindu deities but are considered to be of lower caste than the Brahmins and Chhetris.
When Aama visited America with Broughton Coburn, she was surprised by the absence of castes.

CASTE IN NEPAL

Manjushree Thapa

Manjushree Thapa is the author of three books: *Forget Kathmandu: An Elegy for Democracy, The Tutor of History,* and *Mustang Bhot in Fragments.* The second of these, *The Tutor of History,* is considered the first major novel in English to emerge from Nepal. She coedited an anthology, *Secret Voices: New Writing from Nepal,* and has also translated Nepali fiction into English. She is based in Kathmandu.

WHEN I MEET STRANGERS IN NEPAL, it always strikes me that everyone asks, with great interest, "Where are you from?" and "What is your name?" And they are not content with cursory answers. "Which part of the Baneswor neighborhood do you live in?" they will ask. "The old part or the new? What kind of Thapa are you? Is your father descended from the eastern Thapas or the western ones?" The most avid even ask for my *gotra,* the lineage name that dictates who Hindus can and cannot marry (if they follow tradition). The answers to all these questions allow people to determine my exact place in society—which seems to reassure them, makes them feel like they know who I am.

This habit, seemingly quaint and innocuous, has its dark aspects. It arises, obviously, out of the immense stratification of Nepali society. We have so many caste and ethnic groups with so many small subdivisions of their own, we can't keep track of them all. But our need to place each other also betrays a deeper value system. We tend to believe that a person's character rests not in his or her individual traits or accomplishments, but in the caste, ethnic, or regional identities that the person inherited. We are, as it were, where we were born.

To some, their inherited identity is a source of pride. The ruling families—the Shahs, the Ranas, and other courtier families of the Chhetri, or Kshetriya, caste—have long celebrated their clans' power. The Janajatis, or ethnic tribes, have also in recent years rallied around their diverse languages, religions, and cultural practices. The Janajati rights movement, which has gathered force since 1990, has been able to inculcate in members of even the least powerful ethnic tribes, such as the Tharus of the western Terai, the same pride as in members of the most well-established ethnic tribes, such as the Thakalis of Mustang, the Gurungs of the western hills, or the Newars of Kathmandu. Thanks in large part to this movement, Nepali national identity is now seen as a mosaic.

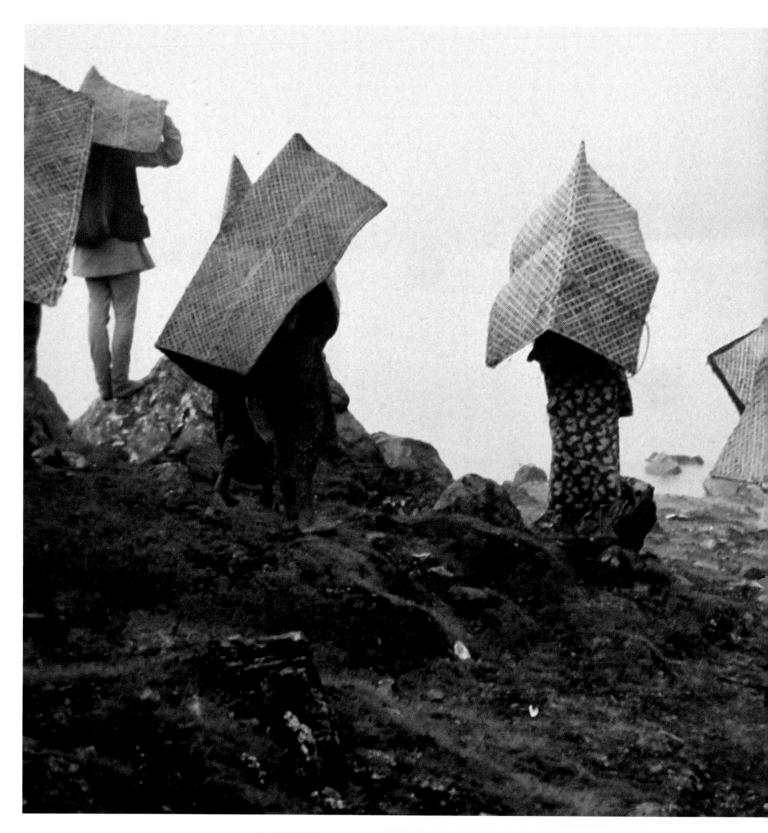

Hindu pilgrims arrive at the sacred lake of Dudh Kund, at 15,022 feet, near Khumbu. The next morning,

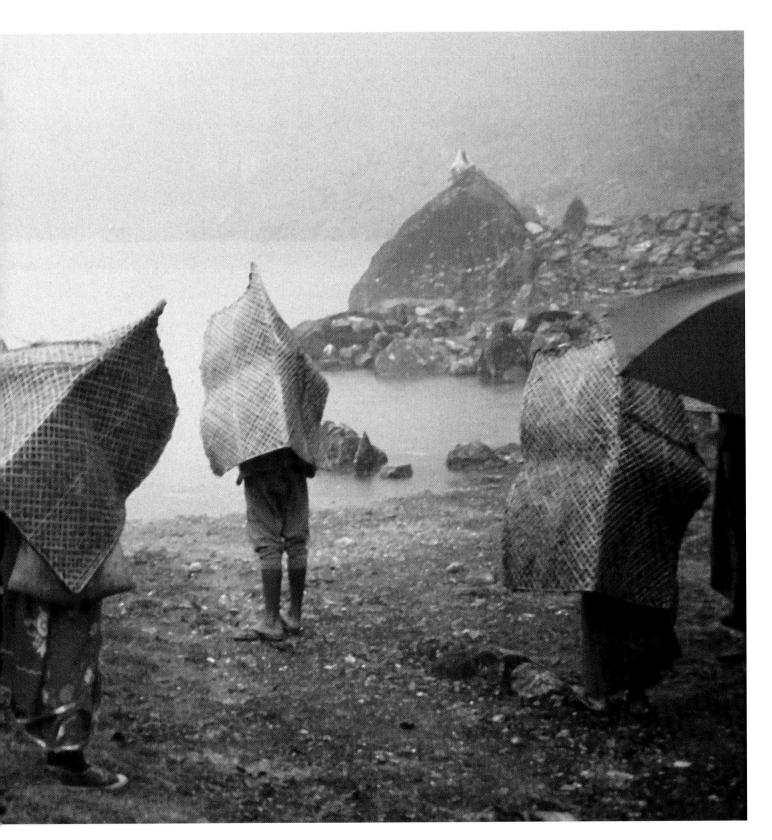

on Janai Purni, the sacred full moon of August, they will purify themselves by bathing in the freezing water.

Yet to many others, their inherited identities remain a source of some discomfort. The Hindu caste system places the Bahuns, or Brahmins, at the top of the hierarchy and Dalits, or untouchables, at the bottom. The law does not sanction caste discrimination, but it is very much in practice throughout Nepal.

The Dalits make up at least 13 percent of Nepal's population and perhaps as much as 20 percent—the official statistics are contested. They have traditionally been involved in caste-dictated occupations: the Sarkis are shoemakers, the Chamars dispose of carcasses, the Damais are tailors, the Badis are musicians and dancers. Nowadays many

Young men in Kathmandu shave their heads after a parent dies. To
pull the grieving person from the underworld, a topknot is left behind.

Dalits eschew traditional caste occupations, but most Nepali villages still have Dalit households who are engaged in these jobs.

The Dalits' social standing varies across regional and economic conditions throughout Nepal, but they suffer similar forms of discrimination arising from the belief that they are impure and untouchable. They are not allowed into the houses of many of the people of the "higher" Hindu castes or into the houses of many Janajatis. In many villages they are not allowed to take water from the common tap or well. Dalit children are sometimes barred from schools and often made to sit apart from other students. In the towns and cities, landlords are loath to rent to Dalits, and hotels and tea shops are unwilling to house and feed them. Even otherwise modern people often refuse to open

their lives to them: For instance, office workers will not invite Dalit colleagues home, or even share food with them in office canteens.

So pervasive is discrimination against Dalits, and so entrenched, that what results is nothing less than the segregation of the Dalit population from the mainstream of Nepali life. There are almost no Dalits in government, in the political parties, or in public office. Dalits are almost entirely excluded from the nongovernmental sector; even NGOs that work in Dalit areas and advocate Dalit rights have been woefully understaffed with Dalit professionals, especially at the higher echelons. The private sector is similarly devoid of a significant Dalit presence.

Segregation works in insidious ways. Even modern Nepalis who would never think to treat anyone as untouchable do not question why this is so, because they simply never meet Dalits. Their absence is taken as a given.

The Dalit rights movement—which like the Janajati rights movement came to the fore after 1990—is trying to reverse Dalit segregation. In the past few years, Dalit activists have brought wide attention to cases of discrimination throughout the country, lobbying local and national organizations to redress wrongs and change policy in favor of Dalits. There is still a long way to go, but the movement is gaining ground. The formation of the National Dalit Commission in 2002 is one milestone.

At the local level, though, caste discrimination remains pervasive, often occurring in surprising places. When I worked in Mustang for the Annapurna Conservation Area Project, funded by AHF, I noticed a community of people who lived outside Lo Manthang's walled city, in a flood-prone gulch beside the river. "The river people," the locals called them. They would sing and dance at weddings and festive occasions, but they were considered to be of lower status than the rest of the population. Unlike the situation in Hindu communities, they were allowed into people's houses. But they were nevertheless looked down upon. It struck me as an imprint of the Hindu caste system in a Buddhist society.

There is a great national debate going on in Nepal these days about democracy. The political parties are trying to reestablish democracy, while the monarch and the Maoists prefer other more authoritarian forms of government. Yet the debate too often focuses on the form of democracy, ignoring questions about the content of democracy: Can democracy flourish in a society that allows people to be treated as untouchable?

It seems to me that the ongoing struggle for democracy will have to address these questions if it is to succeed. Similarly, the nongovernment and private sectors must also examine themselves: Is it enough to believe in abstract ideals of equality? Is it not time to act on them instead?

GIRLS AT RISK

Aruna Uprety

Physician, activist, and author, Aruna Uprety founded the Rural Health Education Services Trust (RHEST) a dozen years ago to forge long-term solutions to the difficult problem of girl trafficking in Nepal. She is an advocate for women's rights in Nepal and the author of five books on the subjects of women's health issues, nutrition, herbal medicine, and HIV/AIDS.

AS IT IS SAID IN NEPAL, "We build the road, and the road builds us." We educate people, and that education gives them confidence to build their own road, to find their own way. But many girls from rural areas and poor families, especially from the lower castes of the Himalaya, are denied the opportunity to make decisions or show initiative on their own.

Education, and choosing one's course in life, are not family and society birthrights in Nepal. Because of this, many girls and women are vulnerable to being trafficked and abused, and they are vulnerable to disease. Five thousand Nepali girls and young women are trafficked to India every year for the purpose of prostitution. This may be the busiest slave traffic of its kind anywhere in the world.

How does it happen? Sometimes girls are handed over by parents or relatives who are duped by a well-dressed man who comes to the village and describes "beautiful places" in India where people can live and work and earn good money. Sometimes a young man arrives in a village and "falls in love" with an innocent girl. They are married, and for their "honeymoon" they go to India, where she winds up trapped in a brothel, her dreams shattered.

It used to be that girls were trafficked from remote hill villages in certain areas of Nepal. Now, trafficking appears to be on the increase across the country, and girls also are taken from areas that have received little attention, even border towns and villages along the East-West Highway.

The trafficked girls end up in brothels in Mumbai and other parts of India where, for years at a time, they are physically abused and held in debt bondage, which is tantamount to slavery. They are raped and beaten severely if they don't surrender easily or if they refuse to have sex with customers.

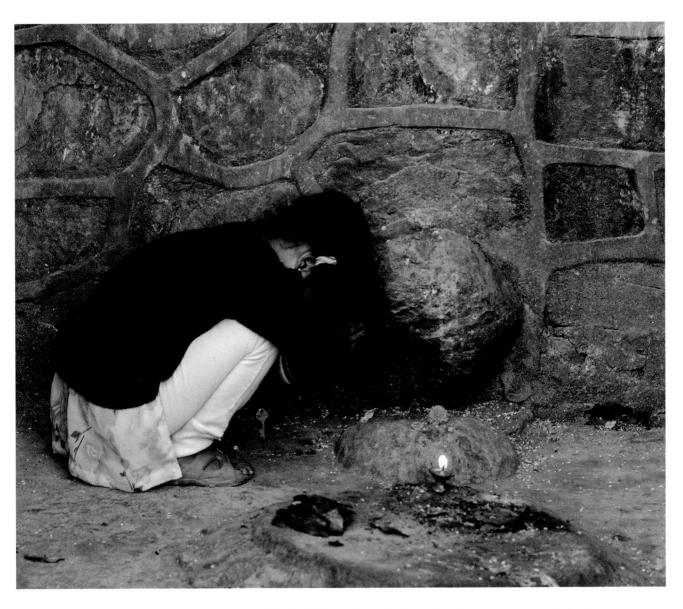

A young Nepali girl worships at a neighborhood Hindu shrine. Is she praying for a chance to attend school, to have a career, or to be free to marry the partner of her choice? Even as Nepal tiptoes into the 21st century, brothers are educated first, and women's rights lag far behind.

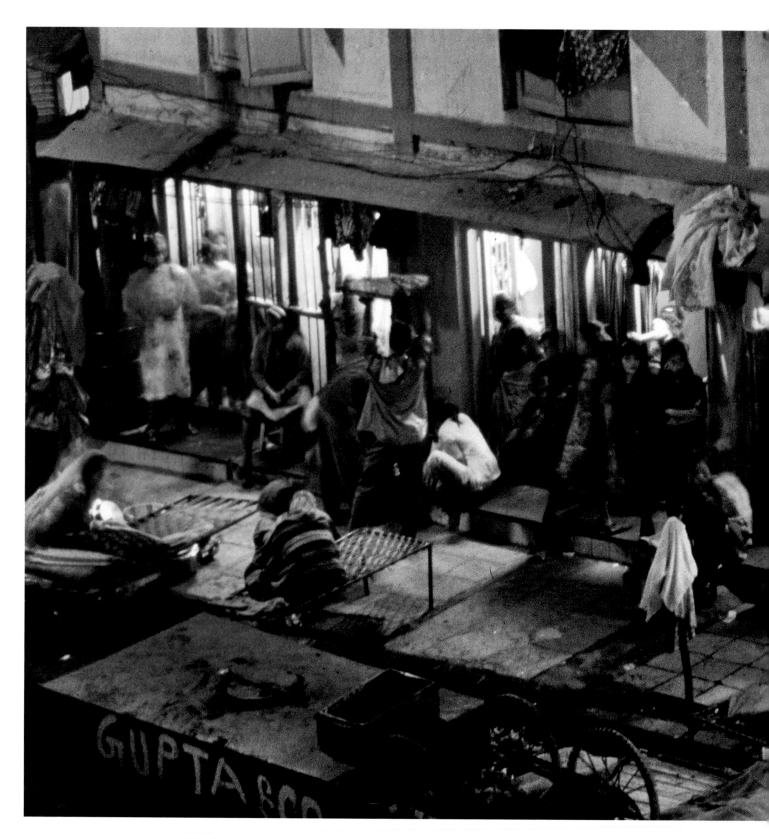

Nepali girls wait for clients in front of the "cages" on Falkland Road in Mumbai, India. Lured or sold

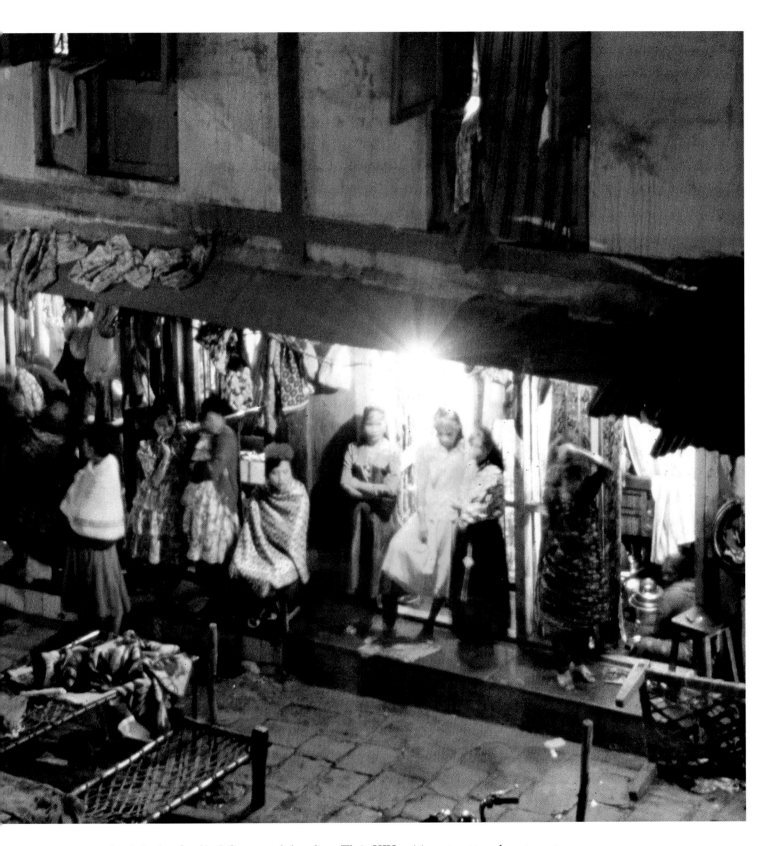

to brothels, they face bleak futures and short lives. Their HIV-positive rates approach 90 percent.

Brothel owners—who may be either men or women—will even beat them after submission if they don't bring in enough money. Many of these young and illiterate girls contract AIDS, and once this condition becomes known to their keepers, the girls are thrown out of the brothels to return home to die—that is, if their communities will accept them back.

All this pain and despair comes cheap. A girl might be sold to a broker for as little as 200 rupees (about three U.S. dollars), then she is resold and delivered to a brothel owner in India for more than a hundred times that amount. She might be 15, she might be 12, but her life is effectively over.

Are there rays of hope? Yes. Awareness is growing among national and international organizations that are working to combat this dreadful business. Border police are being trained to recognize and deal with traffickers. The governments of India and Nepal have enacted some strong laws against trafficking, and information has been spreading through the media and local organizations.

But the most important work happens on the ground.

The Rural Health Education Services Trust (RHEST) partners with the American Himalayan Foundation and works through local partners in remote communities. In addition to raising awareness of the dangers of trafficking, we provide scholarships to girls from the marginalized strata of society.

Two thousand girls have received support from RHEST—girls who otherwise would have been unable to go to school—and we are committed to helping more and more girls each year. We have found that it is through education that girls can realize their great human potential and take their lives into their own hands. Education enables them to recognize the threats of trafficking. It provides skills to help them become economically independent, and it allows them to contribute to their families and society.

When we first began to understand that combating trafficking could only succeed if girls could stay in their homes and in school, I went door to door to each house in the villages to ask parents to allow their daughters to be educated. Not all said yes. But enough did.

Now, years later, as the first hundred girls of RHEST are graduating from high school and preparing to go on to college, schoolmasters and village leaders come to us and ask us to expand our program to include them. I hope someday for 100,000 girls, safe in school, dreaming real dreams.

The road to saving human lives is long. But we must stay the course, and we must not fail.

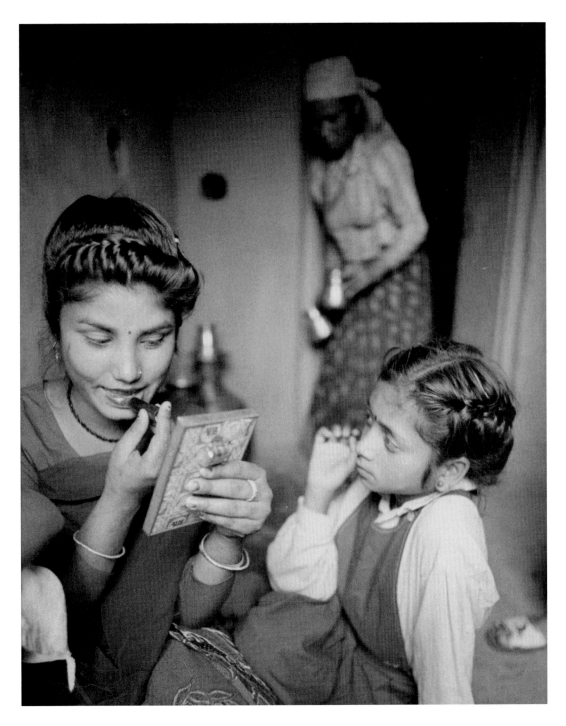

A Nepali woman of the Badi ethnic group prepares for work, while her younger sister and mother look on. It has become a tradition among the Badi: A girl knows that when she reaches puberty, the time will come for her to support her family through prostitution.

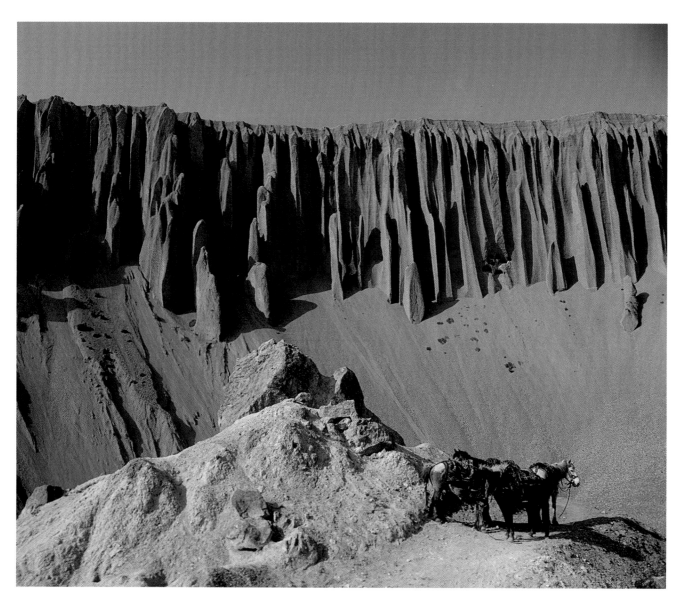

The Yara caves cluster in sheer cliffs in upper Mustang, Nepal. Traversing the Himalayan range, one sees, by turns, uplifted seafloor, metamorphic rock folded and reshaped under pressure, alluvial benches hundreds of feet thick, and thick deposits of Ice Age dust merely pausing on its journey to the Bay of Bengal.

MOVING MOUNTAINS

Roger Bilham

Roger Bilham received his doctorate in geology from a department at Cambridge University that traces its academic roots to Sir George Everest, for whom the mountain was named. Bilham's studies blend two decades of geodesy and two millennia of Earth history to quantify future earthquake hazards in the Himalaya. He is a professor of geological sciences at the University of Colorado in Boulder.

ON THE FIRST OF SEPTEMBER 1803, a violent earthquake shook northern India. Delhi's Qutab Minar, an ornate tower 250 feet tall that had served as a beacon of Muslim architectural ingenuity for the previous 600 years, lost its uppermost stories, dropping 13 feet in height. Twenty miles southeast of Delhi, British forces who had prepared for a lengthy siege of the heavily defended citadel of Aligarh took advantage of the confusion and fires and captured the fort in a single day. A hundred miles to the east, palaces of Lucknow were skewed and rent, and throughout the plains of the Ganges and Jamuna Rivers, shaken villagers watched as water and sand erupted from the ground and streamed over their fields.

The epicenter of all this shaking was in the Garwhal Himalaya, one hundred miles to the north, where landslides engulfed entire villages, leaving, with few exceptions, only rubble from the plains of India to the Tibetan plateau. The 1803 quake was the first great Himalayan earthquake described in writing. Letters, newspapers, and diary entries in British India yield a clear picture of its broad geographic reach. But it has taken the intervening two centuries to understand why these Himalayan earthquakes occur, and why their recurrence is as inevitable and as unpredictable as the fall of fruit from a tree.

Earthquakes occur daily in the Himalaya, but most are too small to feel. Once every several months a detectable rumble marks a magnitude 4 earthquake, and every few years a magnitude 5 quake (releasing 30 times the energy of an M 4) brings inhabitants from their homes. Once a decade, an M 6 earthquake will cause minor damage, and every several decades an M 7 killer quake like the October 2005 Pakistan earthquake will collapse thousands of dwellings in a score of towns around its epicenter. Rarer still are the truly great earthquakes, beyond M 8, which release 32,000 times the energy of an M 5 and send waves of destruction for many miles in all directions.

What causes these inevitable quakes? One hundred eighty million years ago, the Indian plate, which contains the continent of India, broke away from Antarctica. At that point an island, it rafted northward until, 50 million years ago, its northern shores collided with the ranges of southern Tibet, squeezing and contorting the intervening rocks upward into what became the Himalaya. India continues to penetrate beneath Tibet, each too buoyant to sink into Earth's mantle. Seismic images reveal its former surface at a depth of 25 miles below parts of the Tibetan plateau. As a result, this 3-mile-high, 620-mile-wide plateau is effectively two continents thick. The pressures and temperatures at its base cause the rocks to flow sluggishly away from India's advance, curling around India's eastern corner near Burma in a vortex of solid rock.

An enormous amount of energy is needed to sustain the plateau's lofty elevation, and we now believe that some of this energy is the source of, and is released by, great Himalayan earthquakes. Each year, the Indian Plate advances relentlessly two inches toward Asia. It would be fine if this slippage occurred uniformly everywhere. But friction in the shallowest parts of the collision can clamp Asia and India together for hundreds of years beneath the Himalaya, only releasing cataclysmically when sufficient stress has developed to tear the rocks apart. Small earthquakes signify the continued accumulation of stress, but only great earthquakes allow the incremental northward motion of the Indian plate.

Devastating great earthquakes occurred in 1833 and 1934 near Kathmandu, in 1905 near Kangra in the western Himalaya, and in 1950 in far eastern Assam. But the infrequency of these massive quakes—four in 200 years—is sufficient that their effects are not personally remembered by successive generations. Fifty-six years have now elapsed since the region's last great earthquake, and seismologists believe that several parts of the Himalaya could be ready to host another. The Pakistan 2005 quake, though the worst earthquake disaster in the history of the subcontinent, may serve as a wake-up call for the next great earthquake.

The word "great" is reserved for M 8 earthquakes, but some great Himalayan earthquakes are much more severe than others, and can be distinguished by the great length of the ruptures they cause. The 1934 M 8.2 earthquake in eastern Nepal destroyed most of Kathmandu, but 900 years ago an earthquake nearly ten times more powerful shook the region. We infer this from an excavation of the frontal faults of the Himalaya that reveal 65 feet of earthquake slip, circa 1100 (according to carbon-14 dating), but no surface slip at all in 1934. Six hundred years ago a similar giant earthquake ruptured the Himalaya north of Delhi, and we know from Tibetan, Urdu, and Arabic texts that on

134

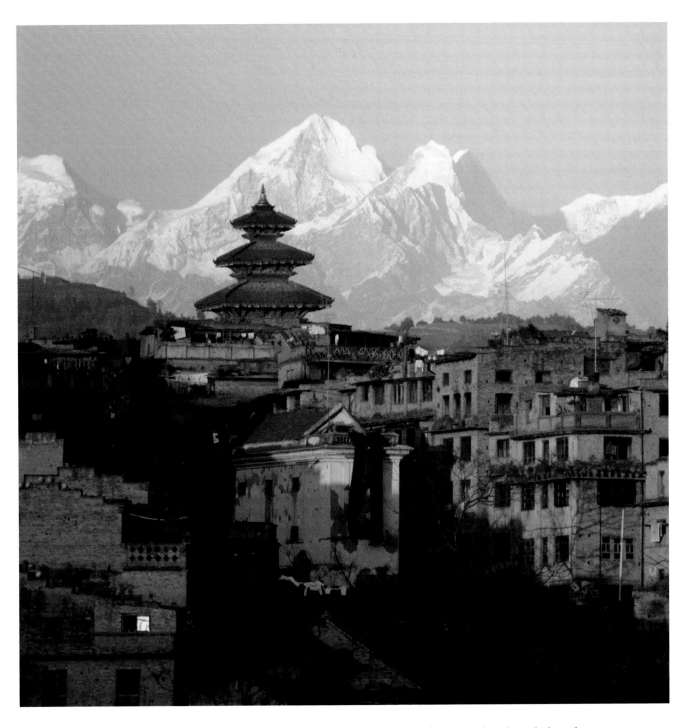

Bhaktapur, like all villages of the Kathmandu Valley, exists in danger of great earthquakes, which tend to recur at intervals just beyond living persons' memories. The quake of 1934 leveled many of the homes and temples of the valley, and many fear a "rain of bricks" when the next one occurs.

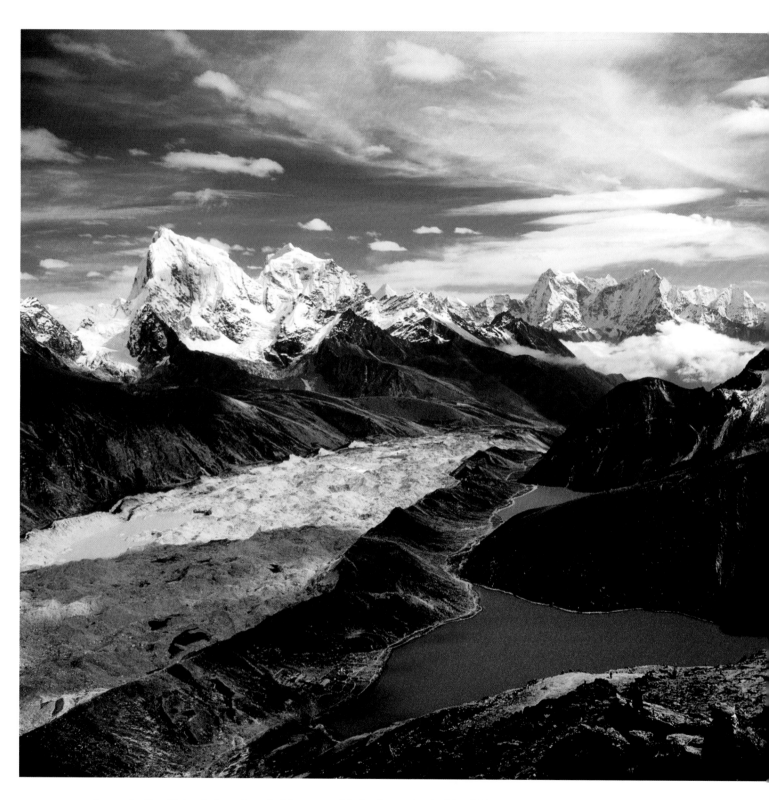

At 15,584 feet, Gokyo Lake nudges the Ngozumpa Glacier, largest in the Nepal Himalaya. Glaciers are receding faster across the range, in some cases creating lakes that result in catastrophic outburst floods.

June 6, 1505, an earthquake damaged monasteries in Tibet and Mustang and cities as far south as Agra, in India.

Over a period of 400 or 500 years, a tremendous amount of strain energy builds up beneath the Greater Himalaya and southern Tibet, waiting to be released. But whether the resulting earthquake is an M 6 or a catastrophic M 8.5 depends only on the total length of the rupture. If a tough region of rocks hinders the lengthwise growth of the rupture, an earthquake may not release all of its pent-up energy. Rupture areas of the very largest earthquakes may exceed 300 miles along the arc, and they tend to occur after delays much longer than the minimum needed for a great quake. Today the so-called elastic reservoir of the Tibetan plateau is sufficiently mature to drive three or four M 8 earthquakes. Unfortunately for planners, because the interval between quakes is inconsistent, forecasting these events is an inexact science.

Many seismologists agree that the next great Himalayan earthquake could occur between Kathmandu and Dehra Dun, the central 375 miles of the Himalaya, which last slipped in 1505. Smaller regions to the west and east are also considered ready for rupture and may in fact slip in more violent earthquakes due to their longer maturity.

Earthquakes destroy more than buildings. Many of the dams being constructed in Himalayan rivers can fail, resulting in secondary damage from disastrous downstream floods. And quakes often trigger landslides that block narrow Himalayan river gorges, creating transient upstream lakes. In the 1950 Assam earthquake, these lakes grew to many miles in length, and they kept growing until their natural dams burst. Villages in their paths were destroyed by the resulting catastrophic floods.

Distressingly, the next great earthquake will be far more devastating. The population has grown more than ten times since 1803; it has nearly tripled since the great earthquake of 1950. Traditional cottages of thatch and wood have been largely abandoned in favor of multiple-dwelling units of concrete and steel or bricks and mortar, some likely to pancake during an earthquake, trapping occupants in a mesh of rubble. Civic structures may withstand strong shaking, but the private dwellings, assembled at minimal cost, of more than 150 million people in northern India, Pakistan, Bhutan, Sikkim, and Nepal will not fare so well. Estimates put the future death toll from a great Himalayan earthquake in the hundreds of thousands, but a nighttime earthquake near the megacities of the Ganges Plain may result in a death toll exceeding a million.

If any good can be said to come from the frequent moderate earthquakes that occur in the Himalaya, it is that they may alert planning authorities to the devastating effects that will accompany a truly giant earthquake there, unless earthquake-resistant design is implemented. ≋

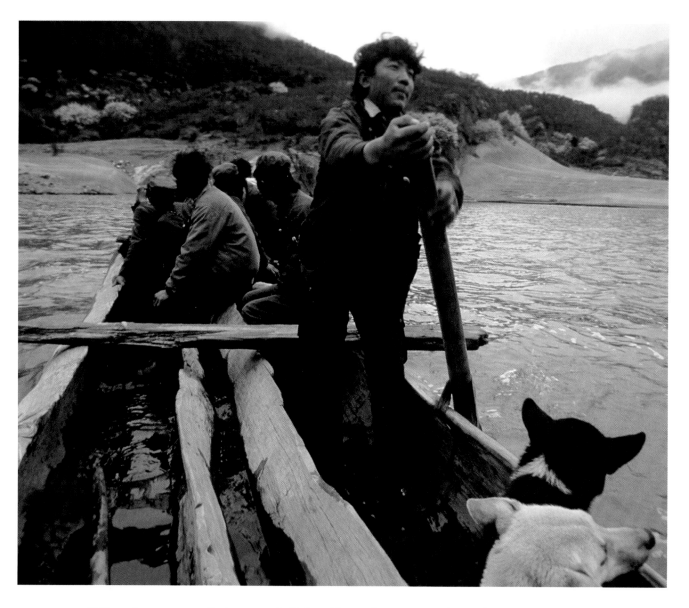

A Tibetan boatman rows pilgrims across the Yarlung Tsangpo River to a sacred waterfall near Gyala village,
at the upstream entrance to the Tsangpo Gorge. The largely unexplored valley is regarded as a béyul,
a sacred refuge of concentrated spiritual energy, and may have inspired James Hilton's Shangri-la.

SECRET HEART OF SHANGRI-LA

Ian Baker

Ian Baker has lived in Nepal for more than 20 years. He is the author of several books about Tibet and Himalayan culture, including *The Heart of the World: A Journey to the Last Secret Place.* He is also the founder of Rare Journeys, an educational travel company that documents some of Earth's wildest and most compelling places.

FOR TIBETANS, PARADISE WAS NEVER LOST, just well hidden. Ancient Buddhist scrolls describe remote sanctuaries called béyul, "secret lands" deep in the Himalaya, where animals and plants display miraculous powers, aging is slowed, and enlightenment can be easily attained. The greatest of these paradisiacal realms is said to lie in the depths of the Earth's deepest chasm, in the heart of southeastern Tibet's Tsangpo River Gorge.

The innermost reaches of the Tsangpo River Gorge remained a blank spot on the map into the last decade of the 20th century. Expeditions launched by the British Raj from 1878 to 1924 attempted to penetrate its depths, but none succeeded. The area remained, as a British field officer described it, "one of the Earth's last secret places."

Beginning in 1993, I made yearly journeys to the gorge, following the accounts of earlier explorers as well as the prophetic scrolls that refer to the region as Beyul Pemako, "Secret Land Shaped like a Lotus." In 1998, the National Geographic Society sponsored my eighth expedition in which, together with teammates Ken Storm and Hamid Sardar, we finally reached the portal to the Tibetans' earthly paradise.

From its source near Mount Kailash, the Tsangpo River flows across Tibet, then plunges into a tangled knot of mountains at the eastern edge of the Himalayan Range, forming a chasm three times the depth of the Grand Canyon. After carving a great arc around a spur of the 25,436-foot summit of Namcha Barwa, the river reemerges in the jungles of northeastern India as the Brahmaputra, having lost an astonishing 11,000 feet in altitude in a mere 50 miles. Nineteenth-century British geographers accounted for the drop by surmising that a sacred waterfall, rumored to exist at the heart of the gorge, would rival the newly discovered Victoria Falls in Africa or even Niagara Falls in America. But all efforts to penetrate and map the Tsangpo's inner gorge met with failure.

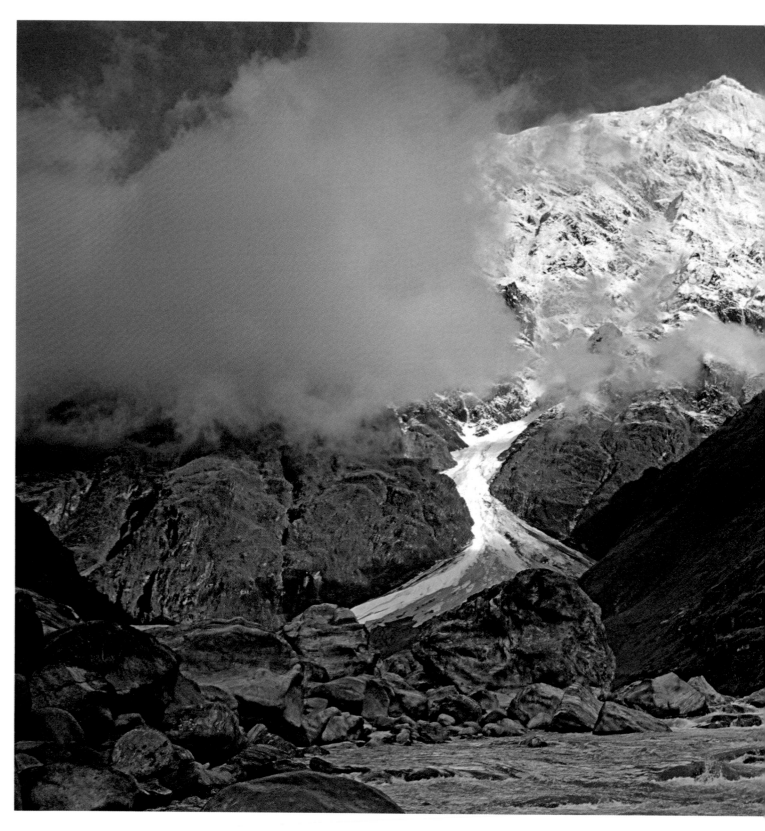

The Yarlung Tsangpo River flows beneath Gyala Pelri, nearly 25,000 feet high, enters one of the

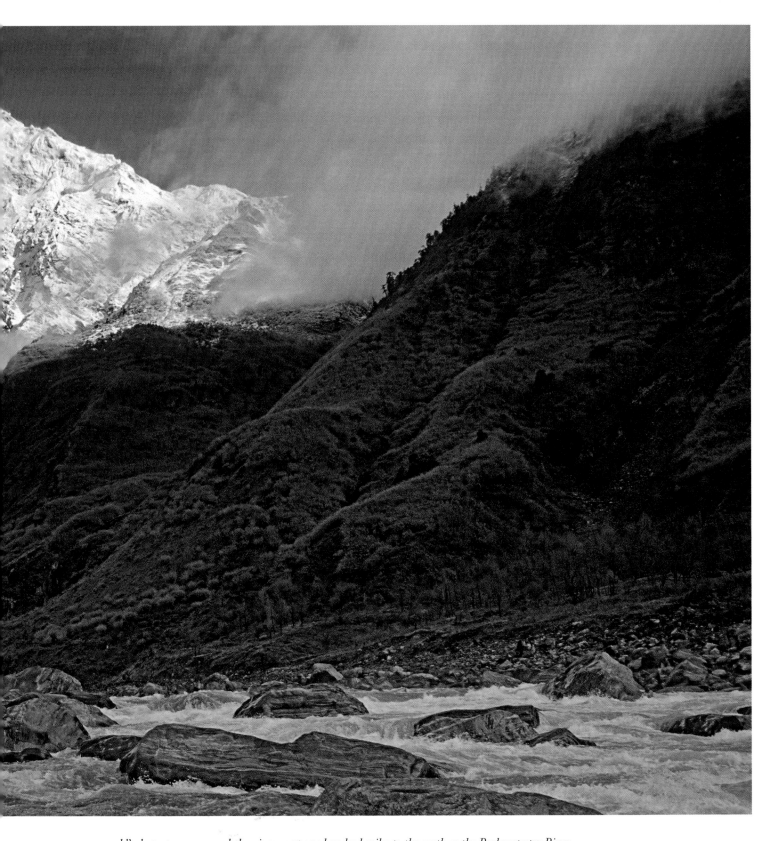

world's deepest canyons, and then issues out one hundred miles to the south as the Brahmaputra River.

The last explorers to search for the legendary waterfall were an English plant collector named Frank Kingdon Ward and a 24-year-old Scottish lord. As the Earl of Cawdor wrote in his journal near the end of their 1924 expedition, "How the old chap who invented these infernal falls must chuckle in his grave when mugs like us go looking for them! And what a number of people have had a miserable time looking for this mythical marvel!" Kingdon Ward and Lord Cawdor returned to London and declared at the Royal Geographical Society that the legendary "Falls of the Tsangpo" were no more than a "religious myth" and a "romance of geography."

The same year that the two explorers dismissed the waterfall as a religious fantasy, an author and ex–ivory poacher named Talbot Mundy drew on Tibetan legends and invoked the Falls of the Tsangpo in a work of fiction. Paralleling Tibetan accounts, his conjured falls conceal a tunnel to a paradisiacal realm in which an ancient lamasery preserving treasures of East and West clings to "a sheer wall of crags, whose edges pierced the sky."

Mundy's novel, *Om: The Secret of the Abor Valley*, was the primary source for James Hilton's 1933 *Lost Horizon*, which introduced the word "Shangri-la" into the English language. Concealing his sources—which also included William Archer's 1920 play, *The Green Goddess*—Hilton relocated Shangri-la to Tibet's northwestern frontier. But its literary origins lay firmly in the depths of the Tsangpo River Gorge.

The real voyage of discovery consists not

in seeing new landscapes,

but in having new eyes.

—Marcel Proust

Although the waterfall at the heart of this legendary Himalayan paradise had been consigned to myth, nearly ten miles of the Tsangpo's innermost chasm remained unexplored until our 1998 expedition. The possibility of a waterfall "of a hundred feet or more," as Kingdon Ward had described it, had not been fully dispelled, and it became the focal point of our journey.

In the course of our research, an elderly Tibetan lama ultimately told us of a sacred cascade at the heart of the gorge conforming to early 19th-century speculations and leading to the purported promised land. Our quest for the geographical sources of

A Menba villager eats lunch of tsampa, *roasted barley flour, at his home in the tiny hamlet of Payi, a two-day hike from the nearest road, near the northern mouth of Tibet's Tsangpo River Gorge.*

Shangri-la led us into a vertiginous world of eroding landslides and precipitous jungles, a place that Kingdon Ward had described disparagingly as "the bowels of the earth." As we neared the depths of the gorge, we rappelled down moss-drenched cliffs toward the hidden waterfall. We documented its height at 108 feet: an auspicious figure in Buddhist numerology that surpassed the estimates of turn-of-the-century geographers, revealing that the most cherished myths can sometimes turn out to be true.

At the base of the falls, with mists swirling above us into clouds, we found ourselves not only at the bottom of what the *Guinness World Records* currently lists as the world's deepest chasm, but also at the threshold of the Tibetans' earthly paradise. A disciple of the aged lama who had directed us there pointed to an oval passageway leading into the overhanging cliff on the opposite side of the river. "That's the door," he said authoritatively. But several hundred feet of seething whitewater lay between us and the opening. Sheer rock walls soared above it.

"How do you get there?" I asked.

I received the inevitable answer: "You don't."

According to our Tibetan guide, only elaborate Tantric rites performed by an accomplished lama could secure access to the realms beyond the granite portal. We had just documented the highest waterfall ever recorded on any of Asia's major rivers but, like our Tibetan companions, we were content to leave the enigma of the oval door intact. The pristine ecosystem to which we had already been admitted was paradise enough.

In the year following our return from the Tsangpo River Gorge, Chinese authorities closed the region to outsiders. The newly designated Yarlung Tsangpo Great Canyon National Reserve covers 3,714 square miles and contains a wealth of medicinal plants, as well as Tibet's last remaining tigers and other rare mammals, such as the black muntjac, or barking deer, and the capped leaf monkey.

Other reports that have been received from China indicate less ecologically oriented intentions. Following completion of the controversial Three Gorges Dam on the Yangtze River, the government announced proposed plans to construct an even larger hydroelectric facility in the great bend of the Tsangpo River Gorge. The 38-million-kilowatt power station would form part of a national strategy to divert water from Tibet to more than 600 cities in northern China that suffer from chronic water shortages. As a consequence, the Tsangpo River Gorge's unique environment would be imperiled, and untold species would vanish beneath the rising waters of an artificial reservoir.

Communism promised the peoples of China and Tibet a practicable earthly paradise. Yet railways, oil and gas pipelines, petrochemical complexes, hydroelectric dams, military bases, and new cities for migrants from China have harmed much of Tibet's environment and culture. A dam at the heart of the Tsangpo River Gorge would destroy an ecosystem that inspired one of the world's most enduring legends: the "wild dream of Shangri-la" described in Hilton's novel and anticipated, centuries earlier, in revered Tibetan texts. The dream is all the more poignant as the nations of the world strengthen, as Hilton wrote, "not in wisdom, but in vulgar passions and the will to destroy."

Ultimately, it matters little whether the legendary paradise in the heart of the Tsangpo River Gorge exists physically, or whether it's a metaphor for the perfected human spirit. The Buddhist legends of "secret lands" urge us to embrace our full potential, not least of which is our capacity to preserve the Earth's last remaining pristine habitats, arguably the only Eden we will ever know. ⚎

REFLECTIONS IN A HIDDEN LAND

George B. Schaller

An award-winning naturalist and vice president of the Wildlife Conservation Society's Science and Exploration Program, George B. Schaller has studied and contributed to the conservation of numerous species of wildlife, from mountain gorillas and tigers to Tibetan antelopes and snow leopards. He has also written and edited many books, including several on the Himalaya and its wildlife.

As a result of better protection, the Tibetan wild ass, or kiang,
has increased in numbers in recent years on the Tibetan Plateau,
200 miles and more upstream from the Tsangpo River Gorge.

WE CROSS A PASS, THE DOXIONG LA, across rushing waters in southeastern Tibet, and camp in the shadow of 25,436-foot Namche Barwa. That evening I stand by my tent beyond the circle of light from the two campfires and look at luminous peaks beneath a sliver of moon. I am restless, a wanderer at the edge of the known. We have come to make a biological record but our visit is fleeting. We will visit these mountains but not inhabit them: We are little more than the droppings of migratory birds.

I am not a climber drawn by the siren songs of summits—though I have ascended such easy mountains as Kilimanjaro, Orizaba, and Ararat—but a nomadic naturalist

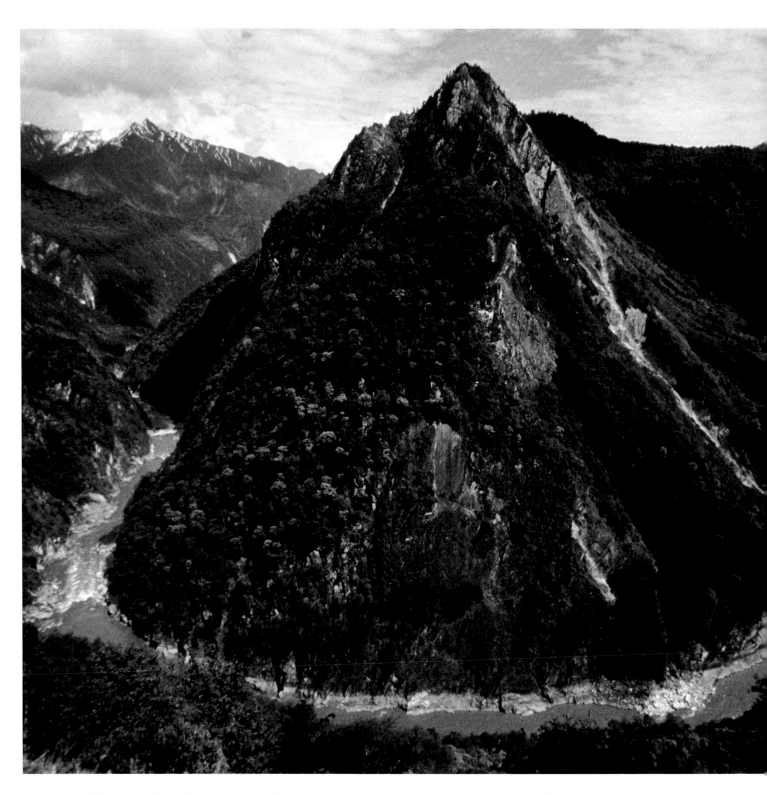

Where the Yarlung Tsangpo River reaches its easternmost point, it makes an unusual northward turn, carves between two 7,000-meter peaks, then abruptly curves south in an arc known as the Big Bend. The Chinese have recently designated 3,540 square miles of this forested corner of Tibet a national reserve.

partial to rambling along ridges, a cloud walker, in search of wild landscapes to study, enjoy, and protect. I prefer a *kora*, the circumambulation of a peak, to sterile summits. My trips can be considered treks and explorations or even expeditions, but not adventures, which to my mind imply bad luck, poor planning, or carelessness. In the past, major expeditions often had a complement of geologists, naturalists, and ethnologists. Charles Darwin was first exposed to the wonders of evolution by being appended to the voyage of the *Beagle*. As I later looked toward the summit of Namche Barwa, I wished that I could tarry here a few weeks to explore the natural world. As a member of a climbing expedition I would have the leisure and logistic support to do so, while others sought personal visions in the snows. Someday climbing expeditions and their sponsors may enrich their purpose by adding exploration and conservation of nature to their agenda again.

The mind shapes a landscape, giving it meaning. Herman Melville expressed this feeling of place: "It is not down on any map; true places never are." I can describe the visible portions of a landscape, its mountains and forests; I can even embrace its mythic concepts, finding glory in peaks and value in wilderness. However, I am also aware of a cultural void in my perceptions: I lack an awareness of the hidden and intangible forces, the spiritual geography of this and other regions. I would have to see with different eyes and hear with different ears to define the landscape as local people do.

Many cultures are dependent on a sacred landscape as part of their value system. For example, Australian Aborigines have their song lines, a labyrinth of invisible paths, the tracks of ancestors. India and Japan have sacred groves of native vegetation. The Buddhist Himalaya has its hidden lands, a visionary landscape of remote sanctuaries, or béyul.

In the eighth or ninth century the Indian sage Padmasambhava, the Lotus-Born, visited Tibet and established Buddhism by converting powerful and belligerent deities and demons into protectors of the new faith. During his wanderings in the Himalaya he created beyul, hidden among the towering peaks. These sanctuaries were places of inner peace and outer tranquility, earthly paradises so lovely and filled with mysterious power that no one ever wants to leave. They are also refuges in time of calamity. Padmasambhava wrote guidebooks to the beyul and hid them so those of faith would find them at critical times and decipher them. Tibetan lamas go into the wilderness in search of them.

Mountaineers sometimes profane the gods and offend local people out of ignorance or indifference by trampling on sacred summits. Climbers in the United States persist in ascending Shiprock, a site holy to the Navajo. A Japanese team tried to climb sacred Kawa Karpo in eastern Tibet. Thousands of Tibetans are said to have prayed that the team would not succeed. All 17 climbers died in an avalanche. Bhutan closed its high summits because of one team's surreptitious attempt at holy Gangkar Punzum. And in a

recent example, a Spanish team planned to climb Mount Kailash, sacred to Tibetan Buddhists and Bön as the center of the world, to Hindus as the paradise of Shiva.

All 8,000-meter peaks have been climbed, as have most 7,000-meter ones, and now the scramble for those of 6,000 meters has begun. Surely a few sacred summits can be spared an assault with cramponed boots and self-serving ambition and instead be shown reverence and respect, not only by local people but also by tourists, trekkers, and trophy climbers, as sublime symbols of beauty, compassion, and human restraint. After all, many mountaineers are on quests similar to those of pilgrims; they are spiritual seekers in search of liberation, fulfillment, and deeper perceptions. To ignore the sacred, to violate the dignity of local people, is to erode the ethical values of a culture and diminish it.

The subject of mountain ethics, a code of climbing conduct, has in recent years been much scrutinized. To halt the degradation of mountains, both physical and aesthetic, some climbers now remove pitons, bolts, and fixed ropes, and they carry out garbage. Yet climbing remains an indulgence with emphasis on individual achievement—a sport rather than a contribution to society. At least some emphasis might also be placed on saving the mountain environment. The current ideal is to "leave it as you found it" or "leave no footsteps." Better yet, do not merely leave it but in some way take a responsibility for protecting it by making a long-term commitment to preserve the cultural and natural environment. I admire Sir Edmund Hillary more for his decades of helping Sherpas build schools and health clinics than for his renown of having climbed Mount Everest first. He did not just consume the mountain but extended his personal challenge to create something profound and lasting.

The environmental movement must have a connection to religion. Conservation these days stresses scientific and economic values and neglects the spiritual ones. Yet conservation requires commitment, faith, hope, and a deep moral vision, just as religion does. Buddhism, with its inherent concern for nature and its respected teachers, offers this. The absence of true environmental compassion is due to a lack of ecological knowledge and a failure to incorporate the full range of ethical values into actions.

A new spiritual awakening eluded me in the hidden lands of the Himalaya, but the travels did offer greater understanding as well as useful reflections. Paradise must be regained, though not just through visions and merit, as the ancient guidebooks instruct. There must also be a commitment to protect the landscape and a recognition that all animals and plants have intrinsic worth. In this way the hidden lands could provide guidance to all humankind: They could show the way to spiritual and ecological enlightenment. Hidden lands no doubt persist in all faiths. But no visionary in the future will be able to find their treasures if the land is destroyed now. ≋

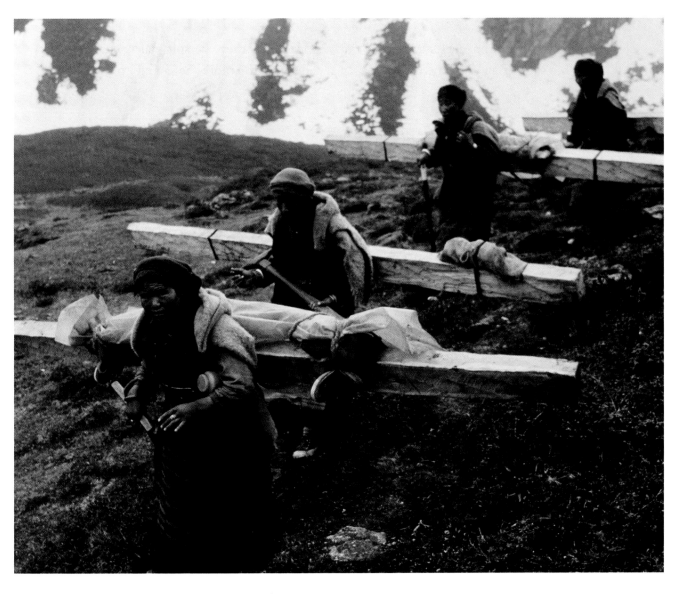

Tibetan villagers walk three days to a road head, carrying hand-hewn timbers from the lush forests of the Kharta valley, below the East Face of Everest, now within the Qomolangma Nature Preserve. The influx of settlers from China into Tibet has led to a mushrooming demand for natural resources.

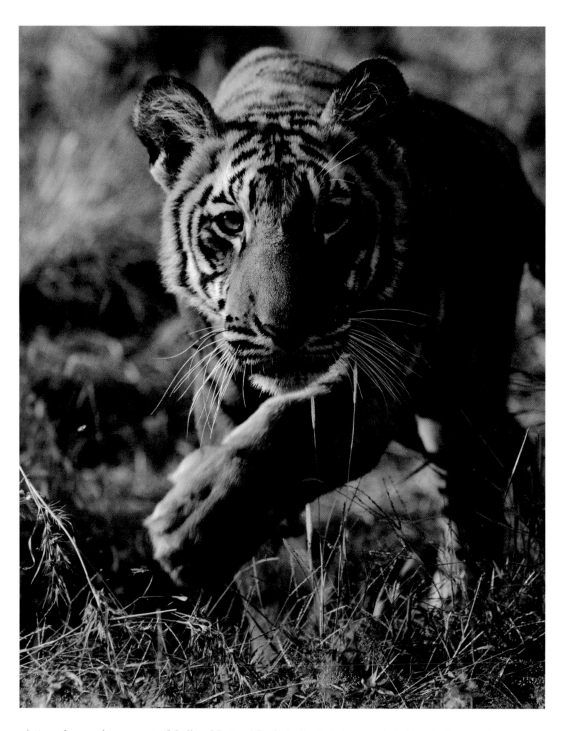

A tiger charges the camera in Madhav National Park, India. Suitable jungle habitat is disappearing, but Royal Bengal tigers are also being poached for bones and other body parts, which become ingredients in Chinese medicine and tonics. As few as 2,500 wild tigers remain on the Indian subcontinent.

MAN-EATER OF TIGER TOPS

Hemanta Mishra

Hemanta Mishra is executive director of the New Peak Foundation and senior advisor to the American Himalayan Foundation. He was instrumental in creating a network of national parks and wildlife reserves in Nepal, including Royal Chitwan, Langtang, and Sagarmatha National Parks, along with the Annapurna Conservation Area, for which he was awarded the J. Paul Getty Conservation Prize.

THE DEATH WAS CLEAN, SILENT, AND SWIFT. The odds were stacked against the skinny, wrinkled man with sunken eyes. His name was Kumal, and he had been a boatman, ferrying tourists across the Narayani River in Nepal's Royal Chitwan National Park. After a hard day's work, Kumal was resting in his mud-and-thatch hut on a humid summer night. The killer was a handsome male with sinewy muscles and massively strong paws supporting a 400-pound body. By morning, very little of Kumal remained. Of his killer, there was only a pugmark in the mud with a bent toe, earning him the name Bange Bhale or "Twisted Male."

Only one in a thousand tigers becomes a man-eater, but this statistic is meaningless to those whose kin have been devoured by one. A tiger killing a human is the ultimate expression of conflict between humans and wildlife, and it hinders efforts to save the animal from extinction.

On the Christmas Eve following Kumal's murder, Bange Bhale wandered back to Chitwan. The tiger stalked a *mahout*, or elephant driver, pouncing upon him in broad daylight. Fortunately, the mahout's elephant was nearby and charged at the tiger, leaving the mahout badly mauled, but alive. Bange Bhale escaped, again leaving his pugmark as a calling card in the mud.

On New Year's Eve, I arrived at Tiger Tops, an upscale jungle lodge, accompanied by Zbigniew Brzezinski, President Jimmy Carter's national security advisor, and his wife. When we pulled into camp, I was mobbed by a terrified and weary Tiger Tops staff, led by Ram Prit Yadav, a National Park ranger. "It's glamorous of you to come down here to sip expensive Scotch and hobnob with American statesmen," Ram grumbled accusingly, "but what about the people who have to work in a jungle with a hungry, man-eating tiger on the prowl?"

*I want to realize brotherhood or identity
not merely with the beings called human,
but I want to realize identity
with all life, even with such beings
as crawl on earth.*

—Mahatma Gandhi

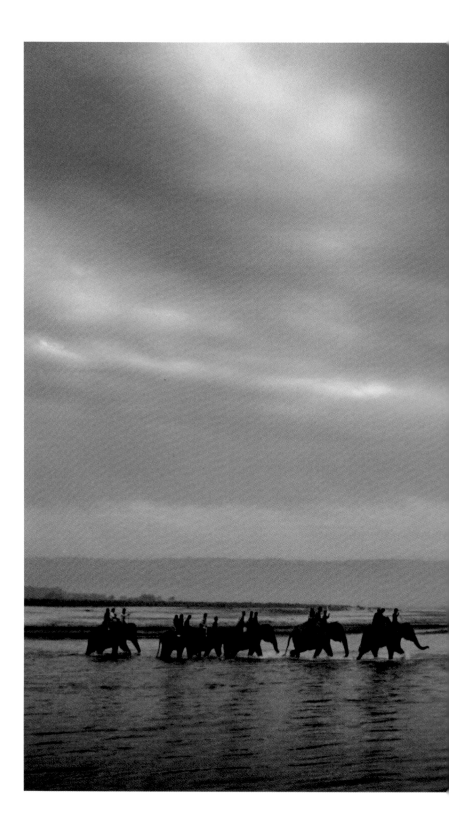

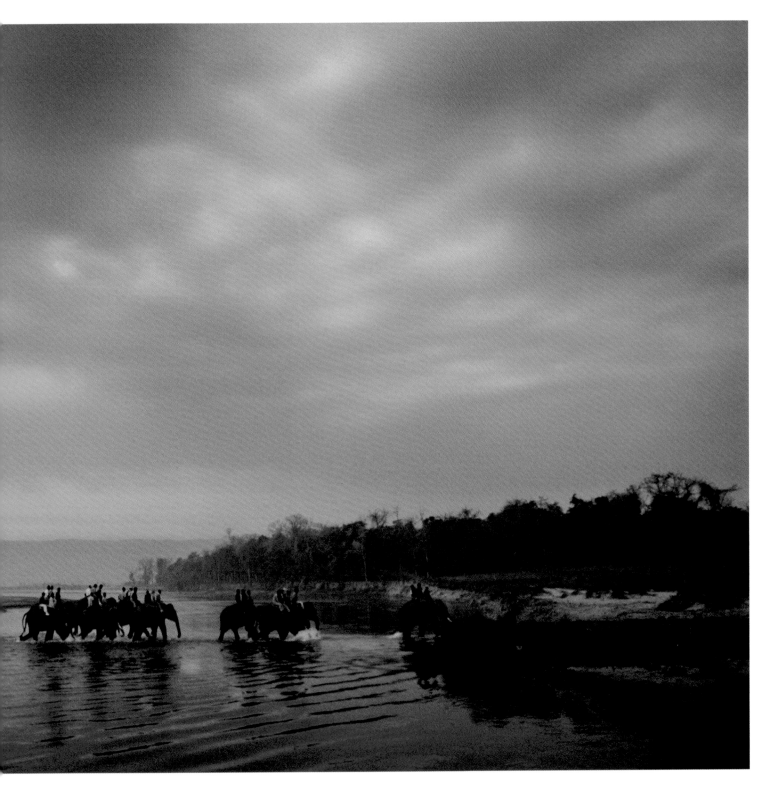

Biologists in Royal Chitwan National Park, Nepal, ride elephants across a branch of the Rapti River to Icharni Island, on a mission to immobilize a tiger with a tranquilizer dart and affix it with a radio collar.

Ram indicated a group of somber Tiger Tops staff members. "These people must walk alone in the jungle, in the dark, and lay out live bait, so that tourists can hide in the safety of a blind and gander at a feasting tiger. Then they go home to sleep, as Kumal the boatman did, in open sheds on the banks of the river!"

"Out there," said a staff member, "we're like live tiger bait, ourselves!"

Even man-eaters are fully protected under the laws of Nepal. To catch or kill one, I needed written orders from Kathmandu. As ecologist for the National Parks Department, I had been sanctioned before by the royal palace to capture man-eating tigers. This time, however, I was torn between my official duty of guiding the Brzezinskis on their holiday and my responsibility to protect the impoverished and vulnerable staff who worked in the jungle. I quickly realized the absurdity of discussing permits and orders and regulations when a stalking killer was running amok in our backyard. We would take action. And, we would bring Bange Bhale back alive. That night, carrying kerosene pressure lamps on elephant back, we hastily tethered a dozen live buffalo baits in the area where the tiger was last reported. Normally, this procedure would be done before sunset, so I doubted that Bange Bhale would take any of the baits.

The next morning, I was surprised to see that the tiger had killed one of the buffalo, not far from the site where he had eaten Kumal, the boatman. Typically, after killing an animal bait, the tiger snaps the tether and drags the kill a few yards into cover. After feeding on part of it, he moves to a nearby stream to drink, then returns to guard it and feed on it later. The parks staff and I surveyed the area and determined, by the orientation of the pugmarks, the direction that Bange Bhale had dragged his kill.

To catch the tiger, we used a combination of modern technology and the big-game hunting techniques, or *shikar*, developed in Nepal during the late 19th century. The operation consisted of several routine—but risky—steps. Using elephants, we laid a *vhit* cloth, a three-foot-high wall of white cotton stretched out nearly a mile into a large V or funnel configuration, positioned with the tiger roughly in the center of the V. The tiger could easily leap over or crawl under this thin band of cloth, but trepidation or instinct causes the animal to avoid the strange barrier.

A dozen or more elephants dispersed across the wide end of the funnel. Carrying the loaded dart gun, I stepped from my elephant into a tree at the narrow end of the V. Then men and elephants advanced toward the narrow end of the funnel, shouting *Haat! Haat!* while thrashing the vegetation, flushing the tiger toward me. I had instructed Mr. Brzezinski, an expert shot, to shoot the tiger if it attempted to reach me in the tree.

Slowly, Bange Bhale zigzagged toward me, then stood alert on his hind feet, scanning the row of noisy elephants. My heart pounded, my palms sweated, and my body

Rana Tharu women of western Nepal prepare traditional stoves from clay. Tharu society is often referred to as matriarchal, and these women enjoy an independence rarely seen in South Asia. They live on the border of tiger country, and the Tharu and other villagers of the Terai region are sometimes prey to the cat.

trembled. I took a deep breath and slowly squeezed the trigger. *Phut.* The dart drove home on the tiger's right shoulder. He made one loud call—*hwaak*—ran past my tree, and disappeared into thick cover.

I signaled the mahouts to remain quiet, to avoid scaring the tiger toward water, where he could drown when the drug took effect. After ten minutes, I descended from the tree onto the back of an elephant, and we found Bange Bhale in the grass, drugged and sleeping. I dismounted from the elephant and pulled the tiger's tail. No movement. Bange Bhale was out. We took measurements and examined his feet and jaws for wounds, to see if injuries or poor heath had led him to abandon his natural prey and seek humans.

No wounds. Bange Bhale was a perfectly healthy tiger. He would spend the rest of his life in the Kathmandu Zoo, where he sired half a dozen cubs.

In the early 20th century, there were more than 100,000 tigers living in the wild. Today, there are fewer than 7,000, and across the Indian subcontinent Royal Bengal tigers may number as few as 2,500. The decimation of this fierce species comes not from the killing of man-eaters like Bange Bhale, but from poaching and habitat destruction. At the current rate of decline, experts predict that tigers will be extinct in the wild by 2020.

Demand by the nouveau riche in China and the Middle East for body parts of tigers now makes poaching the biggest factor driving tiger extinction. In eastern China, where they are used in traditional medicines, tiger bones fetch $6,000 per kilogram. Tiger penises sell for $270 a gram and are used in virility pills—which have only modestly been supplanted by Viagra. In the Middle East, tiger skins are sold for wall hangings or rugs, and tiger teeth are sold as magical amulets at $900 apiece. Even the tiger's fat is used, for treating rheumatism, and sells for $100 per kilogram.

Meanwhile, as law and order have broken down as a result of the Maoist insurgency, Nepal has become a key transit point between the Indian subcontinent and China in the illicit trade in tiger parts.

But there is some reason for hope. If poaching and habitat destruction can be controlled, the tiger population will certainly recover. Governments, international donors, and nongovernmental organizations are slowly beginning to understand the tiger's key role in the ecological services that nature provides. Through complicated biological linkages, the tiger contributes even to soil and water conservation in the Himalaya. Clearly, the survival of the tiger is linked with our own survival.

What will be the fate of tigers in the 21st century—and, with them, what will be the fate of humanity? We may not have the answers, but we do know that if the tiger becomes extinct, history will curse us all. The children of our children, and their children, will remember us not as protectors of the environment but as cowardly bystanders.

GHOST CAT OF THE HIMALS

Rodney Jackson

Founder and director of the Snow Leopard Conservancy, Rodney Jackson is the leading authority on wild snow leopards. A 1981 Rolex Award laureate, Jackson conducted the seminal snow leopard study in Nepal's remote Himalaya. He and his conservancy team have pioneered camera-trapping techniques and created community-based conservation and ecotourism programs.

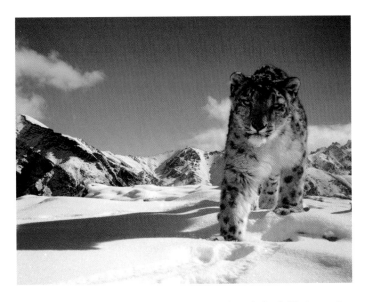

Mikmar, a snow leopard in Hemis National Park, Ladakh, is caught by one of the Snow Leopard Conservancy-India's remote camera traps.

I GREW UP IN ZIMBABWE'S HIGH VELD, spending the years of my youth blissfully tracking leopards in the bush near my home, clambering up *kopjes,* low granite domes, always close to Africa's bountiful wildlife. In those days I never imagined I would devote my life to saving a cat that inhabits the highest, snowiest, and most remote corners of Asia—a cat that humans rarely even glimpse in the wild.

While studying wildlife biology in California, I saw a picture of a wild snow leopard in NATIONAL GEOGRAPHIC magazine, taken in Pakistan by George Schaller. The

cat's long, smoky-gray tail mesmerized me, and her green, amber-flecked eyes seemed to reflect the vastness of her Himalayan haunts. She was amazingly well camouflaged—but not well enough to keep her from being killed for her fur.

Near the end of my studies, I saw an insurance company's advertisement featuring a snow leopard. "It will take a miracle to save the snow leopard," the bold caption read. "Don't count on a miracle to save your company." I sent an impassioned letter to the CEO, stressing that it would not take a miracle to save this beautiful and elusive feline— instead, it would require that a determined researcher study the cat in the wild. The company responded by giving me a modest grant that helped jump-start the first in-depth study of wild snow leopards.

It took 12 days for my partner, Darla Hillard, and our Nepalese associates and I to trek from the Jumla airstrip, in northwest Nepal, to the uninhabited and rugged Langu

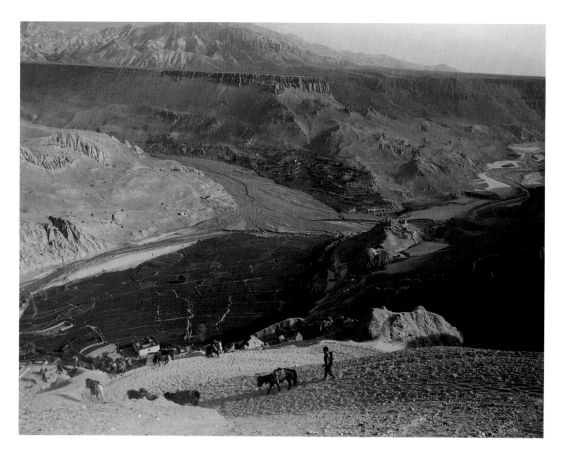

Ponies descend into the hamlet of Dri, on the Kali Gandaki River in Mustang. The Dri villagers' herds of sheep and goats often fall prey to snow leopards, which break into vulnerable corrals at night.

Gorge. We set out several live animal traps and prepared to wait for weeks or even months to catch a cat. But the next morning I was astonished to find a snow leopard staring back at me, a large male in prime condition. The next hour passed like a dream as we immobilized and radio-collared the cat. I buried my fingers in his thick, exquisite fur and traced the length of his sumptuous tail. I peered into eyes that held a deep and gentle calmness, a look reflecting centuries of mystery and folklore.

This animal is different, I sensed, a beast from another realm. It was free, untamed, and powerful, a spirit that couldn't be caged, the embodiment of wildness. Here, perhaps, was the legendary flying snow lion that graces the flag of Tibet, the mythical beast that carried a great Tibetan warrior to Crystal Mountain, at the head of the Langu Gorge.

In late winter, villagers huddle around the fire in their stone houses as the snow leopards' high-pitched mating yowls pierce the frigid air and blowing snow. The elders sometimes caution children that this is the call of the yeti—another mythical incarnation, perhaps, of this elusive shape-shifting cat.

I'm reminded of one of the many legends of Milarepa, the great 12th-century Buddhist poet-saint who roamed throughout Tibet and the Himalayan borderlands. While he was living in solitary devotion in the Great Cave of Conquering Demons, a mountain storm stranded him for six months. When the snow finally melted, six of his followers went to retrieve Milarepa's body, only to find that he had transformed himself into a snow leopard.

Over a period of four years in the Langu Gorge, we tracked and radio-tagged five different cats, documenting their movements, food habits, and social interactions. We learned that although snow leopards are solitary, they have a sophisticated communication system, leaving scrapes and scents along shared travel routes. This ensures efficient, mutual use of their scarce natural prey, primarily blue sheep.

During the 1990s I visited much of the snow leopard's range, traversing several countries, assessing the condition of their habitat, and training local biologists and park managers to use simple, systematic methods to survey for snow leopards and their prey. Working in the headwaters of remote valleys, I began to empathize with the local sheep- and goatherders. Children are the primary custodians of livestock, and more of them were attending school. The animal husbandry skills of past generations were being lost. Increasingly, snow leopards were breaking into poorly constructed livestock pens, killing dozens of animals in a single night, resulting in disaster for the family. For some, their sheep and goats represent their entire life savings.

In 2000, I founded the Snow Leopard Conservancy to help communities predator-proof their livestock pens and to transform the snow leopard from a despised pest into

a valued asset. In addition to improved herding techniques, solar-electric fencing may be an effective new technique for keeping snow leopards and livestock separated. Corrals of rammed earth are now being constructed, similar to the 23-foot-high boundary edifice that has protected Lo Manthang for centuries. "With enclosed corrals, we shepherds can sleep at home, instead of out on the cold ground, guarding the pen," we heard from Tashi Largyal, a livestock herder in Ladakh's Hemis National Park. "And by not killing snow leopards, we can be better Buddhists."

The Buddhist reverence for life, however, only goes so far; even the devout will retaliate against stock-raiding snow leopards. At our AHF-funded project site in Nepal's ancient kingdom of Mustang, a herder had poisoned a snow leopard that killed his horse. Reviving an old tradition, he stuffed the carcass with straw and paraded it through nearby villages. In earlier days, villagers would have showered rewards on him, but this time he was arrested, fined, and incarcerated. Just as significant, he received the censure of his fellow villagers—a penalty that promises to be long remembered and respected.

In the Langu Gorge, we saw snow leopards only 18 times. In Hemis National Park, we now see them regularly in winter and spring; and recently, with our team, I even watched a pair of snow leopards engage in courtship and mating over most of a day. They approached one another slowly and gently, intertwining for a moment and then parting in an intimate, hopeful encounter. The following spring, our remote cameras caught sight of two cubs.

Ladakhi herders once asked us why we named our organization after a reviled predator. Now they describe snow leopards and other wildlife as the "necklace around our mountains." The cats have built a bridge between nature and culture, bringing new opportunities for local communities. Trekkers can stay in a traditional Ladakhi home, join in village life, learn about the local natural history, and have an excellent chance of seeing a wild snow leopard or at least its fresh signs. Income from these traditional homestays is invested in village conservation funds. The entire program has effectively elevated the snow leopard's status, and these magnificent animals are now worth more alive than they are dead.

With any luck, I have 15 good years to continue working for the conservation of this remarkable animal. But in the communities that overlap with its habitat, the future of the snow leopard is ultimately in the hands of young people, guided by a new generation of conservationists in their own country.

May this magnificent cat continue to gaze out across the mighty Himalaya, its amber-green eyes fixed on a distant blue sheep, and bless these mountains with its very essence and magic.

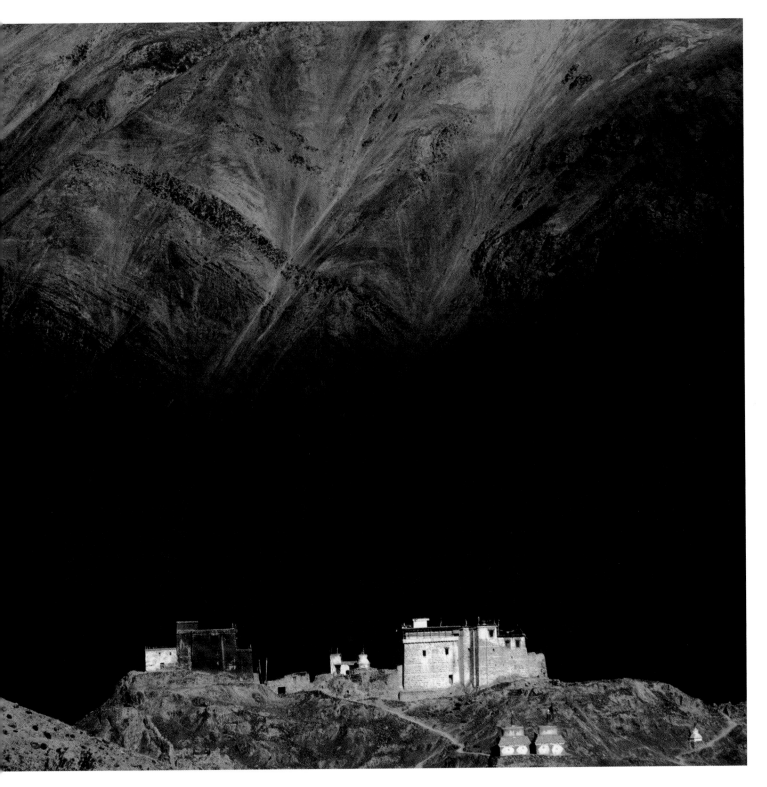

Under pressure in much of India, wild animals thrive near monasteries such as Ladakh's Temisgan, where monks prohibit killing. Visitors come to view native wildlife, transforming prowlers into welcome attractions.

HOPE

SIGNS OF HOPE

Visiting that place, and these people, you immediately realize
that you've been given an astonishing gift.
And having received something so valuable,
how could anyone not feel the urge to give something back?

—Jon Krakauer

HOW DO YOU DESCRIBE THE EMOTION OF A BOY who spent his first decade of life unable to walk, and then is surgically healed and reintroduced to the world? Or a girl who is given a chance to study and goes on to a career in nursing, education, or village leadership? Or of a village, when new skills and jobs and pride are created, giving young people reason to remain in their homeland and restore its ancient monuments?

Hope. It's what fills the space left by despair, when one has beaten the odds, when one has triumphed over hardship. Suffering and tough breaks describe the lives of many in the Himalaya. This may be why, for them, hope has so much potential.

The Himalaya has brought us Hinduism, Buddhism, and of course His Holiness the Dalai Lama, a compelling spokesman for peace, a symbol of hope for our planet. Indeed, considering the size of Tibet's native population—one three-hundredth of that of the rest of China—Tibet is now firmly seated in the front row of the world's consciousness.

In the back row, working quietly, are Tibetan and Nepalese doctors performing 15-minute cataract surgeries in remote field conditions, bringing sight to those who

PRECEDING PAGES: *Pigeons and a worker greet the dawn at Swayambhunath in Kathmandu, Nepal.*

164

haven't seen in years. Orthopedic surgeons are routinely patching kids together using state-of-the-art techniques, sending them off on prosthetics made from old bicycle parts. Barefoot doctors and nurses are delivering basic but lifesaving medical attention to nomads in rural Tibet, while emergency care awaits recently escaped refugees.

Each of these acts is an expression of hope and a manifestation of compassion, the subject of the Dalai Lama's most frequent and forthright teaching.

Compassion and hope have tendrils in education, too, reaching into the foothills and high valleys of the Himalaya, bringing improved local livelihoods, opportunities in the outside world, and a chance to play a role in a future that is unfolding all too quickly.

The exquisite 15th-century Buddhist assembly halls of Lo Manthang, like the ancient temples in Bhutan, were neglected and damaged, yet they have now been brought back to life. In the course of their restoration, more than the structures have been rejuvenated. Young people have chosen to stick around and work to build their communities and temples, rather than join the exodus to the menial jobs and cinema halls of India and elsewhere.

Dedicated foreigners, too, have used the mountains as a springboard for giving back. Plastic surgeons traverse the globe to repair cleft lips and palates, training local doctors at their sides. One medical worker has stayed on well past retirement to run a clinic that treats patients at a cost of 60 cents per visit.

As Sir Edmund Hillary reiterates, humanitarian work is his greatest pride, inspired by all that the Sherpas have shared with him. He founded the Himalayan Trust, which roused Ang Rita Sherpa, one of the first children in his village to read, to receive highest honors on his final examinations—and eventually run the trust.

Efforts to preserve nature and endangered wildlife can work. In the subtropical belt that crisscrosses the border between Nepal and India, known as the Terai Arc Landscape, villagers have established more than 400 community forest-user groups. Here tigers and rhinos, their former wild enemies, are now regarded as having more value alive than dead. With limited assistance, villagers are restoring degraded forest plots, dispatching poachers, and sharing the income from tourism.

Like the mountains where they live, the character of Himalayan people is steady and strong. The American Himalayan Foundation has been proud to be a part of many of these projects and will continue to support the efforts of dedicated people who are working to make their world a healthier and more engaged place, free of fear, filled with opportunity.

After experiencing the Himalaya, after sharing in its grandeur, its challenges, and especially its hope, we have no choice but to give back.

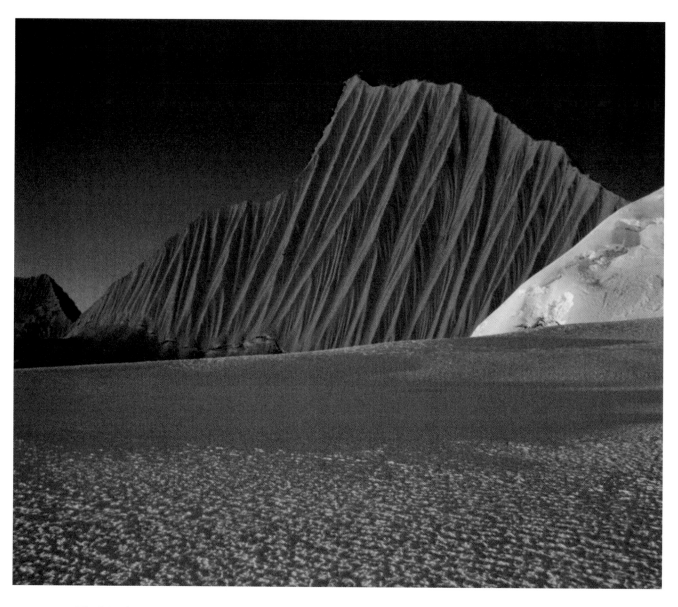

The Mingbo La, a technical climbing pass, connects the Hongu Valley near Makalu with the Everest region. In 1960, Sir Edmund Hillary spent several months near here, leading a series of expeditions including the Silver Hut Expedition, which set up one of the earliest high-altitude physiology field laboratories.

LOVE AND HEROES

Erica Stone

Erica Stone is president of the American Himalayan Foundation, directing its humanitarian and conservation work in Nepal, Tibet, and Bhutan. An M.B.A. from the University of California at Berkeley and fifth-degree black belt in Tae kwon do, she has traveled widely in Asia and delights in the remotest corners of the Himalaya.

I MET A HIMALAYAN CLIMBER—THAT STARTED IT. Gil was big, with clear blue eyes and a ready laugh. He could tell stories all night and take care of patients all day. He was gentle, loved dogs, and was most at home in a tent pitched on a moraine above 15,000 feet. I was so smitten that when he asked one day if I would like to go camping, I said yes before asking where.

Not long after, I sat watching the Kathmandu Valley unfold below me as our flight descended in a magical indigo twilight. A battered truck carried us eastward over the edge of the valley, dropped us at the end of the road, and turned back. For three weeks, we climbed passes and waded rivers, following the route of the '63 American Mount Everest Expedition—to Khumbu and on to Everest Base Camp.

Gil got typhoid, I got cerebral edema, we both survived, we fell in love. The colors, the luminous clarity of the air, the astonishing scale of the landscape—I felt as if my senses were scoured clean and permanently tilted to vertical. It was his favorite place in the world; that he shared it with me felt like a gift.

We traveled together to Asia often after that, until eventually I had walked much of the length and breadth of Nepal. Colorful, crowded, and noisy, Kathmandu felt like home, Namche Bazaar more so. Even poor, trampled Lhasa, with chest-high rows of bullet holes on monastery walls, felt familiar.

On one trip David Shlim, a physician friend who lived in Kathmandu, urged us to visit an orthopedist who had founded a children's hospital that needed an autoclave for sterilizing surgical instruments. On a sunny morning, we jumped into a beat-up taxi and made our way to a tiny hospital, a converted clinic, really, where we met Dr. Ashok Banskota. We walked with him through the wards as he told us his story. He had trained in the United States and returned to his homeland determined to treat as many of Nepal's

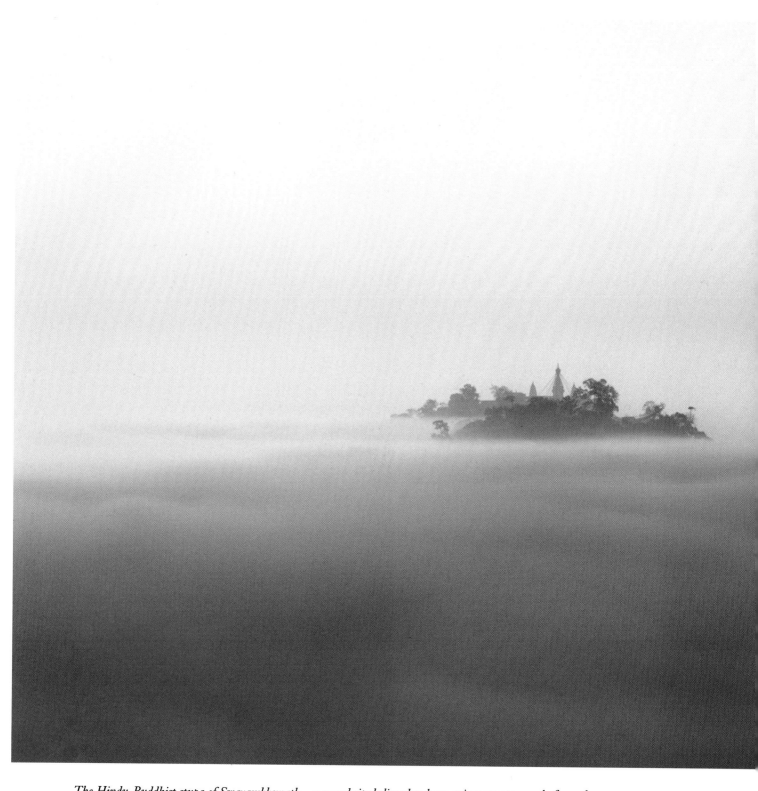

The Hindu-Buddhist stupa of Swayambhunath—a sacred site believed to have arisen spontaneously from the lake that filled the Kathmandu valley—rises above early morning winter clouds that blanket the valley.

To be genuine, compassion must be based on
respect for the other, and on the realization
that others have the right to be happy
and overcome suffering just as much as you.

—His Holiness the Dalai Lama

disabled children as he could. Club feet, tuberculosis of the spine, polio, untreated burns, children carried for days because their families couldn't afford a bus ticket: He took them in and treated them all. I had never met anyone whose passion to heal was so guided by compassion. I was dazzled. In one of those small but defining moments of life, I went from enjoying the mountains and local chang to asking how I could be helpful.

Two years later, my passion for the Himalaya, an M.B.A. degree, and some persistence converged, auspiciously, at the American Himalayan Foundation. I hadn't been able to shake the hopeful feel of that small hospital, remembering the children in the wards, bandaged and small even in their tiny beds, smiling and holding out their hands to Dr. Banskota as he passed. Remembering the kind word or touch that Dr. Banskota had for each one. Here was just one person, yet he was transforming lives.

I visited Dr. Banskota regularly on trips to Nepal—work trips now. He moved to another makeshift hospital, in a converted house, again full of children and light on space and equipment. One day as we negotiated the narrow stairs to the wards, I stopped him and asked, "When are you going to get a real hospital?"

"When you help me build one," he said. That made sense. So we did. The Hospital and Rehabilitation Center for Disabled Children now sits on top of a hill in Banepa, outside Kathmandu, built by AHF and a small group of international agencies. We still fund the surgeries, physical therapy, prosthetics, and training for a dozen more doctors.

Dr. Banskota now has an international reputation, and more silver in his hair. But when I walked through the hospital with him recently, I caught the same feeling that I did that first time. The dozens of children in the wards beamed when he appeared. They loved him before and they love him now, and I could see that he felt the same about them. I was dazzled all over again.

"Hero" is a big word, but I like Jon Krakauer's notion: "While the world can sometimes be an insane and irrational place, there are everyday heroes who say, 'We must do something to make this better.' And they do." Dr. Banskota is clearly one of these heroes, and in my decade and a half with AHF, I have been fortunate to have met many others. Dr. Aruna Uprety, for example, saves thousands of young girls at risk of being sold into brothels by their desperate families. Then she walks to the farthest corners of rural Nepal to bring health care to women, too many seeing a doctor for the first time in their lives.

AHF supports many homes for elders, but I confess to a special affection for one in Kathmandu. This home for elderly Tibetans feels particularly safe and warm, run by women who are volunteers all. I have spent some of my best moments drinking tea and laughing with the *momolas* who live there: my Tibetan grandmothers. They are mischievously sweet and composed despite their grueling histories of poverty and

loneliness. Could I have endured with such grace if I had escaped my homeland with nothing, lost my family, and spent years breaking rocks on an Indian road crew? I only know that between sips of sweet tea and bites of biscuits, they envelop me in their appreciation for life as it is, and I find them heroic.

In the Himalaya I have found, to my surprise and joy, a wealth of committed people who are burning to make life better for others. The American Himalayan Foundation searches out these everyday heroes—those trying to improve their schools,

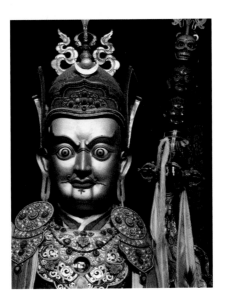

A three-story statue of Padmasambhava,
or Guru Rinpoche, graces the Jokhang
temple in the central cathedral in Lhasa.

their villages, their communities. They become our partners, and those partnerships allow us to respond to what people actually want and need, rather than imposing big plans and grand ideas on them. At the outset, we work from a place of respect and from trust. Our success stories, from Dr. Banskota to the momolas, are testaments to this guiding principle.

I lost my Himalayan climber with the blue eyes to melanoma a few years ago. But the Gil Roberts Memorial Surgical Fund pays for the surgeries at Ashok Banskota's hospital. And I still have the best gift of all from him: the world of the Himalaya. For that, and for all my heroes, I can only be grateful.

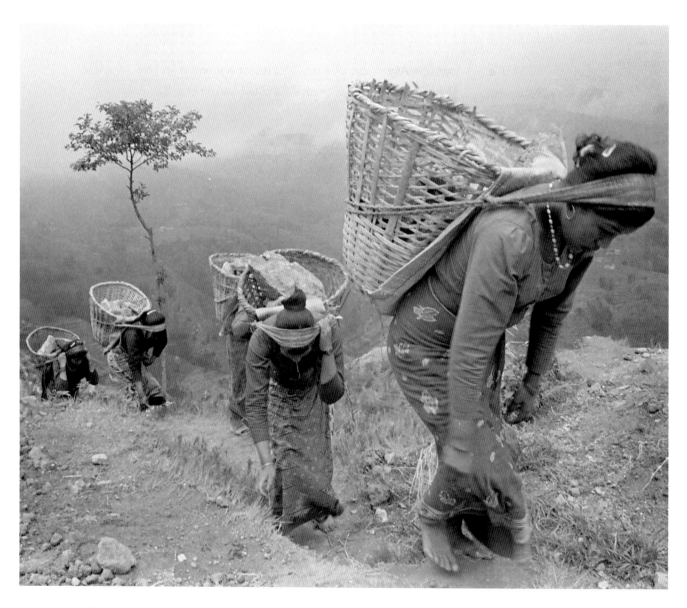

Women of the Tamang ethnic group carry loads of rocks in north-central Nepal. Across the Himalaya, women perform much of the fieldwork and manual labor with a quiet, even cheerful grace. Lack of infrastructure and education means that hill villagers have few other ways to earn a living.

WHAT MY GRANDMOTHER KNEW

Aruna Uprety

Aruna Uprety, M.D., was born in Nepal and received her medical training in Russia. She has been on the front lines of efforts to improve maternal and child health care in remote and conflict-torn areas of Nepal, in Iran after the earthquake, in Afghanistan after the most recent war, and in Sri Lanka after the 2005 tsunami. Between assignments she lives with her husband and two daughters in Kathmandu.

AS A YOUNG GIRL LIVING IN KATHMANDU, I was gently awakened each morning by my grandmother's prayers as she intoned the sacred mantra, *Om*, in tribute to the rising sun and the Himalaya. She filled me with mystical, magical stories of the mountains, and of yogis and holy men who spent years in isolated meditation, emerging only to offer blessings and impart wisdom to their students and acolytes. For her, the Himalaya were the source of the Ganges River, for Hindus the holiest of rivers, the river that quenches our spiritual thirst.

I could feel much of Grandmother's spiritual connection and yearning, and at the same time I felt drawn by needs that went beyond the overtly spiritual.

In the districts of Achham and Doti, my ancestral region in far western Nepal, people live in extreme poverty. Some were freed only a few years ago from centuries of bonded labor, a form of slavery. Women and girls of this remote area have perhaps the lowest social status in the nation. A local proverb says, "One should not be a woman in hilly areas, nor a bullock in Terai region"—a reference to the heavy burdens each carries.

The combination of poverty, poor nutrition, gender discrimination, low literacy rates, near total lack of access to health care (especially in gynecology and obstetrics), and centuries of neglect by the central government have resulted in an alarmingly high rates of maternal death, maternal morbidity, and life-threatening disease. Instances of prolapsed uterus are among the highest in South Asia.

This distressing situation is compounded, in turn, by long-held beliefs about the personal pollution that is believed to affect a woman after childbirth. Women are traditionally sequestered in cow sheds for 11 days after delivering a child, even though they are expected to continue their work in house and field. Green vegetables, milk, and curd are withheld from new mothers, too—right at a time when they need additional nutrients

and care. Maternal death in childbirth is so common in Achham that we have a special term for the unusual event of surviving delivery: It is called *jatkal*, which means "second life." When asking how many children a woman has, a villager may say, "How many jatkals have you had?"

Women do most of the work in families—the nurturing, the education.
They carry the load. When you improve their lot,
the women bring everyone else up with them.
Aruna Uprety, genius that she is, understood from the outset
that the quickest and most effective way
to transform huge parts of society
is to focus your resources on women.

—Jon Krakauer

"As long as we remain in silence," one woman said to me, "can there be any improvement in our condition, in our culture?" I hear variations on this lament frequently, and my heart aches. Clearly, raising awareness and education are among the first long-term methods for reducing these alarming statistics.

This is what brought me back to the far West. I came to research the reproductive health status of women and coordinate and assist in a women's health clinic. Over 10 days, we examined nearly 3,000 women with a variety of medical problems, and we found that a quarter of them were suffering from prolapsed uterus; some had for as long as 30 years. They have done so in silence, knowing they would be ignored or even ostracized by their families if they were to complain of it.

The work is not easy, partly because Nepal has become a battleground. Initially, Maoist insurgents tried to bring social change and justice. They successfully raised awareness about gender discrimination and archaic cultural practices. Many Nepalese hoped that positive social changes in women's lives would result, including a decrease in maternal mortality and an improvement in women's and girls' education.

But the health care delivery structure, impoverished even during times of peace, has not improved. Rebels have destroyed some health posts and have even killed some rural

Sundari Chowk in Patan, Nepal, was once the family residence of a Malla dynasty king. Its devotional bath,
Tusa Hiti, adorns the courtyard. Women of Patan make offerings to the stone deities, known as the Asta
Matrikas, or mother-earth goddesses, so their children will be blessed with education and good health.

health workers. Some women have died during delivery, at times when the rebels blocked the movement of ambulances. In some cases, the government has responded by curtailing the delivery of medicines. In this environment, it is a challenge to conduct education programs or week-long health camps. It is even difficult to get medical personnel to accompany us to insurgency-afflicted areas.

In spite of frequent feelings of desperation, I see some reason for hope. In Achham, we were able to negotiate with the local cadre of the rebel party. After demonstrating our good intentions and making our funding transparent to them, they allowed us to continue our work. During two health camps conducted over the course of a year, we operated on 200 women.

The Ministry of Health has now created training curricula on debilitating diseases for nurses and local auxiliary nurse-midwives. After 18 months of training, these educated nurse-midwives go out to work in government health posts and health centers around the country to help women during pregnancy and childbirth. As a result, village women have become more aware of the treatment options. They are healthier before and after giving birth, and their newborns come into the world with better prospects for lifelong health as well.

Nurse Kamala, who assists me in Aacham, grew up in a nearby village, but she was able to go to college through the American Himalayan Foundation's In Honor of Amar Scholarship Fund, which was established for the late Amar Rana. Kamala's mother is one of my patients, and though she is in her late 30s, she looks 50: the result of poor general health and the strain of raising seven children. Kamala insisted that her mother come to the hospital for a medical checkup. It was her first visit to a medical facility. When I spoke with her, I could feel her pride in her daughter—the first girl in their community to graduate from high school. Their smiles were the greatest reward I could imagine.

One cannot act important and mighty in the presence of the Himalaya. Their sheer immensity dwarfs all human achievements. When I think of the greatness and history of this mountain range, human sorrows and achievements appear trivial. The Himalaya have given us medicines, fresh water, and even precious gems, and they have known human suffering. They have seen empires rise and fall, and they have seen natural disaster. Simply knowing this may be what inspires me.

Even on the most difficult days I maintain an inner hope, and I feel strengthened by the knowledge that for each night of darkness there must be a sunny morning. I turn to the mountains and think of my grandmother, whose life was so different from mine. She honored the Himalaya with her prayers. I intend to honor the Himalaya by using what I have learned to help others.

FROM SCHOOL, FREEDOM

Bruce Moore

Bruce Moore, based in Kathmandu as field director of the American Himalayan Foundation, came to Nepal from Australia in 1993. He first worked in the private sector and then joined the foundation in 2000. He has helped AHF in-country scholarships grow. From serving a few hundred girls in its first years, the program now supports more than two thousand—a feat of which he is immensely proud.

In Kham, Shechen School students wave exuberantly.
Most classes in Tibet are taught in Chinese, but here
students learn to read and write in Tibetan.

"THE BENEFIT OF AN EDUCATION IS NOT SIMPLY that I will learn new things; what is more important is that it will give me freedom," said Laxmi, a 15-year-old girl from Achham, in western Nepal.

Such seriousness from a girl in junior high who, only minutes before, was giggling with her friends in the playground of their rundown village school. Laxmi is one of 2,000 schoolgirls in Nepal receiving a scholarship thanks to the Rural Health Education Services Trust (RHEST), the American Himalayan Foundation's partner in bringing

Most Nepalis, including these Terai villagers, depend on subsistence agriculture and can ill afford

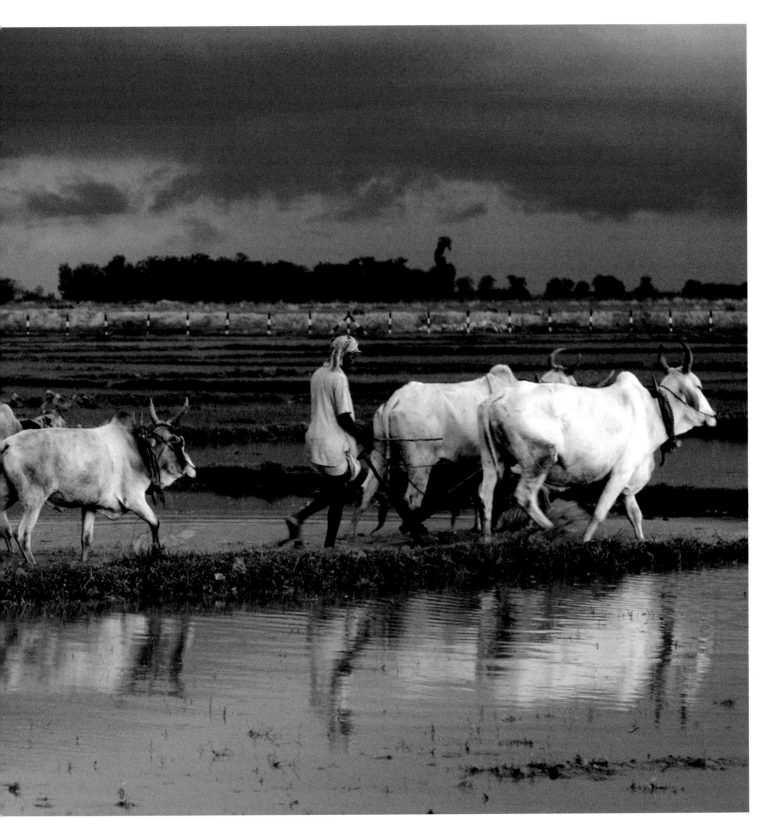

the luxury of sending children to school—but the land can't support expanding families, either.

scholarships and rural medical services to those in the Himalaya who need them most. Despite their teenage demeanors, Laxmi and her friends take the opportunity to attend school very seriously.

As a child, I never gave much thought to going to school. It was something we just did. Sure, I appreciated the opportunities for friendship and social interaction, but learning was just a by-product. Vacations passed too quickly, school terms were too long, Fridays took forever to come, and Mondays were upon us all too soon. Schooling was taken for granted. We never knew anybody who didn't go to school, and while we may have been proud of our achievements or those of our fellow students, I can't say that we were proud to go to school.

In Nepal, things were, and are, very different.

Before 1950, education was reserved for the upper echelon of society. The Ranas—the family that ruled Nepal for decades as hereditary prime ministers—recognized the political dangers of an educated population and knew illiteracy could be used as a tool for subjugation. A year before the Rana regime fell, only one percent of Nepal's children attended school. The national literacy rate was a mere 5 percent.

Fifty-five years later, more than half of the nation's citizens are literate, and even in the least developed areas there are more children who can read and write than children who can't. In many cases, these children are the first in their families to go to school—a source of pride for parents and students alike. In Nepal, attending school means more than gaining knowledge. It is about increasing one's value as a human being, about being recognized in the community as a person who can contribute to the development of the family, the village, and even the nation.

Baruna, another young high school student who is receiving a RHEST scholarship, told me that although an education would enable her to become a nurse, it would also give her an independence unknown by her illiterate mother and grandmother. But she recognizes the desperation of other girls whose parents are not as understanding as hers. "I work hard in the house before and after school," she said, "but some girls who don't go to school do nothing but labor from the moment they wake until the time they sleep. They know they'll be married off early or sold into servitude, or worse. They are so sad, and resigned to their future. I feel lucky." Some of the girls joke that an education will help them be matched with a better husband. But they also know that it will give them much more, and they are prepared to work hard for it: The high school graduation rate for RHEST students is three times the national average.

While education in Nepal is making progress, barriers remain. Many families face difficult decisions in sending children to school, and limited options are available to them.

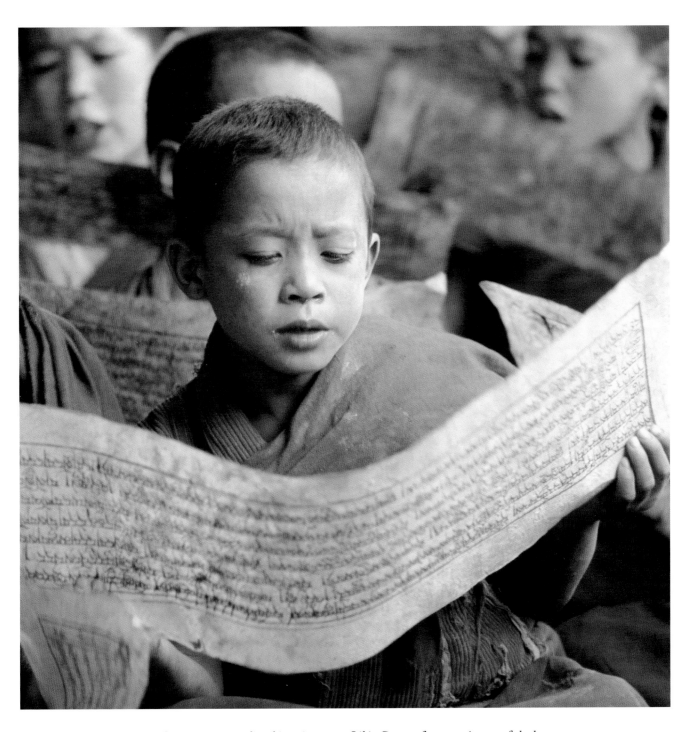

This novice monk, or tawa, *is reading his scriptures at Likir Gompa, for centuries one of the largest monasteries in Ladakh, northern India. In 2001, when photographer Jaroslav Poncar revisited the monastery, he found that the monastic school had grown even bigger in the 20 years since his last visit.*

A child in school, particularly an older child, means one fewer pair of hands to help earn an income or care for younger siblings at home.

While I was visiting the remote area of upper Mustang, north of Annapurna, a group of teachers asked me to the home of a 14-year-old boy whose father had taken him out of school after class 5, the last level of compulsory schooling. The teachers judged Tashi to be very bright, and they hoped I would be able to add to their voices and convince his parents to enroll him in high school. His parents were poor and uneducated, but not unintelligent. "We realize that it would be better if Tashi continued in school," his father told me with regret, "but he is our only child, and I need help with the farm. The harvest and livestock are our main sources of income, and my wife and I can't do it alone anymore." There was undeniable logic to their argument, but young Tashi's face showed such disappointment. Hope had been pulled out from beneath him; he would be among the 50 percent of teenagers in Nepal who don't attend high school. Children in Nepal, particularly in rural areas, wear their school uniforms with pride. Despite an inadequate syllabus and a dysfunctional system in which fewer than 30 percent pass the high school exams, they appreciate the opportunity to learn, and Tashi wanted to get all the learning he could.

Another example: In early 2005, the police handed over a young, mentally disabled child, Sujan, to a shelter for street children. From there, he was enrolled in the Navjyoti Center for Mentally Handicapped Children. Both the shelter and the center are supported by the American Himalayan Foundation.

On his first day, I arrived at the shelter to take him to school. Usually, he found it almost impossible to communicate with words or emotion, but when he saw his uniform, his joy was apparent. Here, even a child as developmentally challenged as Sujan recognized that going to school was a near-incredible opportunity. For years he must have watched as other children filed past in the mornings in spotless school dress, carrying backpacks full of books to some magical land known as school. Now, at eight years old, he would join them. The shelter staff later told me that the following Saturday—the one-day weekend for Nepali students—they had a hard time stopping him from dressing in his uniform and heading out the gate for the bus.

More than 4,000 students, many of them girls, now receive AHF assistance in attending school. It can cost less than one hundred dollars a year per child, but the value that comes from such a contribution is priceless—for the students, the community, and beyond. Thousands of young lives now move toward a future in which they can be independent, free from the confines of ignorance, able to contribute to the development of their nation to a far greater degree than the generations that came before them.

WALKING AGAIN

Ashok K. Banskota

Ashok K. Banskota, born in Nepal in 1948, is an orthopedic surgeon trained in the United States and devoted to bringing expert care to the Nepali people. He helped found the Hospital and Rehabilitation Center for Disabled Children, a specialized children's orthopedic hospital near Kathmandu, which has become a beacon of hope for disabled and disadvantaged children.

Himalayan travel occurs mostly on foot, meaning that the sick and injured must be carried to receive treatment.

NEPAL'S MOUNTAINOUS TERRAIN, ruggedly beautiful though it is, can present an enormous obstacle to the sick person in urgent need of medical attention. A limited infrastructure of roads and communication means that serious limb- and life-threatening complications often develop before patients are able to reach a hospital.

Children are especially at risk. They are commonly looked after by older siblings or the elderly while the parents are away at work. A toddler named Kanchi was one typical victim: At her home in the far western district of Dadeldhura, she fell into the kitchen's open fire pit and severely burned her thighs, legs, and groin. She survived, but her life

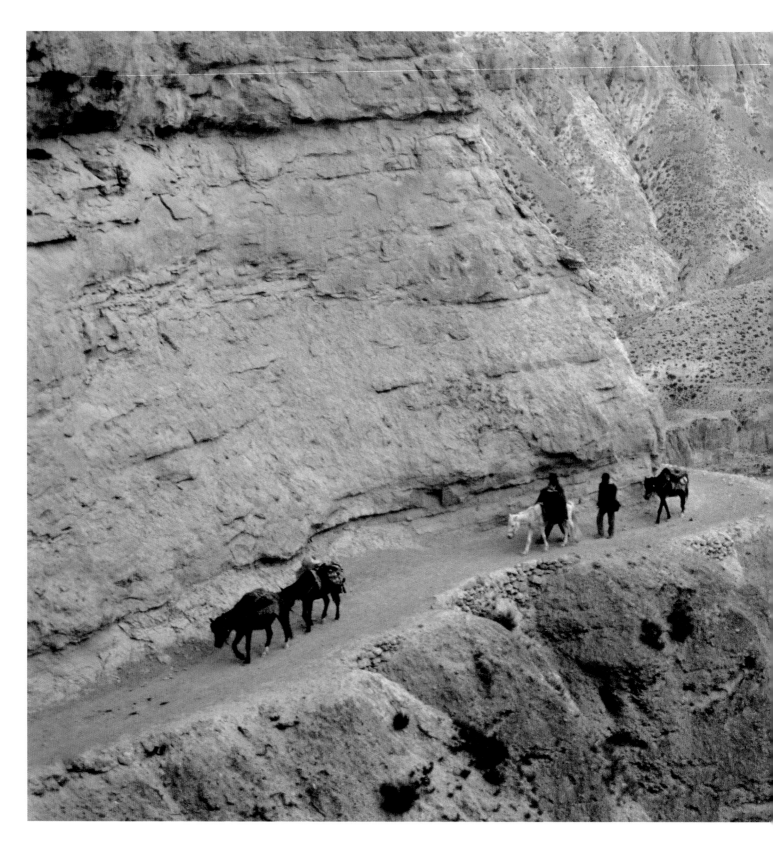

Nepal's rugged terrain—seldom as benign as this main trail to upper Mustang—requires

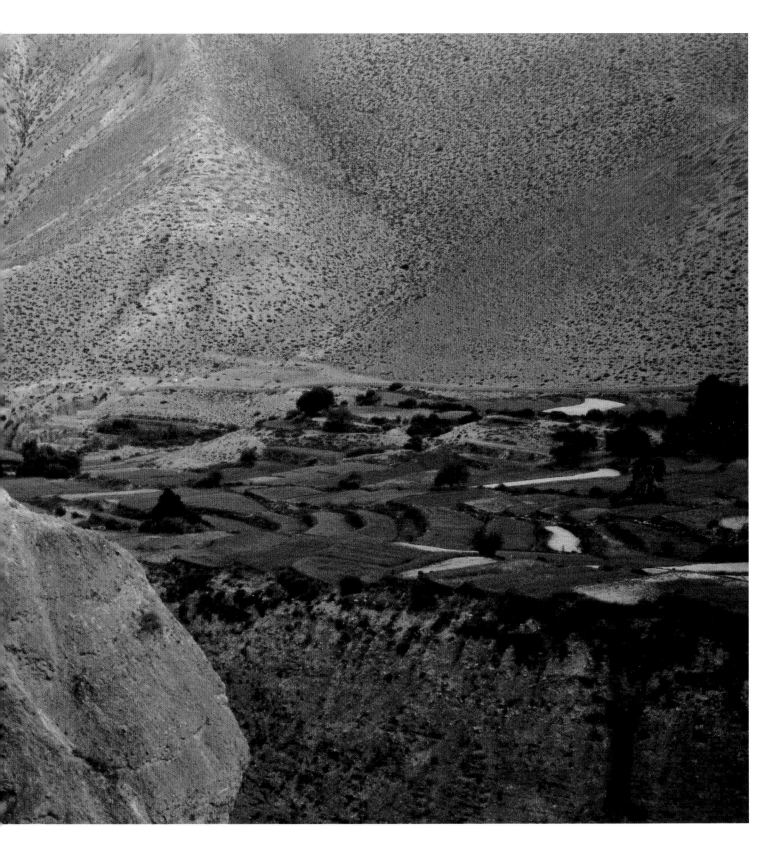

that field teams be dispatched to remote areas to identify children in need of medical care.

was changed forever. As a result of burn contractures, she could only propel herself around the house with her hands. Surrounded by poverty and teased by other children, her life was perpetual misery.

At the age of 15, however, Kanchi was screened for treatment at a mobile camp of the Hospital and Rehabilitation Center for Disabled Children (HRDC). A five-hour operation successfully relieved her burn contractures, and skin was grafted to fill the raw defects. In an intensive treatment regime, doctors, nurses, physiotherapists, and orthotists helped her regain mobility and strength. The rehabilitation worked. One day, she finally stood. And then—for the second time in her life—she began to walk. After three months, she was walking independently. It was a joyous moment for the staff of the hospital when she joined other children of her age at school.

In another instance, a 14-year-old boy named Hari had suffered a bone condition of his left shin that would not heal. Despite several operations, he had not walked upon his leg for nearly ten years. His parents could do little for him.

By now psychologically disturbed, in addition to lacking love and attention at home, Hari ran away, alternately dragging his leg or hobbling about on splintered crutches. In the streets of Chitwan, where at least he was anonymous, he searched desperately for a job. With his one good leg, he found sufficient strength to power a bicycle rickshaw, which gave him a way to be useful. But the infection worsened and the wound on his injured leg dehisced, exposing the metallic hardware. Gradually, the metal implants began to loosen and fall off.

At the HRDC outpatient clinic, Hari's condition was quickly diagnosed as pseudarthrosis, a congenital defect of the bone. Its management is extremely difficult, but Hari was admitted, his wounds cleaned, and the metallic implants removed. The shin deformity was straightened and the leg immobilized in an external ring fixator, an ingenious device that encircles the affected limb. With controlled traction applied through adjustment screws, bone tissues actually grow toward each other in response to natural bone-mending impulses. The design of the fixator permits the surgeons to devise almost any correction, including lengthening of bone, shortening, or angular and rotational correction. Plus, these metal fixators can be reused, after sterilization, many times over. We have scores of them in use at the hospital at any one time.

After six months of treatment, Hari was discharged to a group home, the external ring fixator still attached. Since then, he has fully recovered and is able to walk normally. Not only is his left leg functional, but his entire physiognomy and mental state have revived. During rehabilitation at the hospital, Hari learned to read and write, and now he has begun studying to become a doctor.

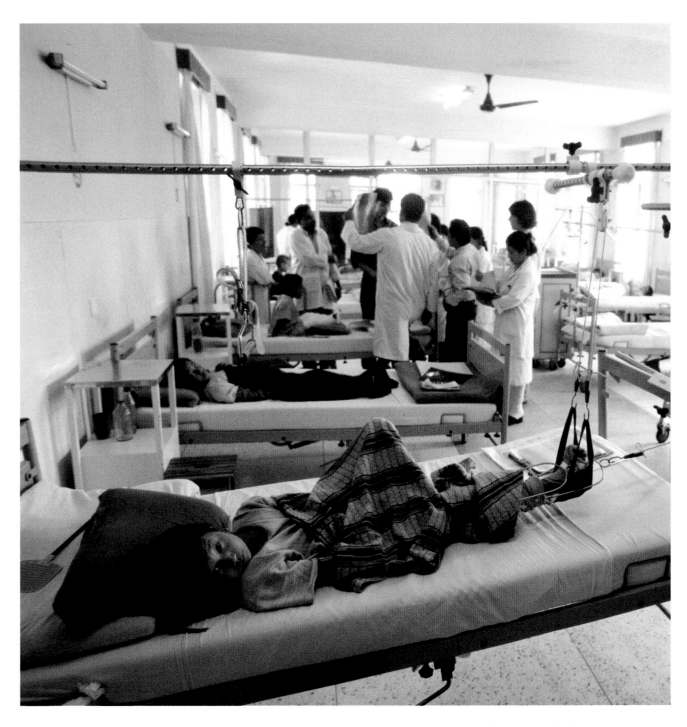

Nepali orthopedic residents make rounds at the Hospital and Rehabilitation Center for Disabled Children in Banepa, near Kathmandu. These young doctors perform complicated surgeries with skill and care, but it is their compassion and enthusiasm that endear them to their many young patients.

Distressingly, Hari's and Kanchi's stories are not atypical. Since 1985, HRDC has been providing comprehensive surgical and rehabilitative care to musculoskeletally handicapped children under 18 years of age, especially those from disadvantaged socio-economic backgrounds. We see congenital deformities of every type, infections in bones and joints and their complications (including pyogenic infection, tubercular disease, and poliomyelitis), chronic burn contractures, disabilities resulting from neuromuscular afflictions and nutritional deficiencies, complications from untreated or inadequately treated injuries, and more.

Strength doesn't come from physical capacity.

It comes from an indomitable will.

—Mahatma Gandhi

Due to poverty, little or no initial treatment, and logistical difficulties that result from Nepal's mountainous terrain, we often see these disabilities at a dramatically late stage. To address this, HRDC has developed an extensive village outreach program in addition to its hospital-based activities. Field workers travel to 30 districts throughout Nepal, conducting home visits, participating in mobile camps, providing education on preventative care, and promoting the services we provide.

Field work is essential, and it focuses on prevention. Nearly half of the cases we see, including burn contractures, infections, and complications from trauma, are preventable. Education and provision of basic human needs such as improved sanitation and clean drinking water would greatly reduce such preventable causes of physical disability.

There is some concern about the future. Will the services be interrupted? There are no guarantees, but I am convinced that good, honest work will find the support it needs, while the needy children of Nepal will certainly continue to need our help. HRDC is passing through its adolescence, and we are working to expand our field outreach activities to include safe and simple surgeries in more rural treatment facilities. I would love to see satellite HRDCs established, which would benefit even more children and free up the central complex to handle more difficult work.

The HRDC success story involves many, including the American Himalayan Foundation. It is the best work anyone could ever ask for: fulfilling, pure, divinely rewarding. We have taken large strides, as have the children we have helped, but there are many more miles to go on this fascinating journey of healing, helping, and sharing.

Jigme Palbar Bista

Jigme Palbar Bista, the Raja or Gyalpo of the Kingdom of Lo (Mustang), is the 26th in a long and illustrious lineage of monarchs who have ruled this regional kingdom since the 14th century. He is the only king to have witnessed Mustang's ancient glory as well as its recent progress.

*Born to an aristocratic family in Shigatse, Tibet, the
Queen of Mustang is respectfully called Gyalmo Kusho.
She presides with a quiet yet commanding grace.*

IN THE YEAR 1350 IN THE LAND KNOWN AS LO, or Mustang, a village elder had a prophetic dream: Their future ruler would arrive imminently. At noon the next day, my unsuspecting ancestor, Amepal, 25 generations previous to my own, arrived in Mustang. He was traveling from Tibet on pilgrimage to India, but the local people insisted he become their leader, the first Raja of Mustang.

Since that time, Amepal's descendants, my family, have ruled this magnificent land, sequestered from modernization. Because our land is filled with untouched monasteries

At the 15th-century monastery overlooking Tsarang in upper Mustang, young monks participate in
a ceremony of greeting for a respected lama emerging from a three-year-and-three-month solitary retreat.

from the 15th century and our government is based on Buddhist teachings, some say we are the last remaining Tibetan kingdom.

My family has governed in accordance with these Buddhist laws, which provide guidance for a leader in matters of knowing one's people, knowing what is beneficial, and knowing the right measure at the right time. Specifically, they discuss virtues of sacrifice, gifting, virtue, austerity, integrity, forbearance, and causing no harm or violence. Central to all of these teachings is the welfare of our people.

These laws have sometimes been hard to embrace. For instance, the people of Lo want a road to be built near Lo Manthang that would bring vehicles from Tibet to our villages. They believe the road will reduce costs and add convenience to their lives. Personally, I am not in favor of the road. In rural Tibet, I have observed the negative influences of truck traffic, such as an increase in prostitution, creation of pool halls, and outsiders controlling commerce. I fear that our ancient horse culture might disappear.

I worry also that the road may damage our ancient monuments, and the *dzagri*, the tall boundary wall that has protected Lo Manthang for centuries. Like the houses here, the dzagri and temples are made of compacted clay, and the experts who have come to restore them tell me that the vibration of passing vehicles will weaken these structures until they eventually crumble. And I fear the road could shatter the peace of our tranquil valley.

According to our Buddhist laws, however, I must put aside my own personal views and act in harmony with my people. After lengthy negotiations with the Lobas (the people of Mustang), district officials, and the United Nations, I am pleased that we have settled on an alignment for the road, some distance to the west of Lo Manthang. Our people will still have access to it, but the traffic will not endanger our cultural treasures.

Modernization is also saving our culture. The two great monastic assembly halls within Lo Manthang, Thubchen and Jampa, were built by my ancestors many generations ago. The walls of these buildings are painted with murals of cherished deities, but for the past couple of centuries they have been neglected and have fallen into disrepair, partly due to Mustang's poor economic conditions. Just when we feared they would collapse, the American Himalayan Foundation arrived with the skills needed to repair and restore our ancient monasteries and, more important, our divinities.

Our villagers have now been trained in the delicate techniques of restoration work, which means that we can eventually become less dependent on skilled people from the outside. In this one activity, Lobas have found a local source of income, they have earned religious merit, and they have boosted pride in our culture and history. A few years ago, if a young person wanted to be schooled in Buddhism, he or she would need to travel away from Lo, usually to Kathmandu or India. Now, with high-quality monastic schools in Lo, we have attracted growing numbers of student monks for religious training.

It is a good thing to see the outside world, but many young people are leaving—not just for seasonal work in India and the lowlands of Nepal, but out-migrating for work in America and other countries. It saddens me that these young people are lost to us, and often these are among the more enterprising and ambitious. In the midst of my discouragement, however, I must also be concerned for their welfare. As our youth continue to grow and experience the wider world, I hope that they find health and happiness, and always carry with them the values and beliefs that they have learned here.

While for generations our kingdom has, by modern standards, been on the decline, we are also fortunate that our many precious monuments, especially our grand monastic assembly halls, still stand to remind us of the great cycle of life. Lo will rise again. My son, Jigme Singhi Palbar Bista, will continue to uphold all our traditions and work for the people. By witnessing their joy and well-being, I can thus die happily.

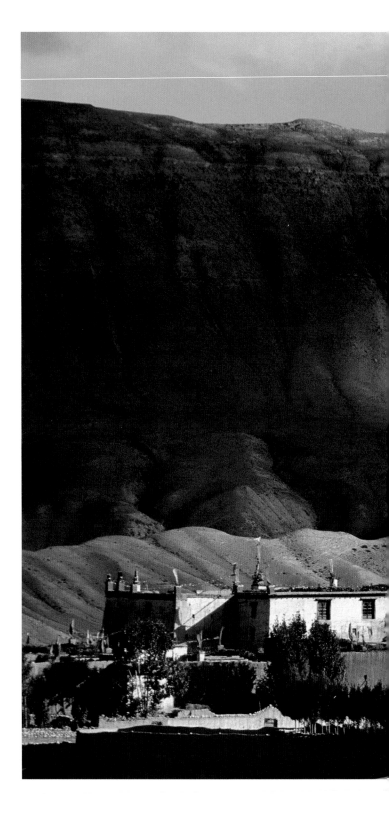

The secret of the mountains is that the mountains
simply exist, as I do myself:
The mountains exist simply, which I do not.
The mountains have no "meaning,"
they are meaning;
the mountains are.

—Peter Matthiessen,
The Snow Leopard

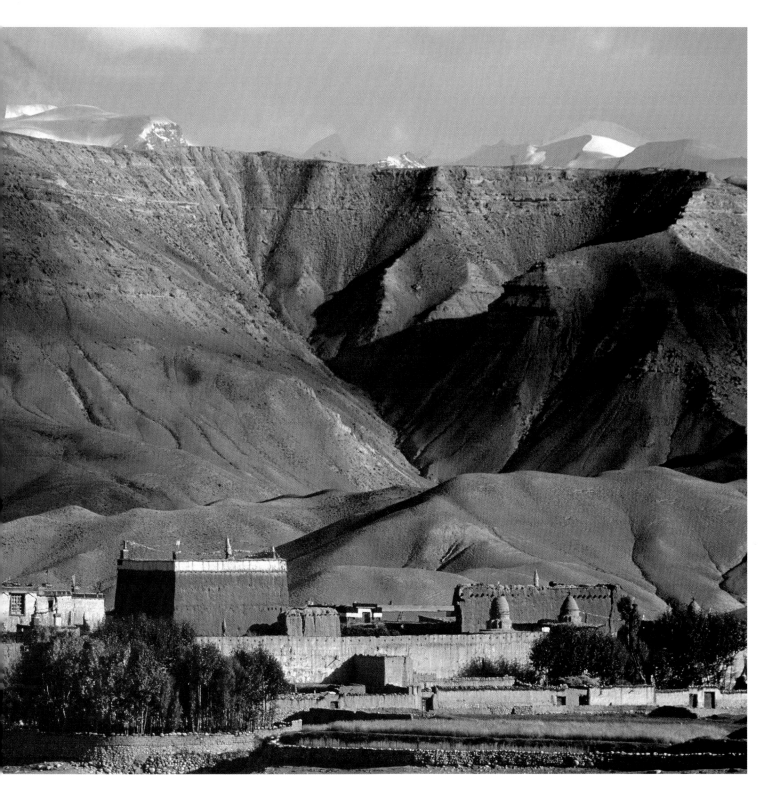

The city walls of Lo Manthang enclose the whitewashed Raja's palace and two ancient monastic assembly halls, Jampa and Thubchen, washed in red earth. Nearly a thousand people reside within these walls.

RESTORING HISTORY

John Sanday

John Sanday, a British architect and conservator, has lived and worked in Nepal for 36 years and has championed Nepal's architectural heritage. He leads the AHF Cultural Heritage Conservation team in Mustang and Bhutan. For conserving monuments and training new conservators in Nepal and Cambodia, Queen Elizabeth II recently awarded Sanday the Order of the British Empire.

I FIRST CAME TO NEPAL 36 YEARS AGO, to do the work I am passionate about: preserving and restoring ancient monuments. At that time, little did I realize that some of the most exquisite structures in Asia lay sequestered in the forbidden kingdom of Mustang, closed to the outside world—until 1992, that is, when I was introduced to the most daunting, and rewarding, challenges of my professional career.

I had been sent to solve a problem: A roof in the main monastic assembly hall of Thubchen, a 15th-century Buddhist temple in Lo Manthang, Mustang's medieval capital, was failing, threatening the integrity of the structure and its superb and delicate wall paintings.

Inside the walled city of Lo Manthang, I wandered the narrow alleyways and ducked through tunnels beneath houses, arriving at a massively wide building. From there, steps led downward to a small porch. An elderly woman, her smile shining through a face coated in soot, opened ancient padlocks that led through an antechamber to a second set of oversized, carved-wood doors. Stepping through this humbling entranceway into a cavernous prayer hall, I was transported into a world of splendor, history, and magic.

Before me, 35 20-foot-tall columns rose toward a darkened ceiling. From the far end of the hall, 20 feet up, the eyes of a beaten copper image of Shakyamuni Buddha surveyed all who entered. A statue of Guru Rinpoche—the Lotus-born Padmasambhava— sat on a lower and smaller altar in front, as if ready to step down to receive visitors.

Dimly, the outlines of wall paintings peered from behind centuries of soot: an odd glint of gold, a muted richness of greens and reds, all painted in brilliant but restrained decoration. What distressed me most was the disfigurement of these images. In some places, rain and leaking meltwater had incised channels nearly two inches deep across the paintings, from ceiling to floor. The base of the rammed-earth walls, eroded by water

A monk prepares a sand mandala in the newly restored Thubchen monastic assembly hall in Lo Manthang, upper Mustang. During its preparation, the lamas infuse the sand with the power of their prayers. When completed, the mandala is swept up and poured into the river, dispersing blessings throughout the valley.

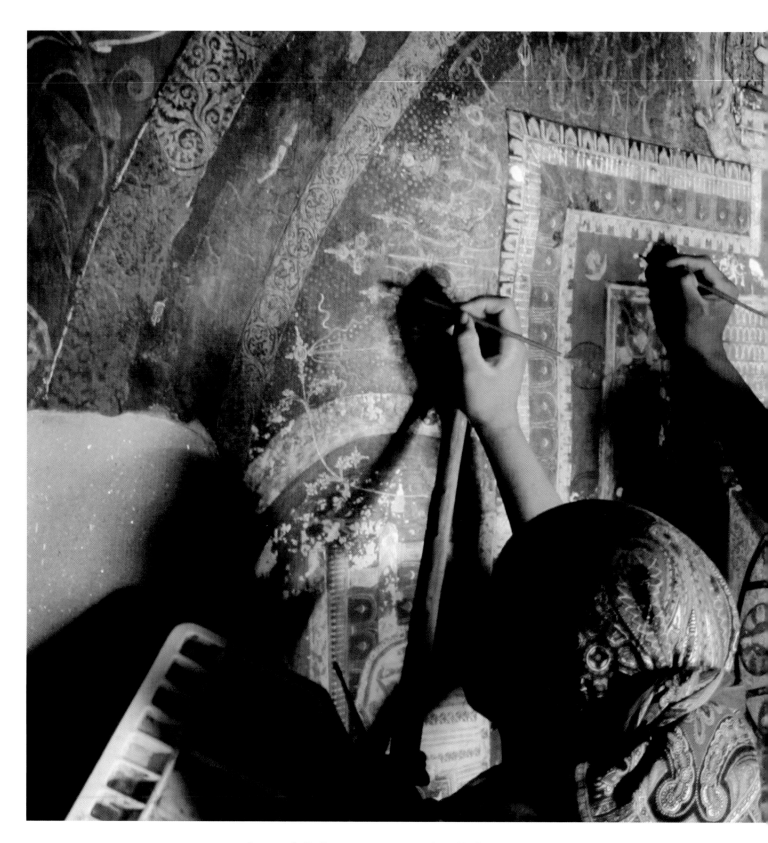

Overseen by Italian conservationists, talented Loba trainees restore priceless wall paintings

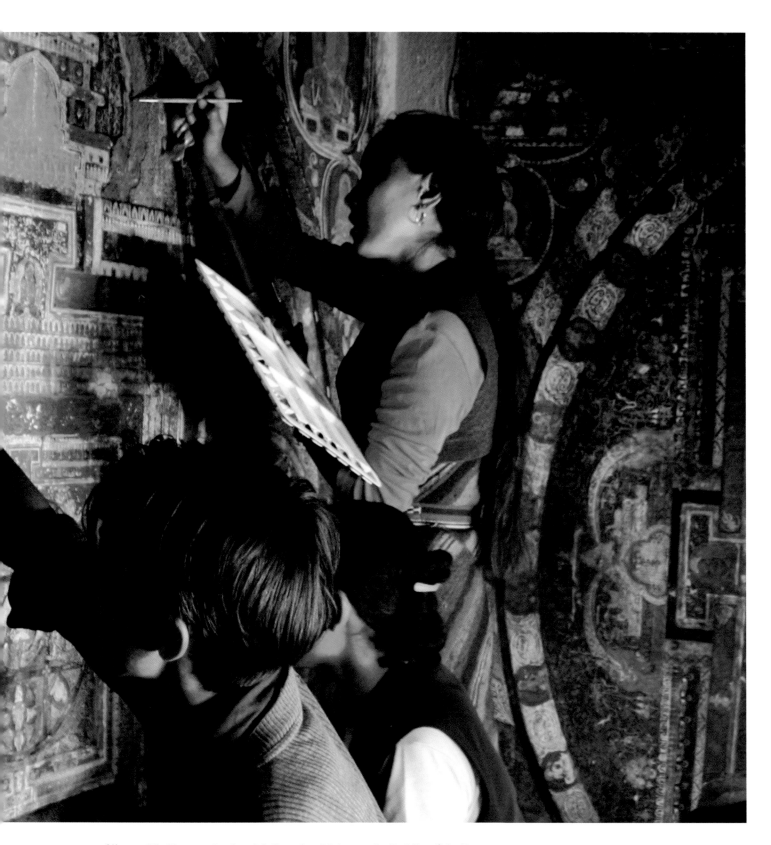

of Jampa Lhakhang—the chapel dedicated to Maitreya, the Buddha of the Future.

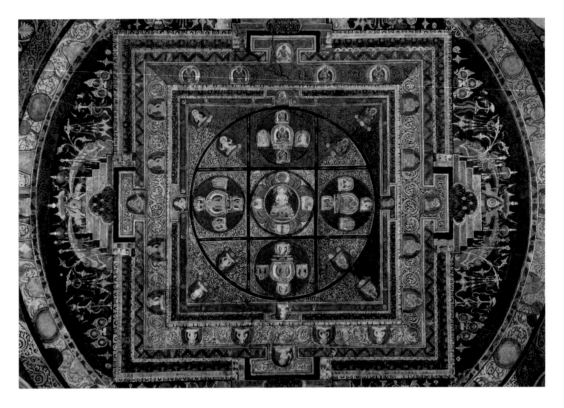

*Mineral pigments endow a mandala with richness in the Maitreya chapel in Lo Manthang. Leaves
of malachite and flowers of cinnabar and orpiment fill an azurite sky, with jewelry rendered in gold.*

penetration, had been crudely buttressed by river boulders. We soon discovered the
problem: Several of the principal rafters over the main altar had fractured, and any dis-
turbance could easily trigger the collapse of the three-foot-thick earthen roof that these
rafters supported. Within hours, we rigged some temporary support—and thereby
secured the confidence of the local community, early on.

In Kathmandu, I had worked with an expert team of Newar carpenters from Kirtipur,
a center for traditional artisans, and I knew wall painting specialists from Italy with expe-
rience in consolidating, cleaning, restoring, even temporarily removing priceless works of
art from their foundation walls. All of us, working together, could save Thubchen.

The village crier meandered through Lo Manthang's alleyways, hailing the Lobas to
a town meeting. The Raja, accompanied by the Khempo, the Lobas' respected religious
leader, presided from the shade of umbrellas held by their attendants. Lo Manthang's
elected leaders guided the discussion, modulating it to a controlled brawl, the usual tenor
for such gatherings.

Before the work could begin, the Khempo conducted an Artsok ceremony, to protect the "wisdom beings"—the sacred energy of the deities that inhabit the statues and wall paintings, which would feel the pain of repair work. The Khempo strolled purposefully beneath the soot-darkened deities of Thubchen's assembly hall, holding before him a staff topped by a mirror-like brass disk called a *melung* to collect the sacred energy. Then he carefully enveloped the disk in a blessing scarf. During the restoration work, it was to this veiled disk that the Lobas performed prostrations. Following completion of the work, the ritual was conducted in reverse, the sacred energy retransferred to the walls and statuary.

Large timbers were needed to replace those distorted and fractured by age and earthquakes. The Raja himself offered to gallop on his horse—the fastest in the kingdom—over a 16,000-foot pass to a village well beyond the Tibet border to personally cut a deal for timber. Once the lumber was delivered to the frontier, teams of villagers had to carry 60 large beams, eight people to a timber.

Twenty feet above Thubchen's floor, the columns end in finely detailed capitals. They bear composite beams made up of 11 layers of timber, arranged in a network so complicated that the Newar carpenters built a scale model to understand the structure. By applying loads to the model, the team diagnosed the dynamics that had slowly contorted Thubchen's extensive roof.

The painting restoration team had worked on Renaissance wall paintings in Italy, yet even they were astounded by the beauty and quality of Thubchen's masterpieces. After experimenting with various cleaning formulas, they developed simple techniques to consolidate and then restore the frail paintings. Their enthusiasm infected the community, too, especially when the gilded, smiling face of a Shakyamuni Buddha once again beamed from the wall, his form swathed in cinnabar robes of deep and radiant detail, highlighted by patterns of gleaming gold and silver.

The real challenge—and ultimate success—lay in training the team of more than one hundred Lobas, at least a dozen of them women, in the art and science of structural repair and wall-painting conservation. The Italian specialists agreed that these workers were among the most naturally talented and diligent novices that they had worked with. Now, after six years of work and practice, the Loba trainees are sufficiently competent to lead restoration teams in other neglected Himalayan valleys.

Mustang may be entering a new renaissance of its own, for in less than a decade we have seen the revival of disappearing art forms and building traditions. Personally, I'm proud that our team has helped to rejuvenate the local community and bring renewed interest in traditional religious art and architecture to the people of Mustang.

THE HIGH ROAD TO LO

Broughton Coburn

Broughton Coburn has worked in conservation and development in the Himalaya for 20 of the past 33 years. He is the author or editor of six books on the region, including *Everest: Mountain Without Mercy* and, for young adult readers, *Triumph on Everest: A Photobiography of Sir Edmund Hillary*. He lives in Wyoming with his wife and two children.

FROM A WIND-BLOWN RIDGE AT 14,000 FEET, our ponies descended in a slow-motion surf ride across a rumpled desert landscape. Through the valley fog, the outline of the ancient walled city of Lo Manthang appeared, resting placidly on an irrigated oasis, as if arising from within our imaginations. An avalanche of adjectives from early journals of British exploration cascaded over me. Timeless. Austere. Forsaken. Glorious. I pictured multitudes of wild-eyed serfs streaming from the citadel's turreted bastions. Someone had set back the calendar on us, like a thousand years or so.

Lo Manthang, the capital of Lo, or Mustang, is entered through a single opening in the 15-foot-thick wall. The late afternoon's gathering of villagers, nomads, and children greeted us. "We have a wager to settle," one of them led off boisterously. "Do you shear the hair that grows all over your bodies and then sell it?" Ah. The subject of hairy arms always works as a conversation starter.

A feudal monarchy of nobles, monks, herders, farmers, and traders, governed by a king—the Raja, or Gyalpo—Mustang endures as a window on life in Tibet before the Chinese occupation. The Tibetan-speaking Lobas have been shielded by, or are victims of, their isolation. They understood the Buddhist Wheel of Life—the cycle of birth, death, and rebirth—before they knew the wheel.

I was here for the American Himalayan Foundation, reviewing snow leopard conservation work and other projects. Like a good development worker, I asked one villager leader near Lo Manthang what he regarded as the primary need of the village.

"Ammunition." Seeing my perplexed look, he elaborated. "More bullets."

"For…?" I asked.

"For killing snow leopard. How else can we keep them from eating our livestock?" In Mustang, the numbers of wild blue sheep—the snow leopard's main prey—have been

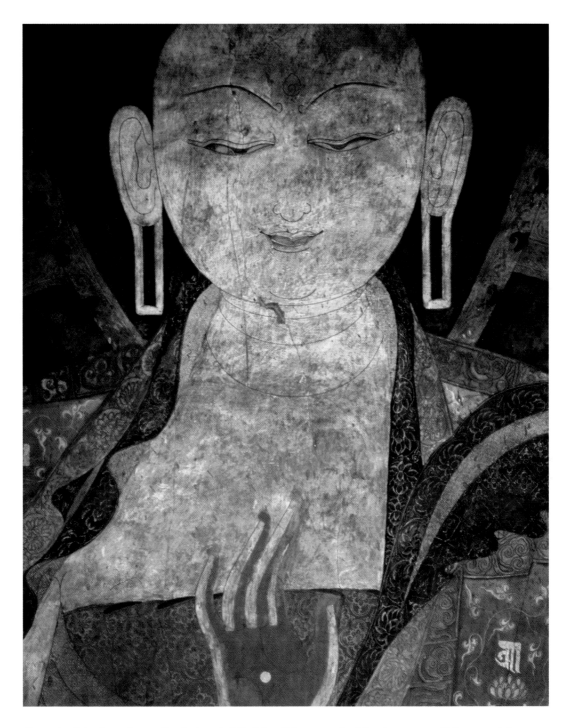

Several original ten-foot wall paintings in Thubchen Monastery, Lo Manthang, are still intact and date from around 1470, when the building was first constructed. The painting above, one of eight Medicine Buddhas on the south wall, was photographed before cleaning; now its gold appears brilliantly new.

The caves of Drakmar, in upper Mustang, estimated to be more than four thousand years old, offer a glimpse into an era before the arrival of Buddhism one thousand years ago.

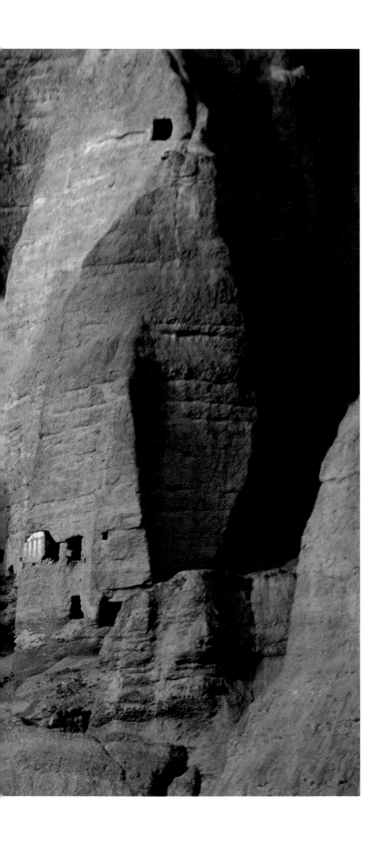

Love and compassion are necessities, not luxuries.
Without them, humanity cannot survive.

—His Holiness the Dalai Lama

declining, and the livestock herding techniques of the Lobas are less than perfect. As a result, the feline phantoms have been leaping into corrals full of sheep and goats, killing 50 or more animals in a single night. The Raja himself lost nearly 80 livestock in one such incident. The leopard had dropped through the smoke hole in the corral's roof.

Retaliatory killing is the usual response. The Raja has asked the Annapurna Conservation Area Project, the Snow Leopard Conservancy, and AHF if there are any other measures that might reduce the losses.

Chhimi Gurung is one who has responded, and he has chosen to brave Mustang's harsh winters rather than join the seasonal migration to the outside world. "Predator-proofing the corrals is the best way to keep livestock and snow leopard separated," he says. He has been helping villagers build traditional *gyang* walls of compacted clay, ten feet high, replicating the technique used to build Lo Manthang's great boundary wall. He has also introduced solar-powered electric fences that are portable, inexpensive, and effective.

Conservation and development in Mustang, as elsewhere, rely on the participation of local people. In a joint effort between AHF and the Lobas, ten day-care centers operate in villages throughout Mustang, introducing children to early education while freeing their parents to work in the fields. AHF also gives scholarships to older youth and educational support to monastic schools and nunneries, helping to reinforce traditional Buddhist training and provide incentives for young people to stay within the area. Even the youngest students are learning to read in three languages and write in three scripts.

The repair and restoration of Mustang's neglected monuments, AHF's longest running endeavor, may have provided the best inducement for young people to remain and build their community. When architect John Sanday first visited Lo Manthang's 15th-century Thubchen monastery assembly hall, he found soot and debris dating back more than a century. At the beginning of the restoration project, when his team was enlisting local trainees, more than one villager was skeptical. "Our young people are only wasting their time, playing about like children with foreigners obsessed by old things," an elderly matron said as she watched seven young Loba men brandishing cotton swabs alongside Italian restorationists.

Like lotuses blooming from the mud, darkened wall paintings soon emerged into brilliance. Momentum gathered quickly, and within two years, mothers of Lo were heard begging Sanday and the Italians to teach their sons and daughters, too. "Our youngsters would have found nothing but trouble to get into if they were simply hanging around here," one mother said. "Or they would have left for the big city or a foreign country by now, never to return."

The Raja (left), ex officio patron of Mustang's ancient monuments, and the Khempo, the area's religious leader, prepare to make heartfelt appeals at a boisterous town meeting held to assign restoration tasks.

If they want, Lobas can soon leave Mustang on a road. Sections of a motorable track are being dug from Tibet to the district center in Jomsom, through the middle of Mustang. But many are wondering what benefit it will bring to the Lobas. The road is likely to depress tourism and the traditional horse culture. Meanwhile, Chinese sundries, alcohol, and cigarettes are the most common imports, other than an occasional load of timber. The ancient, formerly forbidden kingdom is stampeding toward—or being dragged to—its date with the modern world.

But the modern era has also brought education, health, jobs, renewed appreciation for an ancient cultural heritage, and the technologies to preserve it. Each day during the restoration work, the Raja and the Khempo visited the temples, joined by Lobas wandering in from their fields and pastures. "It's as if you have brought sight to the blind," the late Khempo told John Sanday and his team. As they gazed upward, the color and luminosity of the painted deities bathed them in reflected light, blessing all as if radiance from heaven.

A lama performs a ritual dance in the courtyard of Buli Lhakhang, in Bumthang, Bhutan, during the rededication of the restored monastic complex. The lamas often retell and reenact the stories and legends of Buddhism during such special occasions, and dance is a common way of teaching religion to the community.

RENEWING THE PAST

Stan Armington

Stan Armington has lived and trekked in the Himalaya for more than 30 years. He is the author of two guidebooks for travel in the Himalaya, *Bhutan* and *Trekking in the Nepal Himalaya*. He is also the director of Malla Treks in Kathmandu, Nepal, and has founded some of the classic watering holes in South Asia.

IN FEBRUARY 2005, I SAT WITH conservation architect John Sanday in the courtyard of Buli Lhakhang, a 400-year-old temple in the small community of Gaytsa, in Bhutan's Bumthang district. We were watching the Mani Drubchen festival, which was kicked off by a cleansing fire ceremony. Excited villagers ran, leapt, and ducked through a blazing archway, while monks threw handfuls of gunpowder that exploded in a dazzling shower of sparks. My eyes and nose stung from the smoke and smell of singed hair. Every two years, the Buli community celebrates this five-day pageant of masked dances and religious allegorical plays, with women folk singers and buffoonery by *atsara* clowns.

As an author of travel books, I have visited every hotel in Bhutan, checked every menu, and eaten every version of *ema datse*, the national dish of chili and cheese. But my plan to similarly cover the country's religious buildings proved to be a naive dream. There are more than 2,000 *dzongs*, temples, and monasteries scattered across this mountainous kingdom—all in varying states of repair.

In many temples, once-brilliant wall paintings had lost their luster from centuries of smoke from butter lamps, and in many I found paint chips flaking to the floor. Typically, timber beams were riddled with insects and rot, awaiting collapse. In Bhutan, such temples are usually torn down and completely rebuilt. Although Bhutanese craftsmen and artists are highly skilled, this proficiency is most often applied to new construction and to overpainting of faded frescoes with new images. Many Bhutanese understand the importance of their artistic heritage, but few artisans have the skill and knowledge to restore old works of art to the radiance they once possessed. My concern had led me to John Sanday, who was pioneering restoration techniques in Mustang. Together we visited many of Bhutan's significant temples and found that the restoration needs greatly exceeded our estimates.

Thuksey Rinpoche (far right) presides over reconsecration rituals at Buli Lhakhang. Buli's renovation marks

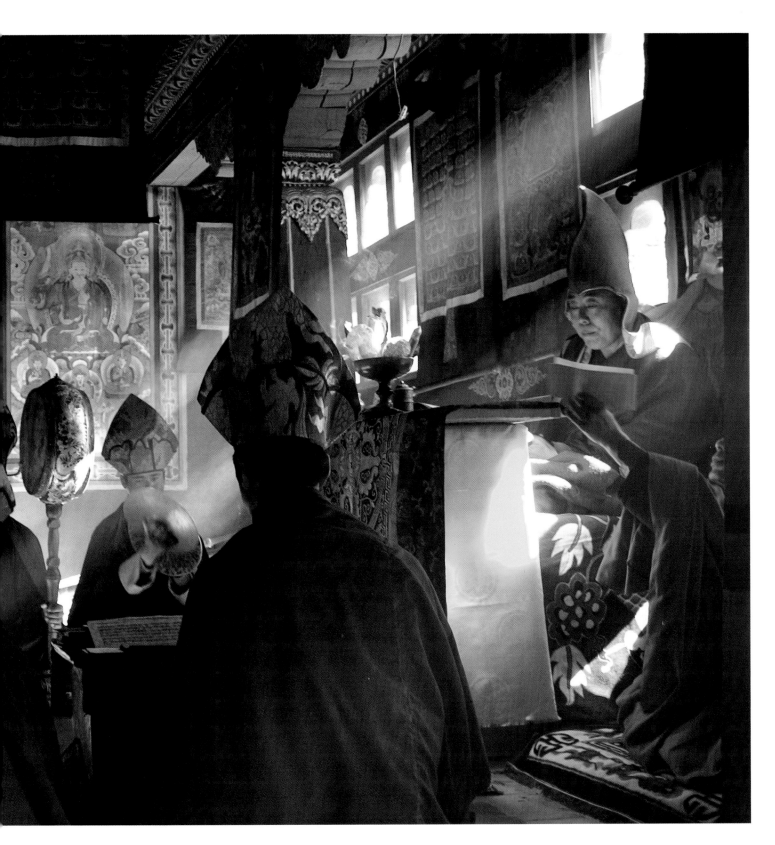

a turning point for Bhutan, now beginning to restore instead of reconstruct its sacred monuments.

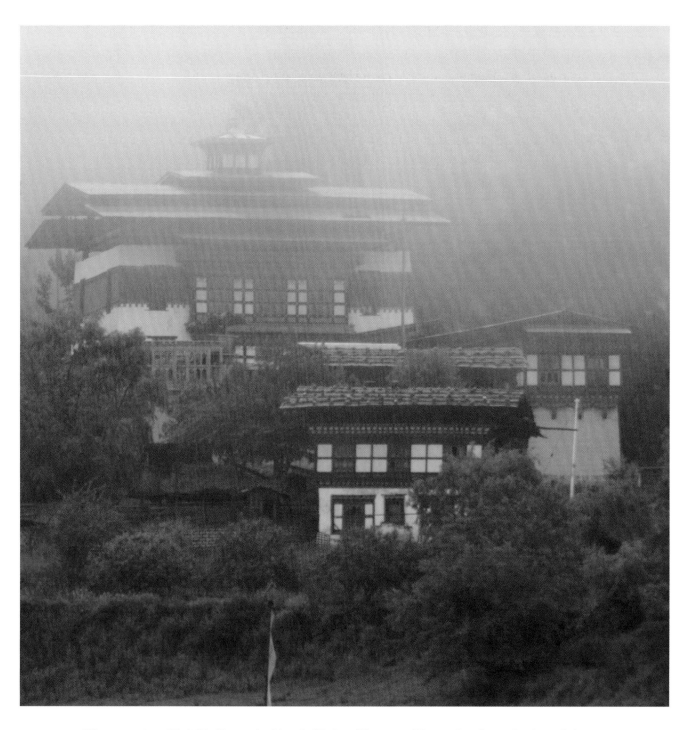

The restoration of Buli Lhakhang, the Chapel of Buli in Bhumtang, Bhutan, has shown that beyond the actual repair of sagging and tattered monuments, the training of local craftsmen in traditional construction and painting techniques provides an enormous long-term benefit.

We met with Prime Minister Lyonpo Jigme Y Thinley in Thimphu, Bhutan's capital. He exclaimed that our proposal was exactly what he had been searching for, and he sent us off to meet the home minister, who suggested that we focus on Bumthang, Bhutan's cultural heartland. We set off to choose the optimum "classroom" for the necessary architects, engineers, painters and painting restorers, masons, carpenters, and wood-carvers. Indeed, training of local craftsmen would be critical to the work's success.

We found the four-century-old monastic complex of Buli to be structurally threatened, and its wall paintings were deteriorating. The two-story decorated window (rabsey) was in a perilous state, and the severe tilt of the wooden columns that supported the upper floor terrified me. But John and his team exuded confidence.

Driving back to Thimphu, I spotted a friend by the roadside. We roared to a stop. It was not the person I expected, but his look-alike brother instead. Thanks to this mistake in identity, we inducted our first trainee, Karma Gelay, an architect who specializes in designing traditional buildings. Karma became the mainstay of the project, helping us to overcome bureaucratic hurdles and interpret the restoration techniques for the team of trainees.

An agreement was signed between the American Himalayan Foundation and the Royal Government of Bhutan, but before work could begin a ceremony was conducted in which the spirits of the divinities were collected and transferred to a protected place within the temple. The rabsey was removed and rebuilt, using most of the original timber. Village elders recalled for us how the building had been changed during previous repairs, and the team uncovered ancient carved columns. They restored the entrance to its original form and redecorated the exterior with traditional painted motifs that now blend seamlessly with remnants of the original.

Five years after it all began, under the gaze of the fully restored temple and immersed in smoke, color, and festivities, I watched the Buli Mani Drubchen. Buli's monastic complex now stands secure, and the wall paintings have been cleaned and restored into what has become an icon for building conservation technology. Lyonpo Jigme, now Bhutan's home minister, brought the *dzongdags* (governors) of the country's 20 districts to Buli, to show them what he described as the first sincere effort at building conservation in Bhutan. Most significantly, the Bhutanese trainees are keen and ready to take on new projects.

In December 2005, at an elaborate rededication ceremony, Thuksey Rinpoche, a visiting lama, transferred the spirits of the deities back to the statues and paintings. The spirits have returned. Indeed, they are thriving, and can now be worshiped with pride and devotion for centuries to come.

SERVING IN THE LAND OF SNOWS

Matthieu Ricard

Matthieu Ricard, born in 1946, is an internationally respected author, translator, and photographer. A Tibetan Buddhist monk, he earned a Ph.D. degree in molecular biology before leaving France for the Himalaya, where he has spent the last 30 years. He has published many books including, with his father, Jean-François Revel, *The Monk and the Philosopher: A Father and Son Discuss the Meaning of Life*.

EACH YEAR I VISIT A REMOTE AREA OF EASTERN TIBET. It takes an entire day to drive through high-altitude meadows covered with colorful flowers and pitted by holes and small hills created by tens of thousands of abra, cute tailless rodents whose underground galleries wreak havoc throughout the grassland. There are no roads or bridges in this land, so in order to avoid sinking into treacherous marshes, we climb over verdant hills and, when faced with a river, we use our car as a boat.

Driving through this landscape is unlike any other adventure. Tibetan drivers are virtuoso river crossers: They search for traces of car tracks, then judge whether the river is too high. They enter the stream neither too quickly nor too slowly, and as the water rises almost to the windows and begins to leak inside, some hold their breath, some recite mantras, some laugh excitedly. At times, the current has been so strong that we have felt the car being lifted and ferried sideways. As water flushes over the hood, moments of intense expectation are followed by sighs of relief and cheers once we reach the other side.

My first time in this magnificent region was in 1985, when I accompanied my spiritual teacher, Dilgo Khyentse Rinpoche, on his first return to his homeland after 35 years in exile in Bhutan and Nepal.

On our way to Shechen Monastery, 300 horsemen with tanned faces, clutching multicolored banners, came to greet him several hours from our destination. When Rinpoche arrived, monastery horsemen walked their horses around his car in a large circle, doffing their white hats in reverence as they passed in front of him and the monks leading the procession.

The nomads in the region, too, had hurried down from the hillsides to stand by the side of the road. Holding smoldering branches of juniper, which produced a fragrant white incense, each small nomad group stopped Khyentse Rinpoche's car to receive his

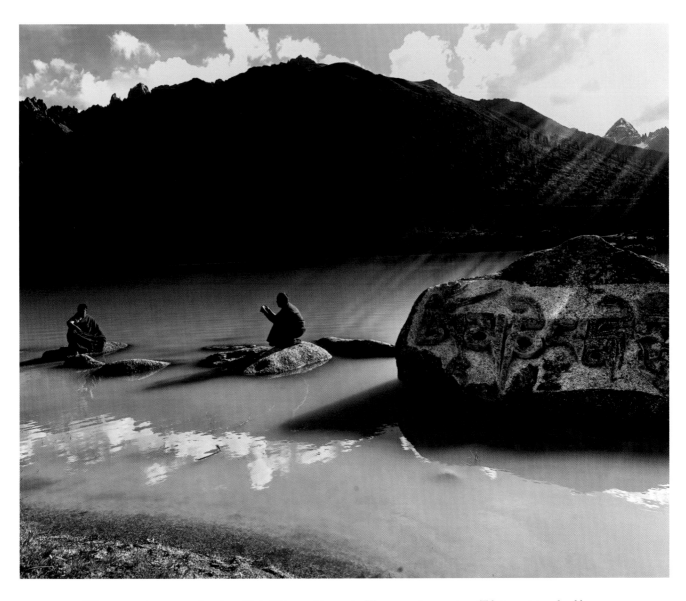

Tibetan monks rest on the edge of lake Yiloung Lhatso, in Kham province, eastern Tibet, next to a boulder engraved with Om Mani Padme Hum, *the mantra of Avalokitesvara, the Buddha of Compassion. Many of Tibet's greatest lamas come from Kham, and their teachings continue to reach around the world.*

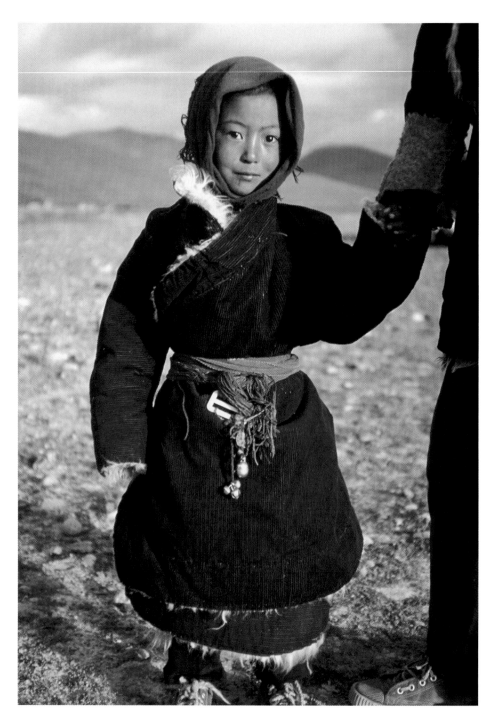

A young pilgrim on the Tibetan Plateau accompanies her parent to Mount Kailash. Religion is woven into the fabric of Tibetans' daily lives, and the vitality of their Buddhist faith, even after nearly half a century under Chinese rule, has not waned.

blessing. The women wore hair ornaments of coral, turquoise, and amber and carried, in the folds of their coats, children with cheeks reddened by the winter winds.

After 35 years, only ruins remained of Shechen Monastery. As Khyentse Rinpoche approached, the music of strident oboes, clanging cymbals, and the deep roar of 15-foot-long trumpets burst into life, filling the valley with majestic echoes. A long procession of monks and musicians led Rinpoche into a makeshift temple, the only structure still standing. When he took his seat, a crowd of monks and laypeople filed past to receive his blessing, gazing at him in fervent devotion. Few could hold back tears.

Prayer is not asking, it is a longing of the soul.

It is daily admission of one's weakness …

It is better in prayer to have a heart without words

than words without a heart.

—Mahatma Gandhi

Khyentse Rinpoche smiled at each one of them, now and then recognizing a face from the past. They would later tell him of their unspeakable ordeal at the hands of the Chinese, but on that day the first priority was the joy of reunion. For them, seeing Rinpoche was like witnessing a sudden, brilliant sunrise after a long night of darkness.

In my many trips back to the region since that first visit, I have seen this look of a dawning light peering behind dark and discouraged eyes. Since 2000, against all odds, the volunteers of the Shechen Project have built and now manage sixteen small clinics, ten schools, nine bridges, and two homes for the elderly. Each five- or six-room clinic is equipped with medical supplies and a doctor, who often lives there with his family, plus a helper. These medical outposts are primitive compared to modern facilities—there generally isn't even electricity or running water—but they are far better than the alternative of no facility at all.

Throughout eastern Tibet, the Shechen volunteers regularly encounter cases of gravely ill patients who suffer for weeks and months with little hope for recovery. A couple of years ago, we visited a group of nomads two hours from the monastery. In a yak-hair tent, a young girl churned cheese in a big pot on the traditional mud hearth erected in the middle of the tent. Sun rays played with the blue smoke that escaped

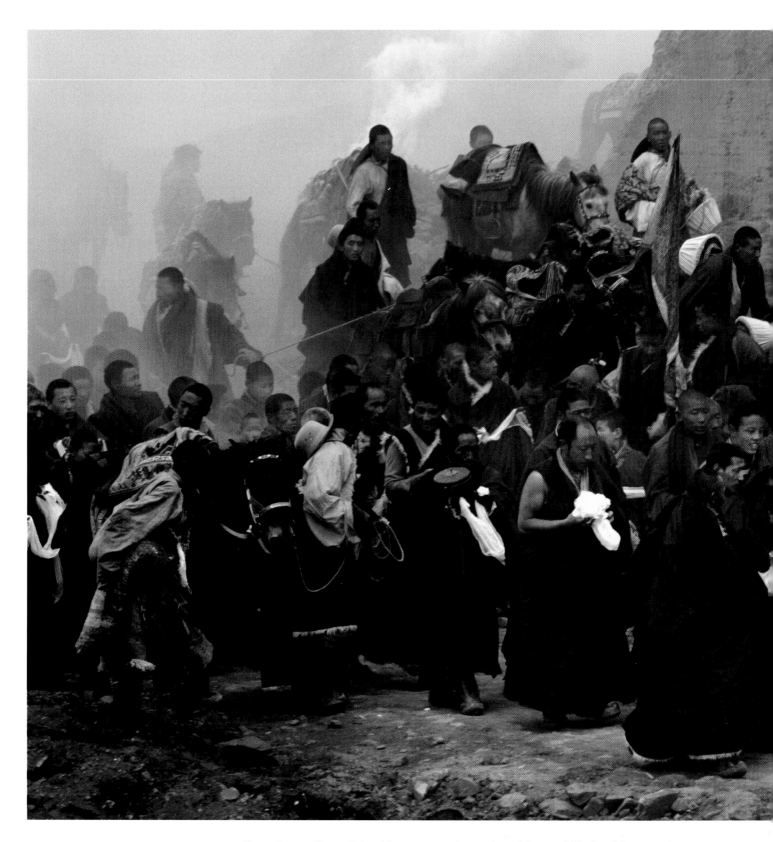

Preparing to offer traditional kata scarves, the monks and lamas of Shechen Monastery in

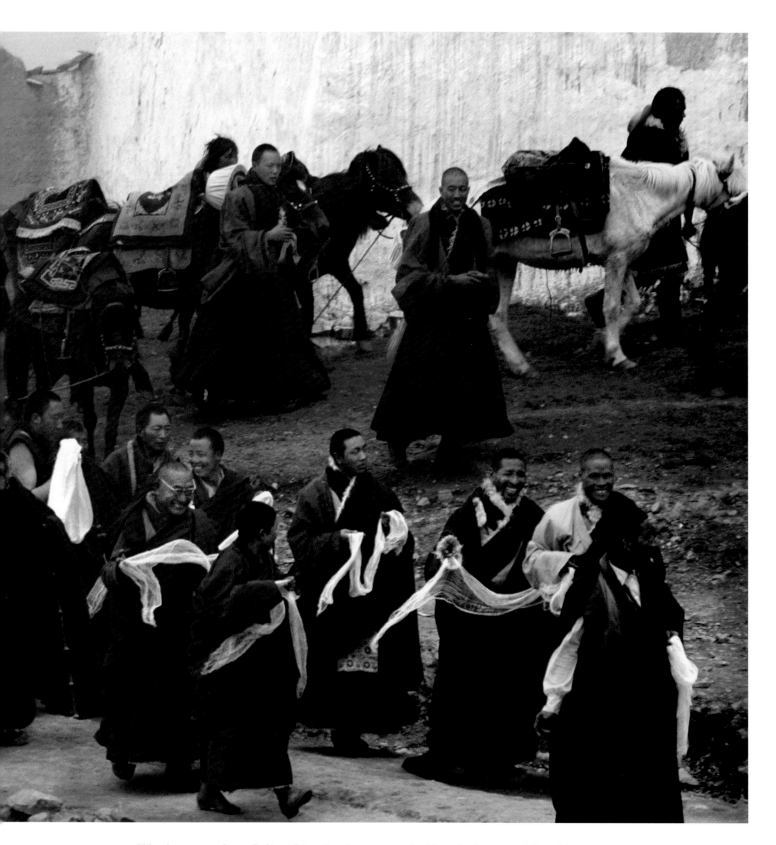

eastern Tibet hurry to welcome Rabjam Rinpoche, the monastery's abbot, who has arrived from Bhutan.

slowly through an opening in the ceiling. As the girl's grandmother sat in the background, reciting prayers, the girl's mother, Lhamo, lay on a small mattress. She appeared frail, and an eerie gaze issued from eyes that seemed too large for a face reduced to skin and bones.

When Lhamo first became sick, she had been taken on horseback to a small hospital two days' ride away. She was diagnosed with bone tuberculosis, but her family could not afford to buy the medicine to treat it. The illness progressed, and for three months she had been bedridden, with only her 13-year-old daughter and an elderly mother to attend to her and the chores. Her husband had died a year earlier.

Fortunately, we were carrying enough supplies to provide Lhamo with a year of medicines, and we carefully explained to her daughter how to administer them. The young girl listened attentively and her face registered a faint gleam of hope, mixed with disbelief that her mother would ever recover. Mumbling her prayers, unable to hold back tears, the grandmother thanked us profusely.

What counts is not

the enormity of the task,

but the size of the courage.

—Matthieu Ricard

Because of the Shechen Project, families like Lhamo's are receiving medical care in the face of impossibility. In addition to providing financial support and training for doctors, we also work to educate local people on how to be healthier. By conducting a small survey, we discovered that seven out of ten mothers had lost a child. Our response is called, literally, Save the Mother and Child, a grass-roots initiative which we hope will greatly reduce infant and child mortality. None of this would have been possible without the generous support of donors and foundations, mostly private, including the American Himalayan Foundation. The Shechen Project is run by a tiny staff, but our nascent network of medical centers is growing.

This year we returned to Lhamo's yak-hair tent. We had heard that she survived, but we little expected the radiant smiles of a woman whom we could barely recognize. Lhamo had gained weight and was walking on two wooden canes, her loving daughter at her side. ≋

HOPE BORN OF TRAGEDY

Tsering Lhamo

Tsering Lhamo was born in Tibet in 1958, and her family fled to India in 1960. A qualified nurse, she has worked in health care in the Tibetan community for many years. Currently she runs a health care clinic and organizes health training workshops for Tibet Charity, a nongovernmental organization in Dharamsala, India. She also works with elderly Tibetan nuns.

Nepali police return from the Tibet border after delivering 18 would-be Tibetan refugees to Chinese authorities. Reports suggest that refugees are often imprisoned and treated harshly after forcible repatriation.

I WAS BORN IN A SMALL VILLAGE BY THE NAME OF DUMO, in southern Tibet, where my father was the respected headman. But when I was two years old, my father and some of his friends were arrested for their political beliefs. They were among the first Tibetans who were arrested by the Chinese in Tibet, part of a group that became known as the First 47.

As part of a program of self-criticism and brainwashing called *thamzing*, the villagers were forced to come and torment my father. They pulled his hair, threw sand in his eyes, and kicked him in the back and face. By the end of the first day, he was unable to see and

couldn't stand up straight. Yet he had to endure this for several weeks. At the end, his head was nearly bald from his hair having been pulled out.

Then he was taken to China secretly in the group of 47 Tibetan prisoners. I never saw him again. I learned later that only two of the First 47 survived their imprisonment. My father was not one of the survivors. He died of starvation, in prison.

After my father was taken away, my mother fell ill with the shock. She died a year later, only in her early 30s. My brother, sister, and I were adopted by an aunt and uncle.

Then, in 1960, my aunt was informed that she was also about to be arrested by the Chinese, so we had to leave Tibet and escape into exile. Eight years later, at age 11, I was orphaned again when my adoptive parents died; at the time, I was in Dharamsala at the Tibetan Children's Village (TCV). I felt very lucky that the Dalai Lama's sister chose me to attend school there, and I was the only girl in the first graduating class, in 1978. By then, at a young age, I had become acquainted with both suffering and change—and with hope.

But tragedy struck again. My family and relatives spent many years working as road laborers in Bhutan and India. It was during that time that my brother had an accident; a tree branch fell on his chest, and he suffered an internal injury. He was taken to a hospital, where he died as a result of poor treatment. He was only 17. His senseless death is what inspired me to become a nurse.

I took my nurse's training in Southern India and returned to Dharamsala as the head nurse—the only trained nurse for the TCV school dispensary—caring for 2,300 students and 150 staff. This experience taught me that, when I begin a task, I should do it thoroughly and properly despite the difficulties that are bound to arise. Whenever patients would come to see me, day or night, I always cared for them or accompanied them to the hospital.

During those five years at TCV, I married and had a baby. My husband and I had nothing: a small room, a kerosene stove on the floor, a metal trunk, a few blankets. We found that loving and caring for each other was far more valuable than money.

In 1990, the Tibetan Department of Health deputed me as health coordinator, responsible for the Tibetan Refugee Reception Center clinic in Kathmandu. At that time, new refugees were coming to Nepal and India in large numbers, and their greatest need was to receive good health care. Initially, the reception center clinic was on the top of a small rented house, which was hard for patients unable to climb stairs.

Many refugees had sold everything they owned to buy food en route, and they arrived in exile with little more than the clothes on their back. The conditions are the worst in winter, and they arrived in Kathmandu suffering from frostbite, which

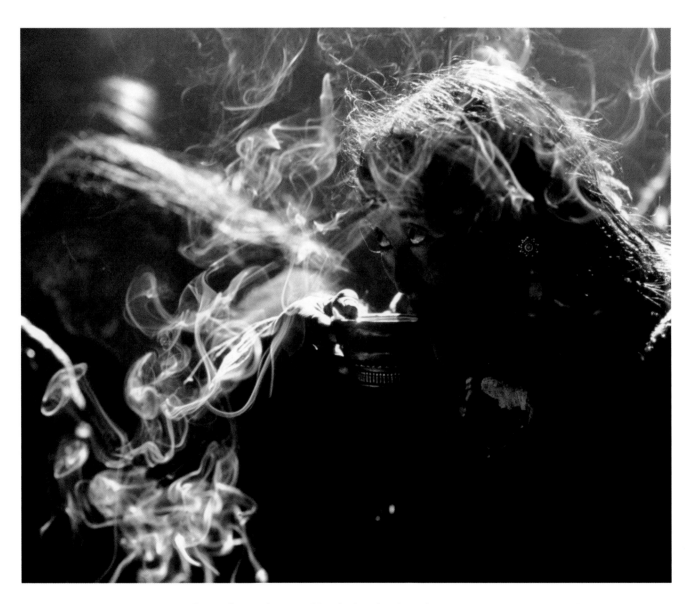

Trans-Himalayan traders in far northwestern Nepal take a break on their month-long trading trip. These border-area ethnic Tibetans and their yak caravans are allowed to move freely between trading posts in Tibet and Nepal, near the border, transporting lumber, grain, salt, and, occasionally, endangered animal parts.

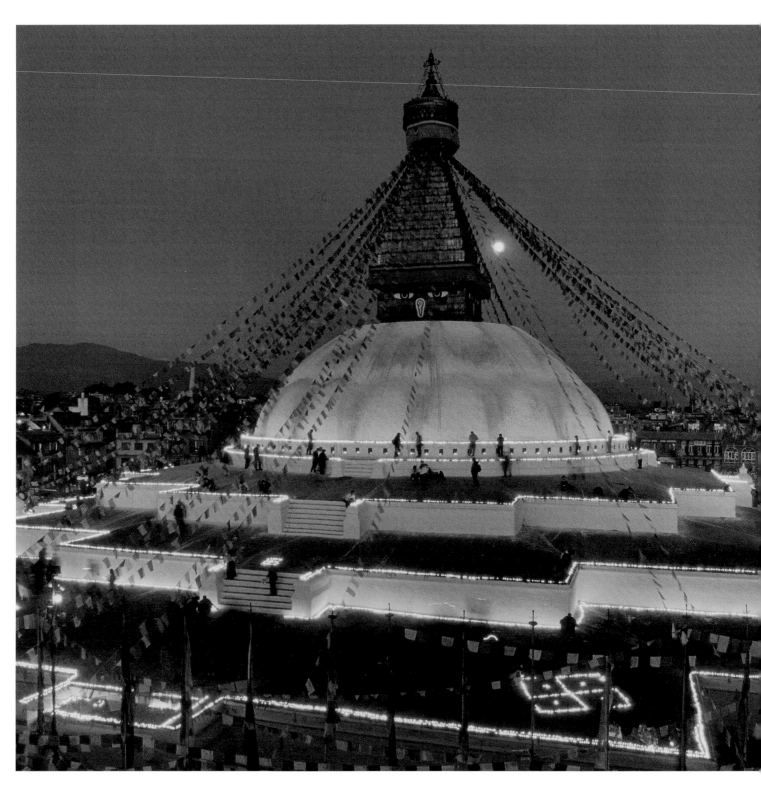

Butter lamps numbering 108,000 are lit as an offering around the base of the Great Stupa of Boudhanath in Kathmandu. The tiers of this seventh-century reliquary represent stages on the way to enlightenment.

sometimes turned gangrenous. They were hungry, and many were vomiting blood from bleeding ulcers, which meant I had to arrange for blood transfusions.

I ran the clinic by myself for nearly three years, buying medicines in the local market and treating 30 to 40 exhausted and sick refugees each day, without the benefit of doctor consults. As soon as one patient stood up, another would lie down in his place.

As if the refugees hadn't suffered enough already, people in the neighborhood caused us trouble: They would come into the guest house, break windows, tease the refugees, and try to run them off. I had to police this, as well as helping the refugees do simple tasks such as shopping, because they didn't know how to speak Nepali.

Torture victims presented the greatest difficulty. Some of the new arrivals from Tibet had been recently released from prison after serving sentences that had lasted 10, 20, and even 30 years. Some had been tortured so severely that they were in chronic pain. Some were incapacitated. These refugees, many of them nuns, were reticent to speak openly, and they remained frightened even after reaching the safety of the reception center.

Sometimes they were arrested in Nepal before they reached Kathmandu. Then they were taken directly to jail, where 40 or 50 of them, including children, were squeezed into a small room with no windows and no food. The United Nations High Commissioner for Refugees (UNHCR) usually secured their release, but there was one case in which a group of 18 of them were deported to Tibet. We learned that all of them were re-arrested in Tibet, and some of them were tortured.

We were funded primarily by UNHCR, but the additional help we received from AHF enabled us to arrange for rapid treatment for the most seriously ill patients. We were fortunate to have skilled and compassionate doctors to help us: Dr. David Shlim was able to treat some of the difficult cases, and I delivered the patients to him, one by one. The frostbite cases were seen by an orthopedic surgeon, Dr. Ashok Banskota, who performed amputations and took excellent care of the refugees. It amazed and humbled me that the refugees never seemed to complain, despite their tremendous suffering. They only expressed gratitude.

When a wealthy Tibetan family offered us land to construct a new reception center and medical clinic, the American Himalayan Foundation and the United Nations joined in with support. The clinic has 31 beds, a nurse's station, an office, and a kitchen. I felt like a rich woman—rich in medication, bed sheets, and supplies. We placed a Medicine Buddha statue right in the middle of our new clinic. This would have a healing effect, I felt, for the refugees after their arduous, dangerous journeys from Tibet to Nepal.

THE REAL GOLDEN YEARS

Luke Sunde

Luke Sunde served 38 years as a U.S. Navy paramedic. In 1982, he went to Nepal. He was instrumental in reviving and then operating the Friends of Shanta Bhawan Clinic, which provides outpatient care to thousands of patients in the Kathmandu Valley each month.

Mothers and young patients wait their turns at the weekly Under Fives Clinic of the Friends of Shanta Bhawan Clinic in Kathmandu. "Wednesday is my favorite day," says director Luke Sunde—the day when the clinic is filled to bursting with children and parents seeking good care, paying just pennies per visit.

IN 1982 SHANTA BHAWAN, the old missionary hospital that operated for three decades in a sprawling Rana mansion near Kathmandu, closed down. It was revived as an outpatient facility in the Tibetan community of Boudhanath, and I committed to work there for one year. The new clinic had trouble raising funds from the beginning. We couldn't even pay the rent for the building, and I was notified that it would simply have to be closed—again. I just couldn't accept that, so I took on its operation and management—a daunting prospect, to be sure—and immediately faced a stack of unpaid bills.

The landlady took pity on us. She allowed us to remain, at least for some time, and I calculated that I could run the clinic out of my own pocket for three months. If the clinic couldn't be brought into solvency by then, I would give up. But with funding from AHF and a few private donors, we managed to get by and, after an enormous amount of red tape, we were able to register the clinic with the government. The patients just kept coming, and we kept caring for them.

In 1995, we started the DOTS program: Directly Observed Treatment Short-course Service, developed especially for treating tuberculosis. Patients under treatment must appear at the clinic every day for eight months, to be seen by one of our staff as they take their daily medicine. We have found that, for this developing country, this is the most effective means of assuring that patients complete their course of treatment.

Tibetan refugees were the bulk of our first patients, but now 3,000 tuberculosis patients and other outpatients from across the country pass through our modest doors each month. We calculate our cost at 60 cents per patient. In addition to general care, we do immunizations, family planning, and prenatal and postnatal care. On immunization days the clinic is packed with mothers or fathers with babies.

For years I was aware that I had diabetes, but I never seemed to have the time to take care of myself. I lost 30 pounds. After dedicating 23 years to the clinic, my wife, Marion, and I decided, at ages 78 and 81, that we would leave the Himalaya and return to Livermore, California, where we had lived for 53 years. Most of our friends had moved into retirement homes. They were thrilled to see us, and even more excited that we might move in and join them. They offered us a place at their card table and told us of how easy and convenient their lives had become. That night I couldn't sleep, and neither could Marion. We arose at four in the morning, looked at each other, and said, "We can't go there. We're not ready for that. We have to return to Nepal, where we're needed."

So we did, and that's where we are now, still running the clinic. If you can't look back on your life with a feeling that you've made a contribution to helping the world, you're finished. Life will abandon me before I abandon our work, our growing clinic family, and our needy—and grateful—patients.

THE NEXT GENERATION

Norbu Tenzing

Norbu Tenzing, eldest son of Tenzing Norgay Sherpa, is the vice president of the American Himalayan Foundation. He lives and works in San Francisco with his wife, Iwona, and daughter, Kinzom, but commutes to Khumbu and Mustang regularly.

THE ASCENT OF MOUNT EVEREST IN 1953 was a defining moment in human achievement and the genesis of a worldwide fascination with the mountains and people of the Himalaya. I have often thought back to that moment, to Edmund Hillary and my father, Tenzing Norgay, standing together on the summit of Mount Everest—two men from different continents and economic backgrounds sharing a moment in history. Together they embodied the best of what climbing is about: respectful collaboration toward a shared goal. The challenge of the world's highest peak paled, however, when compared to the challenges and rewards they faced when they returned to the Himalaya to help the people who live there.

My father did not foresee the degree to which his feat would awaken the national pride and psyche of Nepal and India. Jamey Ramsey Ullman, author of Tenzing's biography, *Tiger of the Snows*, wrote, "Symbolically as well as literally, Tenzing on Everest was a man against the sky, virtually the first humbly born Asian in all history to attain world stature and world renown. And for other Asians his feat was not the mere climbing of a mountain, but a bright portent for themselves and for the future of their world."

Tenzing was feted with honors and medals from Nepal and India. Prime Minister Nehru became a confidant and friend, which made him feel at home in India. My father became a symbol of hope and triumph—of possibility—for all in the subcontinent.

Some credit Tenzing Norgay and Sir Edmund Hillary with introducing Sherpas to the outside world and with bringing trekkers and mountain enthusiasts to the Himalaya in record numbers. But for them, there was an accomplishment of even greater value. It was my father's and Hillary's dedication to the Sherpa and other mountain communities that has been most meaningful for them, for this has had the longest lasting effect.

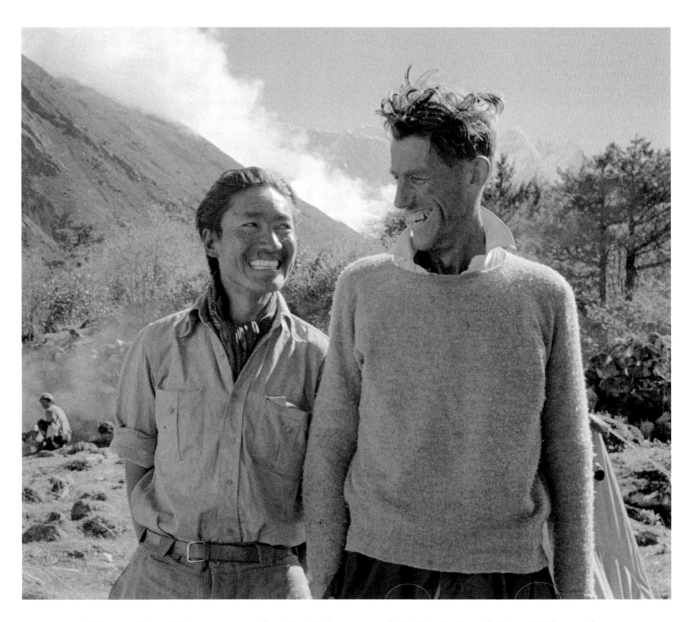

Photographer and Reuters correspondent Peter Jackson captured this historic photo of Edmund Hillary and Tenzing Norgay at Tengboche Monastery on June 4, 1953, following their first ascent of Everest. "I have climbed my mountain, but I must still live my life," Tenzing later told his sons Norbu, Jamling, and Dhamey.

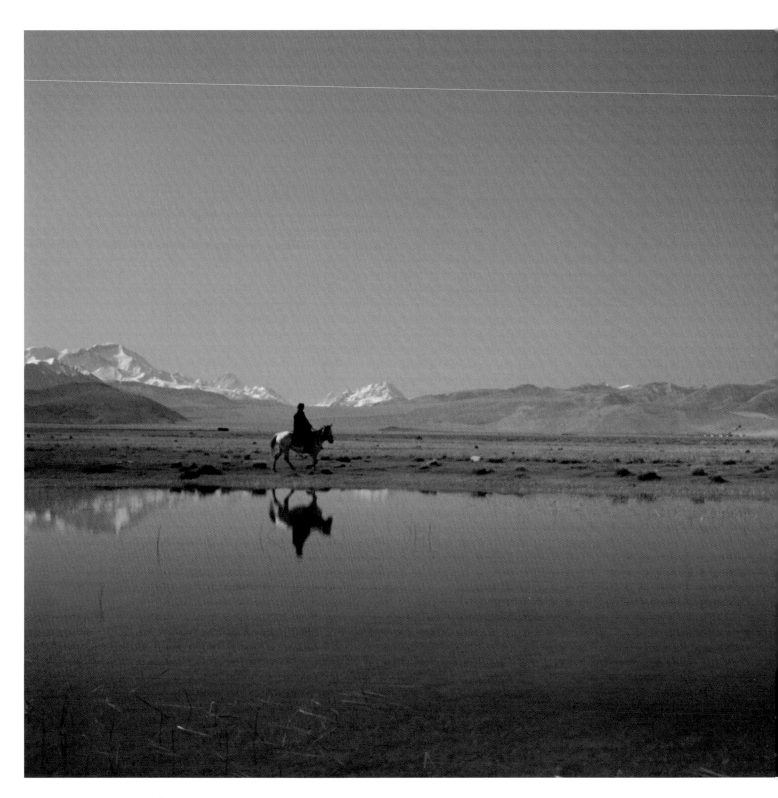

From the Tingri Plain in Tibet, the 19,000-foot Nangpa La (directly behind the horseman) leads to Khumbu. This pass has formed a vital trade and spiritual link between Tibet and Sherpa country in Nepal.

*To claim that one had conquered
would be arrogant, if not sacrilegious.
Humans are granted no more than
an audience with Everest's summit,
and then only rarely
and for brief moments.*

—Jamling Tenzing Norgay,
Touching My Father's Soul

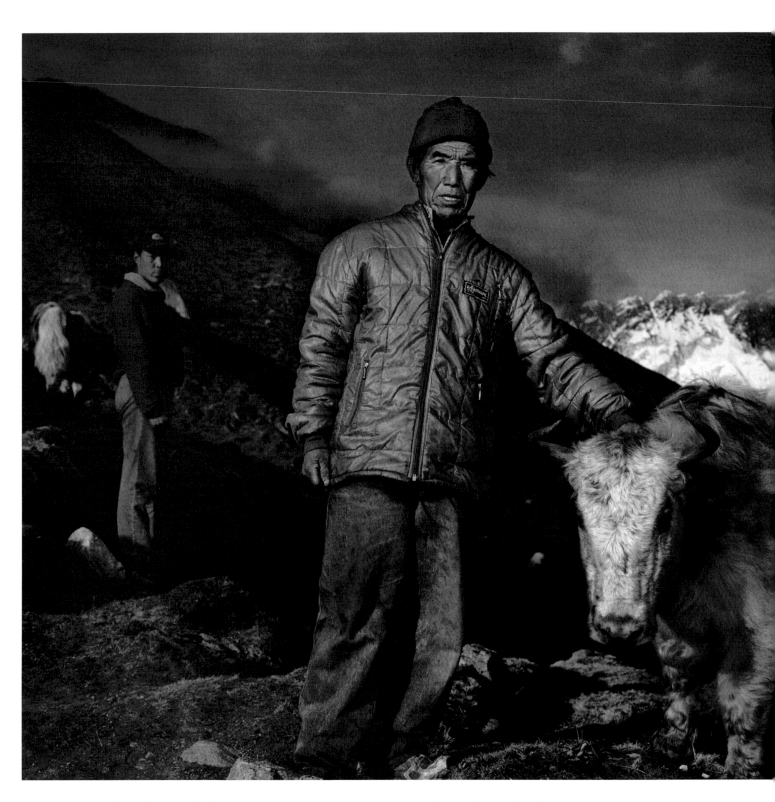

Ang Nuru Sherpa, a climbing sirdar, or leader, and veteran of the 1953 British Everest Expedition, stands regally with one of his yaks above Dingboche, his Khumbu village, the Lhotse-Nuptse wall behind him.

After Everest, Tenzing established a trust to care for the families of Sherpas who died while climbing, and he helped many in the Sherpa community get an education and find jobs that they otherwise wouldn't have been hired for. Prime Minister Nehru asked him to produce "a thousand Tenzings" and inspired him to establish the Himalayan Mountaineering Institute in Darjeeling, which receives more than 200,000 visitors each year. HMI has taught climbing and survival skills to countless numbers of India's military and police, and has inspired many more to "climb their own Everest."

My father cautioned me about the fragility of the environment, and of the adverse consequences of greed and of abandoning religious behavior. He taught me that cultural traditions take generations to form but only a few years to disappear. Change is inevitable, but we can choose the character of that change.

Initially, change in Khumbu and other Himalayan valleys came from friends outside the Sherpa world. Hillary was the most dedicated. He saw and voiced our hardships, and he brought improvements to hill peoples' quality of life. He listened and responded to our priorities, yet he asked for nothing in return.

During the trekking season, as many as 20 small plane flights arrive in Lukla, the gateway to Khumbu, each day. Visitors from around the world come to the Himalaya to fulfill lifelong dreams of trekking or climbing in the shadows of the great peaks. My father said that these visitors are a source of education and communication, because travel fosters international friendship and understanding and forges deep ties.

But he also warned that tourism brings environmental, social, cultural, and economic impacts. In effect, he has challenged my generation to balance personal ambition and new economic opportunities with the reality that many people still live subsistence lives, with little economic security. I am very aware that my generation has benefited from our parents' struggles; our generation was the first to receive an education and learn of the outside world.

From our parents, we have also inherited the delicate responsibility of preserving our rich cultural heritage—our art, rituals, language, and even our local medicines and environment. My Sherpa peers have largely accepted this task, and we are taking charge of our own destiny. A Sherpa Advisory Committee now oversees the Himalayan Trust work in the Everest region, successfully sustaining and building upon the progress started by the trust.

Some of my generation have traveled and seen the world, and some have returned home to share their knowledge and experiences. Recently, I organized the first "Loba-Sherpa Summit" in Kathmandu, an informal gathering of the Sherpa Advisory Committee and members of the Lo Gyalpo Jigme Foundation, from upper

Mustang in northwest Nepal. Although Mustang is separated from Khumbu by towering mountains and hundreds of miles, we share ancestral roots in neighboring Tibet. The Lobas have long lived in isolation, and in terms of development and economy they are 40 years behind Khumbu, but catching up.

The synergy and exchange of ideas was electric, as we discussed day-care centers, the impacts of electricity or construction of a road into a village. The Sherpas recalled what they sacrificed in their race toward development, and the Lobas of Mustang were able to hear what has worked and hasn't worked for the Sherpas—as all of us plunge into the future.

It was one of the most satisfying afternoons of my tenure with the American Himalayan Foundation. I am Sherpa, and I have great love for Mustang and admiration for the Lobas. Sitting together as friends, exploring ways to improve life for our respective peoples, I realized that the baton of progress has been passed to our generation. Sir Edmund Hillary, my father, and many others have built a foundation of achievement for our generation. Now, we must choose the proper path—one that doesn't straddle two worlds, but rather unites them.

You can't see the entire world

from the top of Everest.

—Tenzing Norgay,
as quoted by his son Jamling Tenzing Norgay

My grandfather lived to the age of 90, in the village of Thame, in the same way our ancestors did for over 500 years—living off the land, herding yaks, and trading with Tibetans. He never benefited from tourism. There are many people like him—all those who don't happen to live in the vicinity of the country's few trekking trails.

The world is now a smaller place. What happens in the United States affects the lives of porters who exist on two dollars a day, and it affects the lives of farmers who exist entirely on the fruits of their labors. When we bring help and opportunity to the people of the Himalaya and other developing regions, the entire world benefits.

My father emphasized to my siblings and me, from a young age, the importance of humility. I understand now that it is impossible to achieve everything we would like in a single lifetime. We can only work hard, and work carefully. In the end, our humanity is judged by our compassion.

SCHOOLHOUSE IN THE CLOUDS

Ang Rita Sherpa

Ang Rita Sherpa was in the first graduating class of the Khumjung School, built by Sir Edmund Hillary. He is the director of the Himalayan Trust in Nepal, overseeing the trust's health care, education, environmental, and infrastructure work, and he heads the trust's Sherpa Advisory Committee.

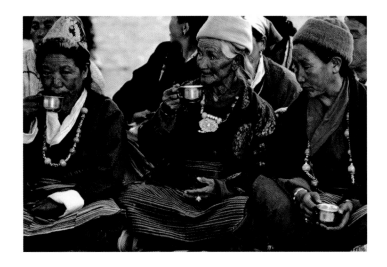

Sherpa women sip tea at a ceremony honoring Sir Edmund Hillary at the Khumjung School, Khumbu. Tsering Dolma (left) was the first woman mayor of Khumjung.

IN 1961, I WAS EIGHT YEARS OLD and lived in a village called Khumjung in the shadow of Mount Everest. My father, Khapa Kalden, was a famous Tibetan painter of murals for Buddhist monasteries and private chapels. The Sherpas of Khumbu lived mainly in a barter economy, and my father was usually paid in the form of goods. We grew potatoes and buckwheat, but in order to acquire grains which were not grown locally—rice, maize, and millet—my mother, with help from my elder sisters, would spin wool and weave blankets for trade. There were no schools in our village, and education was limited to those who enrolled in monasteries and nunneries.

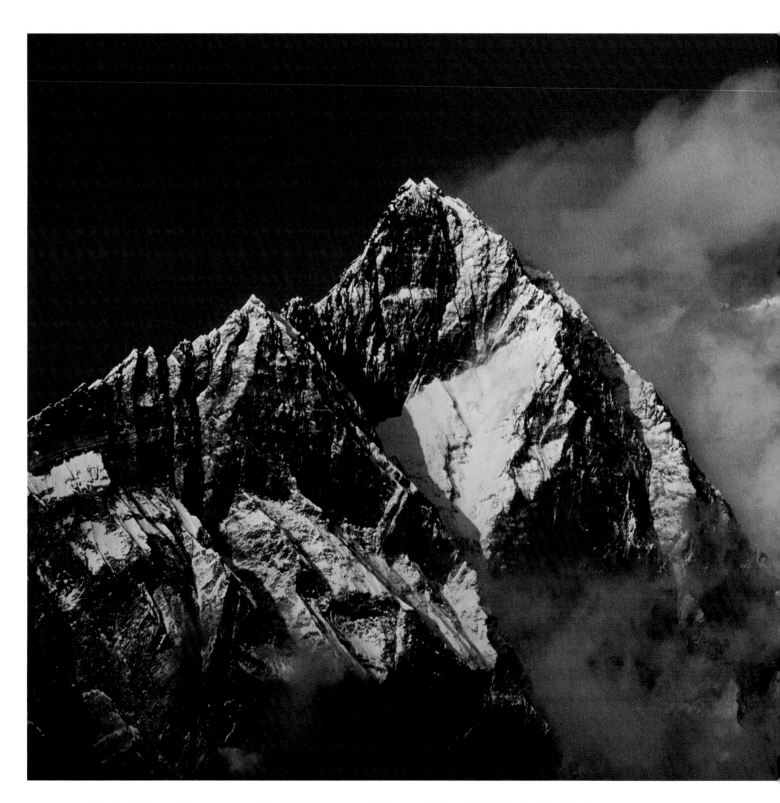

Evening lights up Lhotse, an extension of the Everest massif that overlooks much of Khumbu. The fourth highest mountain in the world at 27,939 feet, Lhotse was first climbed by a Swiss expedition in 1956.

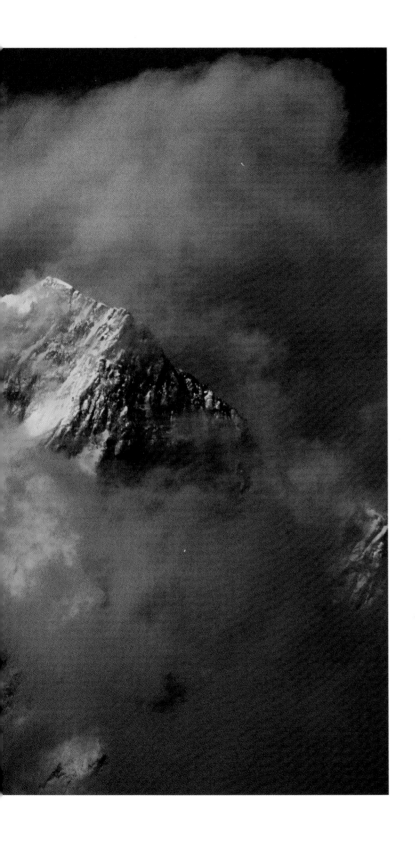

We don't need to be taught about fodder and
firewood. We learn about that from the time
we learn to walk and carry a small load.
Teach us how to read and write.

—Rai woman from Simle, Nepal, 1993

Dewoche Nunnery in Khumbu, near Tengboche Monastery, has been championed by Ang Rita Sherpa. Before receiving AHF support, Dewoche's dozen nuns could not afford to repair roofs or put sugar in their tea.

But in 1961, Sir Edmund Hillary changed this. He hired a teacher from Darjeeling and built the first school in our region. To gather students for classes, the teacher went from house to house, encouraging and cajoling parents to send their children. I was the youngest of seven, and my father informed the teacher that he would send me as the sole member of our family to attend the school.

The first day of class, 47 students in scruffy Sherpa dress, some in bare feet, stood in a ragged line for roll call. Our prefabricated aluminum building was not yet complete, so our class was held outside, on the grass. The weather was chilly, I remember, but none of us noticed, so enthralled were we by the sights and sounds of the Nepali and English alphabets. While we chanted these foreign sounds, villagers came and gazed in wonder and amusement. Within a year, the students in my class could read, write, and sing songs in two languages, and we had learned mathematics as well.

How proud I felt when one of my neighbors came to me, holding out an unopened envelope, and said, "Ang Rita, my brother sent me a letter from Darjeeling,

and I am illiterate, like a deaf and dumb person. Can you read it and explain to me in Sherpa what it says?" At that very moment, even though I was still in primary school, I felt I had become a different person. My life had changed. That's when I realized that being able to read opened doors of opportunity to help others.

My neighbors in the village soon presumed that if I could read, I could also help with domestic and community affairs, and they began to involve me in their decisions. I learned early in life that education plays an important role in shaping a community.

After building that first school in Khumjung, the Himalayan Trust constructed more than 27 schools in the Khumbu District. Now 80 percent of children attend school, and 65 percent graduate from high school. Sir Edmund Hillary calls this one of his proudest achievements, for without the future that education has created, Sherpas' career choices would be limited to farming, yak herding, and carrying loads. Instead, my Khumbu classmates have become doctors, nurses, and teachers, and they run our hospitals, health clinics, and schools. Today many strands connect Khumbu to the world, and change and progress are happening quickly. Trekkers and tourists from many countries have brought new perspectives and economic opportunities to the area. Thanks to education, Sherpas are able to take advantage of these opportunities.

But with progress also comes responsibility for steering those new advances in a positive direction. I believe education's primary aim should not be to enhance one's lifestyle or create personal comfort. Rather, it should be directed to bringing about sensible development, preserving local cultures, and conserving our fragile environment, as well as encouraging friendship and harmony in our communities.

The philosophy of the Himalayan Trust is to help local people in the way that they wish to be helped. Local communities must be the key partners in the management of the schools, hospitals, and other projects that the trust supports. Nowadays, realizing the importance of education, some Khumbu villagers have taken to sending their children away for schooling, believing that outside schools are better. In this way, they are neglecting their language, their culture, and the role of family bonds and affection. I fear that the young children who leave will receive an education, but they will lose their connection to their home. In the end, they will lose more than they gain.

To compare the child of 1961 to the man of today is like a dream. I am a product of Sherpa tradition, as well as of the larger, educated world. I owe my ability to stand in these worlds, and to embrace them both, to something as simple as being able to go to school.

For me and my peers in that first class of Khumjung School, the journey has been long and challenging, but the rewards have been many and great.

THE VIEW FROM THE MOUNTAIN

Peter Hillary

Peter Hillary, the son of Sir Edmund Hillary, has climbed Mount Everest twice and embarked on more than 40 other expeditions around the world. Hillary raises funds for and works on charitable projects in the Himalaya. He has written and contributed to numerous films and books. Married, with four children, he lives in Auckland, New Zealand.

As views go, it's a rather good one. It is geopolitical in its wide range. From the summit of Mount Everest, as you pivot upon your cramponed boots, you scan a horizon of some of the world's most extraordinary terrain: much of the Great Himalayan Range, the Tibetan Plateau, the deep clefts of remote river valleys.

Nima Tashi, my seasoned Everest climbing partner, slapped his arms around my quilted shoulders. "Good going, Peter Sahib."

It was 10:05 in the morning, May 25, 2002. We had work to do. We were there to make a film for the National Geographic Society on the 50th anniversary of my father's and Tenzing's climb. Pete Athans had the camera rolling.

I pulled out my satellite telephone and spoke to Jamling, Tenzing's son, down at Base Camp. I experienced a strong emotional connection. We are the sons of Everest, Jamling and I, sons of two of the great men of Chomolungma. "Who reached the top first, Dad?" the Hillary children would ask our father, perched on his knees. His reply was always the same. "We climbed it together."

I called my wife, Yvonne, and then my father.

"Hello, Dad. It's Peter. I am on the summit." Tears had filled my eyes.

"How was the Hillary Step?" My father asked with a chuckle.

My own ordeal in reaching the summit reminded me of the tremendous difficulties my father and Tenzing faced in getting here. We knew the way. We had maps, photographs, climber testimonials. In 1953, Dad and Tenzing were pioneering the unknown. Physiologists had even questioned whether Everest's altitude could sustain consciousness.

This 2002 climb was Nima Tashi's fifth Everest summit. He got into climbing for the money, he said. The first time that he climbed on the mountain, he was down below, on the approach route, when he received a message from Base Camp that a sick climber

238

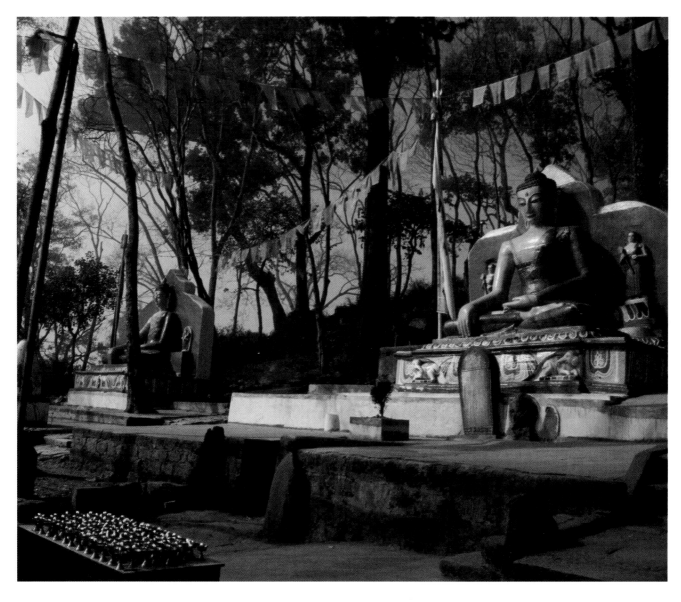

Sherpas wintering in Kathmandu light votive lamps at the base of Swayambhu Hill before climbing to the stupa. Bird songs and temple bells suffuse the swirling morning mist as pilgrims, tourists, and daily supplicants ascend the 200-odd stone steps, spurred on by resident rhesus monkeys.

at Camp III urgently needed bottled oxygen. Nima trekked up to Base Camp, borrowed some crampons, stuffed the oxygen bottles into his pack, and set off up the Khumbu Icefall. Passing Camp I, he trudged up the Western Cwm to Camp II, then up the fixed ropes of the polished ice of the western face of Lhotse to 23,500 feet. After delivering the oxygen bottles at Camp III, he descended all the way to Base Camp. An extraordinary day, by any standard.

The experience of climbing Everest, and of surviving it, has changed Nima's life and mine—and the lives of all those who have approached her. To push oneself to within a wisp of death and return to the valley in the world below is to see life in its raw immediacy, disassembled into its essential components. In some ways it helps you see what is important.

"Our children have eyes, yet they cannot see," the Khumjung villagers petitioned in 1960. "Please build us a school."

Sir Edmund Hillary shot this 1961 photo from the hillside above the construction site of the Khumjung School. Building materials were flown into a makeshift airstrip at 15,000 feet, on the side of Ama Dablam.

First one school was built, then another and another, including the one attended by Nima Tashi and his relatives and friends. Then two hospitals, at Kunde and Paphlu, and a network of medical clinics that provide basic health services where before there were none. Now there are 42 schools, hospitals, and medical clinics, airstrips and bridges, forestry projects and water systems in Khumbu and Solu, to the south. They have all resulted from the collaboration among Ed Hillary, villagers, and a family of friends and organizations like the American Himalayan Foundation.

The teacher education program has provided better child-based teaching, inspiring everyone from students to local school committees to the Nepalese government. Rote learning (backed by a stick) has taken another step into the past. Women's literacy has come forward, too. Educated women inspire children with a zeal for education and vocational possibilities.

All this has been a way to give something back. The Hillarys have been welcomed into the homes of the mountain people we have worked with, and we have made lifelong friends. This alone has been ample reward. If it had not been for the Nepalese hill people's warmth and kindness, I don't know how we would have made it through our own difficult times, including the death of my mother and sister in a plane crash when we were working at Paphlu Hospital.

Dad and I have piloted jet boats up the Ganges River, we've flown to the North Pole with Neil Armstrong, and we've established new routes across Antarctica to the South Pole. When I first climbed Everest in 1990, Dad and I became the first father-son pair to have reach the summit of the mountain, though our climbs were 37 years apart. All these accomplishments give us much satisfaction, but the greatest success has been reaching out the hand of friendship and gifting the fundamentals of education, health care, and the preservation of culture to people in the Himalaya. In a way, this is another "Hillary Step"—a step up for people who need it—and quite different from the famous feature that bears Dad's moniker just beneath the summit of Everest.

Why should we help people in other countries? In the past, people readily left their homes for the new world, for a better life. But not everyone can move to foreign lands of opportunity. The new millennium may be a time to build a new life at home rather than seek it abroad. For many in the world to do this, the wealthy nations of the world need to demonstrate greater generosity and contribute toward a more meaningful sense of global community.

In the foothills of the Himalaya, the climb goes on. It is an impressive thing to determinedly pursue and reach your own goals—to climb your own Everest. It is an even greater thing to help others reach theirs.

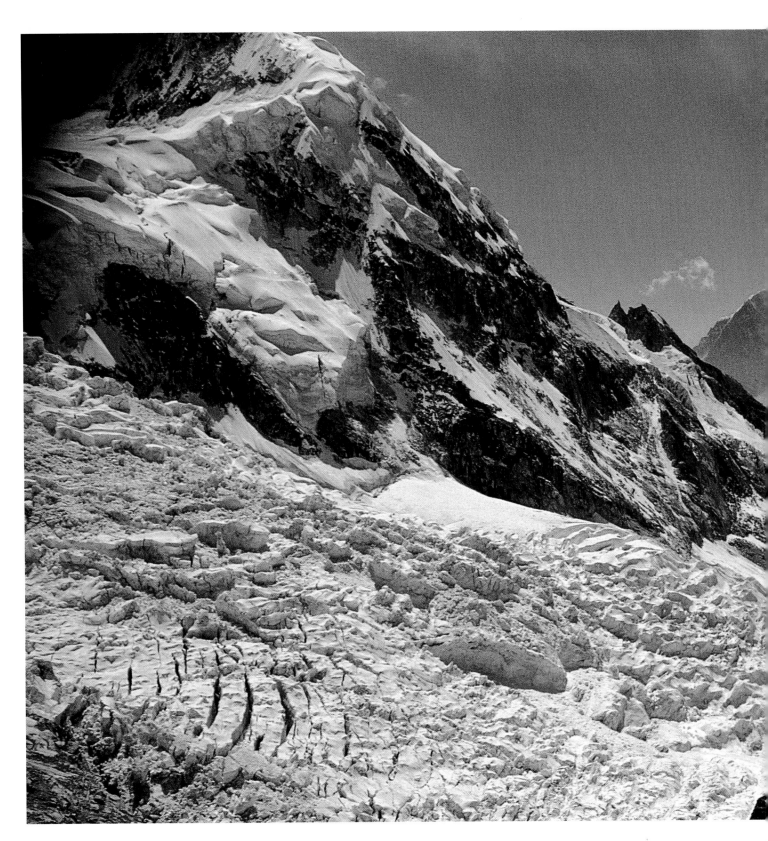

A climber pauses below the 20,000-foot Lho La, beneath the West Ridge of Everest, to view the Khumbu Icefall.

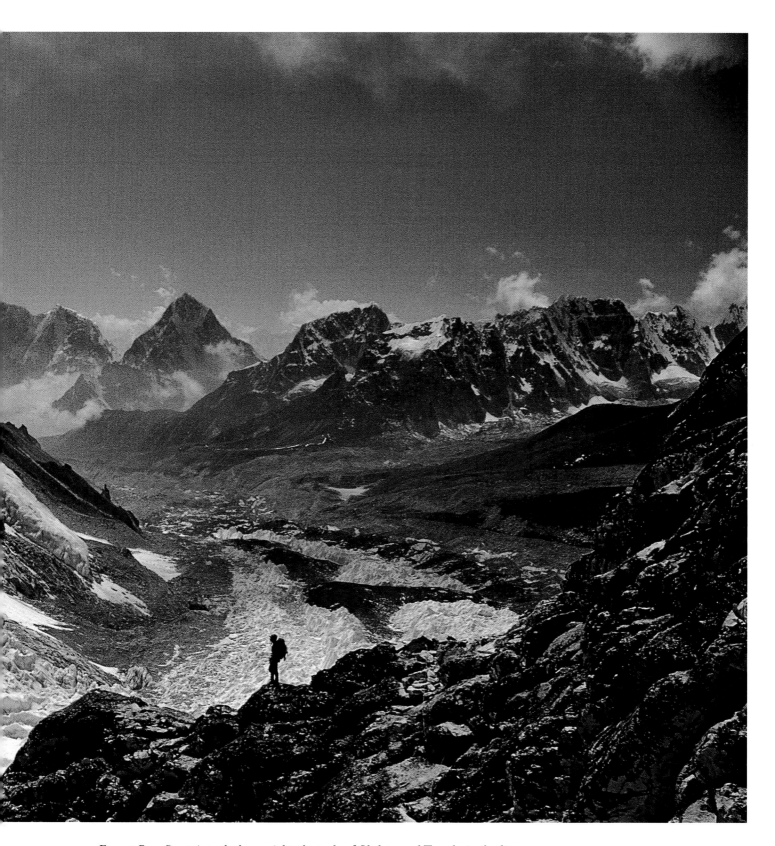

Everest Base Camp is to the lower right, the peaks of Cholatse and Tawoche in the distance.

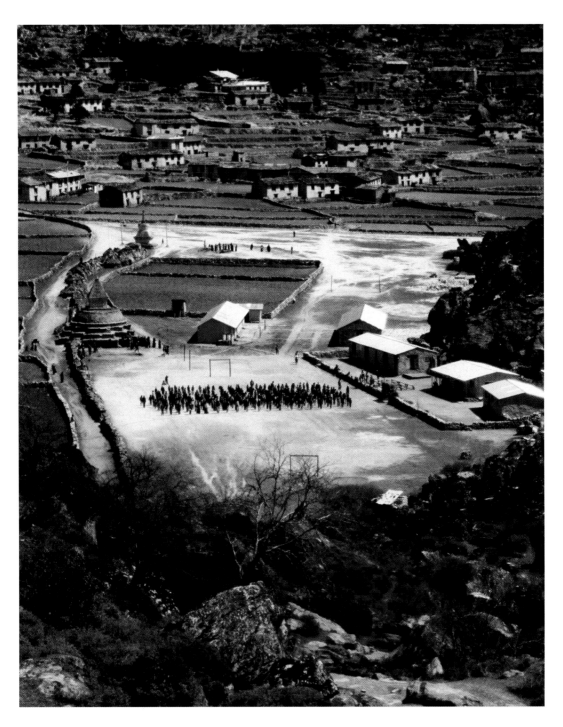

With the village and monastery beyond, Khumjung School students gather for exercises before class. The Himalayan Trust, founded by Sir Edmund Hillary, has built 27 schools. Khumjung was the first, opening in 1961 with 58 children. Some students walked more than two hours each way to attend.

BEYOND THE SUMMIT

Sir Edmund Hillary

FOR THE SUMMIT PUSH, THE FIRST ASSAULT TEAM was to be Charles Evans and Tom Bourdillon with their powerful but somewhat unreliable closed-circuit oxygen equipment. Their main task was to reach the South Summit, and if all went well, they could try a push to the top. Tenzing and I, with our open-circuit oxygen and considerable fitness, would be the summit team.

Tenzing and I climbed up to the South Col in time to see Evans and Bourdillon disappearing into the mist near the South Summit. But, alas, they were having great problems with their oxygen equipment, and on the South Summit they made the sad decision to turn back from the summit ridge. They were absolutely exhausted when we met them back on the South Col.

Tenzing and I spent two miserable nights on the South Col in wild winds and cold temperatures. Then conditions improved, and we climbed up the Southeast Ridge and put in our final camp at 27,700 feet. The next morning we climbed the soft, steep snow slopes above, and somewhat nervously reached the South Summit.

Ahead of us was the narrow summit ridge leading to the top, and I led along it, hacking a line of steps. A formidable rock step barred our way—quite a problem at 29,000 feet. An ice cornice was overhanging on the right side with a long crack inside it—but would it hold, I wondered, or go tumbling down the

mountainside? There was only one way to find out: I wiggled my way inside and jammed my way up to the top.

For the first time I felt confident that we were going to get to the summit.

Tenzing struggled up to join me, and I carried on, cutting steps over hump after hump. Finally, to the right I saw above me a huge snowy dome. On a tight rope, I continued cutting steps upward, with Tenzing close. We looked around in wonder. We had reached the top of the world.

Here man seemed to be reaching for something.

His grip was tenuous, inconsequential,

yet full of beauty and meaning.

His was a world of peace wrought from wildness and latent power....

The summit plume raced eastward,

yet could not free itself from the solid bastion

which gave it birth.

—Thomas F. Hornbein

Over the years, I had built up a close relationship with the Sherpas of Nepal. I had spent a great deal of time in their homes and with their families. I admired their courage, their strength, and their sense of humor in their tough and rigorous environment. I did not feel sorry for them—far from it. But I quickly realized that there were many things they lacked in their society that we take for granted: schools and medical facilities, for instance.

In 1960, I asked a group of Sherpas if we could do something to help. What would it be? Education. It was universally agreed that a school in the large village of Khumjung was essential.

I raised the necessary funds in the United States and was given an aluminum building in Calcutta. It was a laborious task, getting the building into Khumjung

and assembling it. We invited the head lama of Tengboche Monastery to carry out the opening ceremony, and he arrived with a number of his monks, plus trumpets, drums, and cymbals. There was much chanting of prayers. Finally the head lama circulated around the building with us all trailing along behind, and he cast handfuls of rice in every direction, as this is the traditional method of blessing. Then we had a great celebration.

Khumjung School proved a great success, and soon we were having requests from many other villages.

I started to follow a regular routine, a mixture of adventurous activities and aid programs. And nearly every year I was back in the Himalaya, climbing and building schools.

As I got older, I became more involved in the welfare of the Himalayan people. My wife and I traveled around the world, raising funds for projects for these worthy mountain folk. We helped them establish 27 schools, 2 hospitals, and a dozen medical clinics. We constructed several airfields and, at the request of our local friends, we rebuilt Buddhist monasteries and cultural centers.

If Tenzing were alive today, I am sure he would be as proud as I am that our sons, too, have carried on the work of helping the Sherpas build a better life for themselves. His son, Norbu, has been a vice president of the American Himalayan Foundation for over a decade. Norbu, Erica Stone—the foundation president— and my old friend, Dick Blum, the founder and chairman of AHF, have long been solid, faithful partners of the Himalayan Trust.

I have been fortunate enough to be involved in many exciting adventures. But when I look back over my life, I have little doubt that the most worthwhile things I have done have not been standing on the summits of mountains or at the North and South Poles, great experiences though they were.

My most important projects have been the building and maintaining of schools and medical clinics for my good friends in the Himalaya—and helping with their beautiful monasteries, too.

These are the things I will always remember.

The face of the newly restored Shakyamuni Buddha watches over the 15th-century Thubchen assembly hall in Lo Manthang, upper Mustang, Nepal. Made of beaten, gilded copper, spaciously studded with precious gems and clothed in fine silks, the full figure sits serenely on a plinth ten feet above the floor.

YOU CANNOT STAY on the summit forever, you have to come down again … So why bother in the first place? Just this: what is above knows what is below, but what is below does not know what is above.…

One climbs, one sees. One descends, one sees no longer, but one has seen. There is an art of conducting oneself in the lower regions by the memory of what one saw higher up. When one can no longer see, one can at least still know.

—René Daumal, from *Mount Analogue*

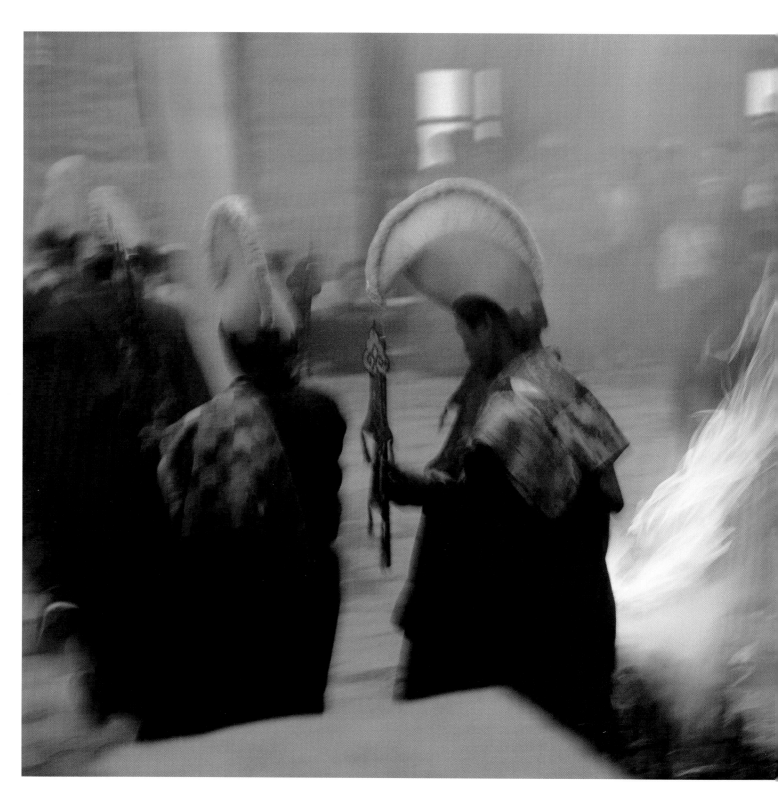

Monks perform a jinsak *fire dance in the rain to burn and cast out negative spirits, part of the rededication of Tengboche monastery.*
FOLLOWING PAGES: *The sun sets as the moon rises on top of the world, bathing in light the world's highest mountains: Everest, Lhotse, and Nuptse, at left; Makalu, distantly center; Cholatse and Taweche, at right.*

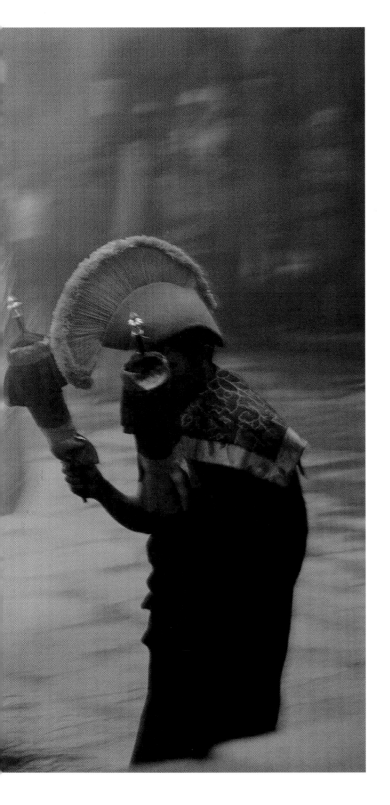

THE AMERICAN HIMALAYAN FOUNDATION provides education, health care, and cultural and environmental preservation in the Himalayan region. AHF also helps Tibetan refugees with their difficult struggle to survive and maintain their culture.

THE AMERICAN HIMALAYAN FOUNDATION
909 Montgomery Street, Suite 400
San Francisco, California 94133
(415) 288-7245
www.himalayan-foundation.org

Proceeds from the sale of this book are being dedicated to projects that the American Himalayan Foundation supports across the Great Himalayan Range.

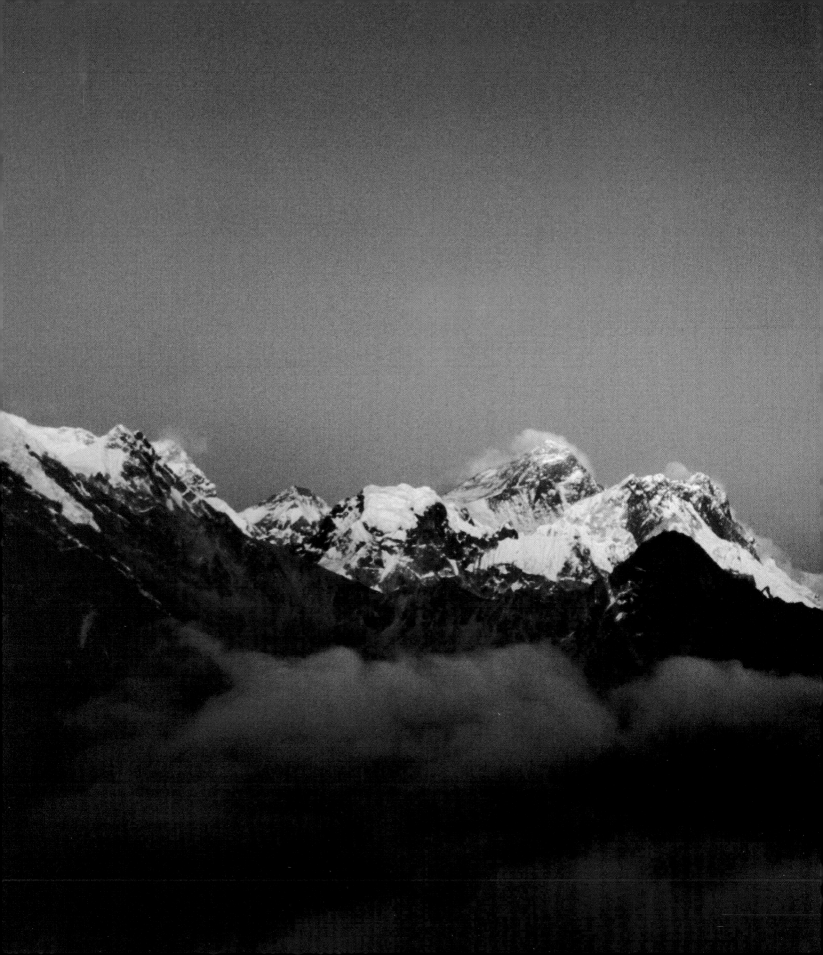

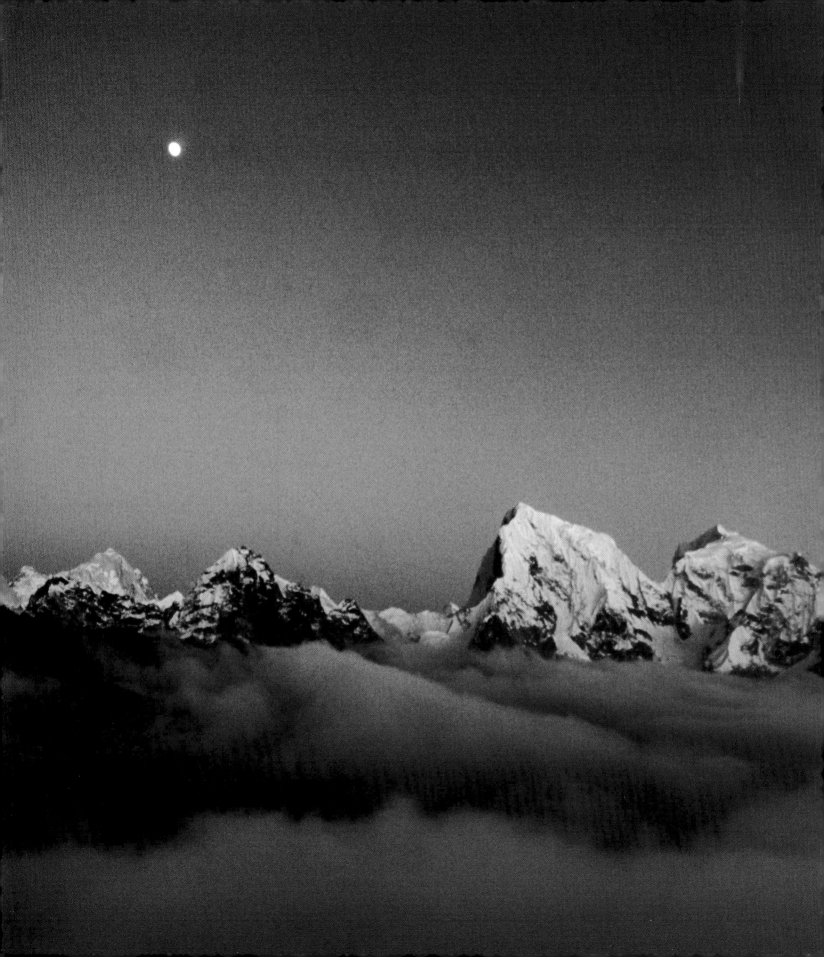

ABOUT: THE PHOTOGRAPHERS

THIS BOOK HAS BEEN BLESSED by the generous donation of photographs of outstanding strength and diversity—images that draw the Great Himalayan Range into a new light that is by turns dazzling, subtle, gorgeous, and finely shaded. The contributing photographers, listed below, range from travelers and pilgrims to artists and professionals, but in every case their imagery reveals a sensibility and vision found only among those who have become part of the Himals.

Thank you, all! Your talent and benevolence is eclipsed only by our gratitude. May your artistic efforts, and the fruits of your acomplishments, multiply in the world.

Thomas Abercrombie: 40
American Everest Expedition, 1963, Collection: 43
Stan Armington: 208, 209
Bruno Baumann: 11, 28
Raju Bhandari: 222
Barry Bishop: 44-45
Heidi Jeanne Blum: 183, 250-251
Richard C. Blum: 113
Geoff Oliver Bugbee: 89
Jimmy Chin: 24-25, 60-61
Liesl Clark: 35, 190, 192-193, 202-203
Broughton Coburn: 72, 120, 122-123, 132, 158, 184-185, 187, 205, 224, 236
Nick Dawson: 116-117, 219
James Whitlow Delano: 104-105
Luigi Fieni: 20, 189, 195, 198, 206, 248
John C. Gray: 54-55
Sir Edmund Hillary: 240
Richard I'Anson/Lonely Planet Images: 70-71, 76-77, 136-137, 160-161, 234-235

International Campaign for Tibet: 96
Peter Jackson: 227
The Jinpa Project, Qinghai: 99
Lanny Johnson: 16
Nancy Jo Johnson: 95
Anne B. Keiser: 233, 244
Debra Kellner: 155
Thomas L. Kelly: 53, 128-129, 131, 135, 168-169, 172, 175, 178-179, 221
Frances Klatzel: 36, 50, 65
Bruce Klepinger: 59
Vassi Koutsaftis : 2-3, 66-67, 69, 86-87, 92-93, 214, 228-229, 239
Craig Lovell/Eagle Visions: 32, 171
Ron Matous: 38-39
Steve McCurry/Magnum Photos: 12, 84, 107
Michael Nichols: 150
Jake Norton/Mountain World Photography: 57, 109

Jaroslav Poncar: 181, 201
Matthieu Ricard: 30-31, 63, 91, 100-101, 177, 213, 216-217
David Samuel Robbins: 62-163, back dust jacket
Gil Roberts: 166
Galen Rowell/Mountain Light: 149
John Sanday: 196-197, 210
George B. Schaller: 145
Martin Schoeller: 230-231
Lawrence Shlim: front dust jacket
Snow Leopard Conservancy: 157
Brian Sokol: 124
William Thompson: 152-153
John Van Hasselt/CORBIS: 110-111
Ed Webster/Mountain Imagery: 48-49, 74, 80-81, 242–243
Brian K.Weirum: 4, 252-253
Jim Whittaker: 46
Gordon Wiltsie: 79, 103, 114, 138, 140-141, 143, 146-147
Sonam Zoksang: 119, 127

ABOUT: THE EDITORS

RICHARD C. BLUM, chairman of Blum Capital Partners and of the American Himalayan Foundation, led the 1981 Everest East Face Expedition. In 1998, the Dalai Lama awarded him the Light of Truth Award for his steadfast support of Himalayan peoples. He recently founded the Blum Center for Developing Economies at the University of California and is a director of the Carter Center.

ERICA STONE was born in Canada, grew up in California, and in the Himalaya found love, adventure and Tibetan grandmothers who know the meaning of life, gratitude, and the art of releasing oneself into laughter. She is president of the American Himalayan Foundation, where she has seen the organization grow to 130 projects, and has thrown more than 100 infamous fundraising events.

BROUGHTON COBURN headed east from the United States in 1971, turned left at India, and landed in the Himalaya, where he spent two decades writing books and working in conservation and development for the United Nations, the World Bank, and other agencies. In a search for efforts that achieve effective, measurable results, he found a home with the American Himalayan Foundation as its first field director, based in Kathmandu.

ACKNOWLEDGMENTS

First and foremost, this book would not have been possible without the kind participation and generous contributions of the esteemed essayists and photographers. As editors, we extend our heartfelt gratitude to you, and hope that you can take as much pride in this truly collaborative effort as we do. You are the jewels in the lotus.

Other individuals have played essential roles in organizing, editing, and crafting this book, and we offer you a million thanks—indeed, the sacred number of 33-times-the-stars-in-the-Milky-Way thanks.

Sarah Lazin, our masterful literary agent, provided hope and direction when at times we seemed to have neither. AHF's own Marilyn Seaton coordinated the veritable traffic jam of details with grace. Image goddesses Sally Vaughn and Jeannie Craig—professionally and with good humor—made thousands of images not only viewable but manageable. Paula Stout and Didi Thunder offered valuable editorial skills and moral support in times of confusion. Gordon Wiltsie and Thomas Kelly provided invaluable practical advice and bearings, Erik Pema Kunsang superbly translated Chokyi Nyima Rinpoche's essay, and Karen McLellan kept us sane. Again, thanks and blessed kata scarves to all of you. To us, you are revealed hidden treasures, like the sacred guiding texts left by Guru Rinpoche to help mankind find its way.

We are also grateful for the kind attention, patience, and counsel of John Ackerly, Ian Alsop, Tsewang Bista, Heidi Blum, Andrew Bronstein, Barbara Brower, Kevin Bubriski, Nicholas Clinch, Pat Emerson, Jim Fisher, William Forbes, Lesley Friedell and the International Campaign for Tibet, Shannon Gaffney, Brian Harris, Suzen Hopkins, Tom Hornbein, Lanny Johnson, Alexa Johnston, Chandra Shekhar Karki, Saskia Kleinert, Jon Krakauer, Ken Kwan, Eileen Moncoeur, Bruce Moore, Tony Meyer, Jan Olsen, Matteo Pistono, Matthieu Ricard, Hiroo Saso, Orville Schell, David Shlim, Junko Tabei, Norbu Tenzing, Jolene Unsoeld, Ed Viesturs, Tsering Wangmo, Ed Webster, and Brian Weirum. May the blessings of all the deities be with you.

CREDITS

Some material in this book came from other sources:

The opening passage and excerpts on page 21 are by Lama Anagarika Govinda from *Insights of Himalayan Pilgrim*, English translation, Dharma Publishing, 1991.

The closing passage is by René Daumal from *Mount Analogue: An Authentic Narrative*, translated by Roger Shattuck, Vincent Stuart Publishers, Ltd., 1959, and City Lights Books, 1971.

"A Visit to Nepal" by President Jimmy Carter is adapted from his book, *An Outdoor Journal: Adventures and Reflections*, Bantam Books, 1988.

Jim Whittaker's "An American on Everest" comes from *A Life on the Edge: Memoirs of Everest and Beyond*, Mountaineers Books, 2000.

"They Took Me In" by David R. Shlim is excerpted from a work in progress, *Adventures in Medicine and Compassion*.

George B. Schaller's contributions are selected and adapted from "Reflections In A Hidden Land" in *Extreme Landscapes: The Lure of Mountain Spaces*, edited by Bernadette McDonald, National Geographic Adventure Press, 2002.

Quotations in the book include passages from:

Tsering Wangmo Dhompa, *In the Absent Everyday*, Apogee Press, 2005.

Mahatma Gandhi, *The Words of Gandhi*, selected by Richard Attenborough, Newmarket Press, 1982.

His Holiness the Dalai Lama, *The Dalai Lama's Book of Wisdom*, Thorsons, 1999

His Holiness the Dalai Lama, *The Dalai Lama's Book of Love & Compassion*, Thorsons, 2002.

Thomas F. Hornbein, *Everest: The West Ridge*, Sierra Club, 1965.

Jon Krakauer, *Into Thin Air*, Villard, 1997.

Peter Matthiessen, *The Snow Leopard*, Viking Press, 1978.

Jamling Tenzing Norgay, *Touching My Father's Soul*, HarperSanFrancisco, 2001.

Hugh Richardson, *Ceremonies of the Lhasa Year*, Serindia, 1993.

HIMALAYA

Edited by Richard C. Blum, Erica Stone, and Broughton Coburn

Published by the National Geographic Society
John M. Fahey, Jr., *President and Chief Executive Officer*
Gilbert M. Grosvenor, *Chairman of the Board*
Nina D. Hoffman, *Executive Vice President;*
 President, Books Publishing Group

Prepared by the Book Division
Kevin Mulroy, *Senior Vice President and Publisher*
Marianne R. Koszorus, *Design Director*
Barbara Brownell Grogan, *Executive Editor*
Elizabeth Newhouse, *Director of Travel Publishing*
Leah Bendavid-Val, *Director of Photography Publishing*
Carl Mehler, *Director of Maps*

Staff for this Book
Susan Tyler Hitchcock, *Project and Text Editor*
Dana Chivvis, *Illustrations Editor*
Cinda Rose, *Art Director*
Margo Browning, *Contributing Editor*
Jennifer Seidel, *Contributing Editor*
Thomas L. Gray, *Map Researcher*
Matt Chwastyk, *Map Production*
Richard S. Wain, *Production Project Manager*
Abby Lepold, *Illustrations Specialist*
Cameron Zotter, *Design Assistant*

Rebecca Hinds, *Managing Editor*
Gary Colbert, *Production Director*

Manufacturing and Quality Management
Christopher A. Liedel, *Chief Financial Officer*
Phillip L. Schlosser, *Vice President*
John T. Dunn, *Technical Director*
Vincent P. Ryan, *Director*
Chris Brown, *Director*
Maryclare Tracy, *Manager*

Founded in 1888, the National Geographic Society is one of the largest nonprofit scientific and educational organizations in the world. It reaches more than 285 million people worldwide each month through its official journal, NATIONAL GEOGRAPHIC, and its four other magazines; the National Geographic Channel; television documentaries; radio programs; films; books; videos and DVDs; maps; and interactive media. National Geographic has funded more than 8,000 scientific research projects and supports an education program combating geographic illiteracy.

For more information, please call
1-800-NGS LINE (647-5463)
or write to the following address:

National Geographic Society
1145 17th Street N.W.
Washington, D.C. 20036-4688 U.S.A.

Log on to nationalgeographic.com;
AOL Keyword: NatGeo.

For information about special discounts for bulk purchases, please contact National Geographic Books Special Sales: ngspecsales@ngs.org

Library of Congress Cataloging-in-Publication Data
Himalaya: personal stories of hope, challenge & grandeur / edited by Richard C. Blum, Erica Stone & Broughton Coburn. p. cm.
ISBN 0-7922-6192-5
1. Himalaya Mountains Region. 2. Himalaya Mountains Region—Pictorial works. I. Blum, Richard C. II. Stone, Erica. III. Coburn, Broughton, 1951-
DS485.H6H54975 2006
954.96—dc22
ISBN-10: 0-7922-6192-5
ISBN-13: 978-0-7922-6192-6